The Face of Minnesota

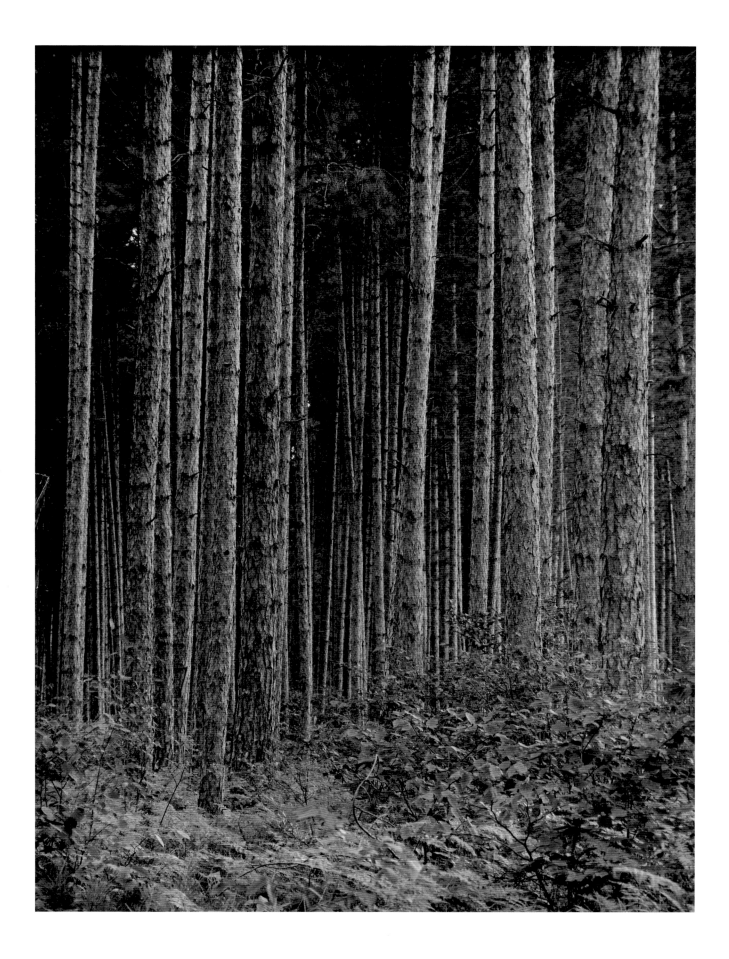

The Face of Minnesota John Szarkowski

FOREWORD BY VERLYN KLINKENBORG

AFTERWORD BY RICHARD BENSON

UNIVERSITY OF MINNESOTA PRESS

MINNEAPOLIS • LONDON

The University of Minnesota Press gratefully acknowledges financial assistance provided by the following for the publication of this book:

Robert Menschel and the Vital Projects Fund, Inc.
Elizabeth and Robert Fisher
Peter Fetterman
Susan and Peter MacGill
The John K. and Elsie Lampert Fesler Fund

Book design by Sara Eisenman
Digital imaging by Thomas Palmer
Printed by Meridian Printing, East Greenwich, Rhode Island
Bound by Acme Bookbinding, Charlestown, Massachusetts

Published by the University of Minnesota Press
111 Third Avenue South, Suite 290
Minneapolis, MN 55401-2520
http://www.upress.umn.edu

LIBRARY OF CONGRESS CATALOGING-IN-PUBLICATION DATA
Szarkowski, John.
 The face of Minnesota / John Szarkowski; foreword by Verlyn Klinkenborg; afterword by Richard Benson.
 p. cm.
Originally published: 1958.
ISBN 978-0-8166-5448-2 (hc : alk. paper)
1. Minnesota — Pictorial works. 2. Minnesota — Civilization. I. Title.
F606.S98 2008
977.60022'2 — dc22 2007053063

Printed in the United States of America on acid-free paper
The University of Minnesota is an equal-opportunity educator and employer.

15 14 13 12 11 10 09 08 10 9 8 7 6 5 4 3 2 1

Contents

PUBLISHER'S NOTE

On May 11, 1858, Minnesota became the thirty-second state to enter the union of the United States of America. One hundred years later, that event was commemorated by *The Face of Minnesota,* a book jointly commissioned by the University of Minnesota Press and the Minnesota Statehood Centennial Commission. On publication, *The Face of Minnesota* captured the interest of Minnesotans but also received national attention, remaining for eight weeks on the *New York Times* best-seller list. At the time the book was an early indication of John Szarkowski's understanding of how language and photography could work so powerfully together, which he demonstrated repeatedly during his distinguished tenure as director of the photography department at the Museum of Modern Art from 1962 to 1991. *The Face of Minnesota* continued to sell in the years following the state's centennial and was reprinted, but it was allowed to go out of print in 1968.

In 2006, the Press and John Szarkowski began a discussion about a new edition of *The Face of Minnesota* for Minnesota's sesquicentennial in 2008, taking full advantage of the many advances in offset printing and digital scanning that had occurred during the intervening half-century. Sadly, as preparations for the book's production began, John suffered a stroke and passed away some months later on July 7, 2007.

This fiftieth anniversary edition of *The Face of Minnesota* would not have been possible without the devotion and determination of John's daughters, Nina Anson Szarkowski Jones and Natasha Szarkowski Brown, as well as many close friends and associates who were dedicated to the completion of this project. The publisher wishes especially to thank Peter MacGill of Pace/MacGill Gallery in New York and Thomas Palmer, whom John entrusted with the scanning of his vintage prints and color transparencies to prepare them for reprinting.

The Minnesota of 2008 looks much different from what it was fifty years ago. Yet *The Face of Minnesota* as published in 1958 is an important testament to the traditions of the state, as well as an impressive record of the photographic vision of John Szarkowski.

Foreword

Verlyn Klinkenborg

I SUPPOSE that John Szarkowski's *The Face of Minnesota* must have been a surprising book when it first appeared in 1958, at least to anyone who read all the way through to the end, including "A Technical Note" that closes the text. Throughout the main body of the book — Szarkowski's essays and notes about Minnesota — you can hear the assurance in his prose. But it's a collective kind of assurance, the feeling that he is speaking of and for an audience who is reading his book to confirm or enlarge its sense of itself. In *The Face of Minnesota* you would hope to see your own face, if you had any kind of connection to the state.

But who is the reader of that "Technical Note"? What you hear there in Szarkowski's prose is no longer a collective assurance, the communal balm of being from the upper Midwest. It is now pointedly personal, a little like the moments in *Walden* when Thoreau ascends to what we take to be his credo. Szarkowski begins by explaining his equipment, the cameras and films he used to take the photographs. Then he begins the fourth paragraph by writing, "I feel that my own picture-making failures can very seldom be blamed on inadequate film speed." This is the audible voice of an inner dialogue, the sound of someone who is working out the lines of an art form for himself and, by extension, for an audience defined not by geography but by art.

And so it proves. Szarkowski's "Technical Note" might just as easily have been called an "Aesthetic Note" or even an "Ethical Note." He is laying down first principles, rules for "a mature and responsible language" of photography that are, first of all, rules for himself. He's marking out the artist's responsibility in a medium where it's all too easy to surrender responsibility to the technical capabilities of the artist's tools. He's saying, in essence, that technique has a way of supplanting intent and that intent is what he wants to recover. This is an age-old dialectic, and Szarkowski's zeal for the purity of intent would matter less if he weren't also so deeply versed in the technical.

Now, fifty years later, the voice of Szarkowski's technical note still sounds fresh and direct, bracingly personal and committed, an early testament of the enormous influence he would wield as Edward Steichen's successor at the Museum of Modern Art. The imperative in that note—the insistence on intent over technique—has not weakened with time. If anything, it has gained in meaning, given the enormous changes in the technical direction of photography since 1958.

The rest of the writing in this book has changed. Szarkowski's essays and notes about Minnesota—its land, people, history, and culture—belong to an era that will seem foreign unless you lived in it. But almost any child who studied in the public schools of the Midwest, as I did, will hear a familiar voice in some of these essays, the voice of destiny. That was the sound of 1958.

You can see the temporal distance in Szarkowski's photographs, the differences between the way people looked and dressed in 1958 and the way they do now. But that's just temporal distance, the present receding into the past, history elapsing. You wouldn't say of the men gathered at the farmers' meeting in North Branch, for instance, that they have dated. They simply belong to their time. But you might say of the language in this book that it doesn't simply belong to its time. Time has reneged on the universalist assumptions in this prose.

Or so it seems at first. Szarkowski alludes easily to "Minnesota" as if it were not a state or an abstraction but a living being with a pulse and a genealogy and a gilded sense of the future. "The canoes," he writes early on, "were lured westward by the promise of beaver pelts and Red Men's souls, but perhaps most of all by the dream of the Passage that would lead through the fresh waters finally to the salt waters, and to China." Well. This is not a rhetoric we smoke any more.

But there's more to Szarkowski's prose than meets the eye. It will sound odd to put it like this, but I look at the photograph of him, age probably 32, on the back cover of the jacket of the 1958 edition (you could drop him happily into Brooklyn today without changing a whisker of his appearance), and I know that the very authority of his "Technical Note" presupposes a kind of irony in his treatment of matters geographical and historical. It is not his irony to muster. It is the irony that surfaces when any one voice—a farmer or a banker or a housewife—speaks against the backdrop of what we choose to call history. History can barely stand up to the rigor of such voices, and Szarkowski knows it, and that's why he uses them. That's why the travelogue sonorousness of the opening essays fades quickly, and we find ourselves soon in the contradictory places recorded by Szarkowski's camera.

I have to admit a couple of weaknesses here. I knew John Szarkowski only as an old man, a neighbor, a curator of ancient apple varieties, a student of barns, and someone who was very kind to me about my own writing. That's one weakness. The other is that I was just coming into real consciousness in 1958, when I was six, and in Iowa, which lies, as some of you may know, just south of Minnesota. If I try, I can look at the photographs in this book and trace their formal properties, acknowledge

their place, their moment, in the history of photography. But it's one thing to see a photograph. It's something entirely different to recognize it. My weakness is that I recognize most of these photographs.

I don't mean merely that I remember the faces and the clothes and the curious humility visible even in the proudest of these pictures. Or that my mother sometimes dressed as strangely (at least in headdress) as the woman outside that curio shop in Bemidji. Or that I could have been one of the kids at that county fair in Windom. I mean that I see intuitively what John Szarkowski was getting at when he released the shutter. If I were a critic, you would have to disregard that last sentence. But I'm just a witness, and so I'll allow myself to say that Szarkowski's photographs of Minnesota do more than capture the particularity of what his camera was pointed at. They do what the very best photography always does: they capture the elision of time.

What do I mean by that? You'll need to look at the cover image of this new edition, the photograph of Mr. Anderson and daughter, near Sandstone: a farmer and his girl, the one hatted, the other hooded, standing on a winter's day in front of a corncrib. You'll see that the light that falls on Mr. Anderson's right cheek comes from a different era than the light falling on his daughter's expectant but doubting eyes. You'll wonder if these looks on their faces came to stay often, or whether Szarkowski caught their one and only visit. You'll notice how the daughter's expression might eventually grow into the father's, if times stay good and the harvests don't let up. Yet no matter how hard you look, no matter how you try to take in the patches in Mr. Anderson's trousers or the grease stains on his daughter's jacket, you simply cannot see the toughness in these two figures, though it must have been there. They are farmers, after all.

That is the secret in many of the photographs in *The Face of Minnesota*. We look for what we know must be there, and yet Szarkowski shows us that there's something richer, if more transient, to be seen. How could the toughness of that farmer and his girl turn into a kind of annunciation? For that's what is really in their faces, the sudden awareness of a beguiling purpose, the quiet mockery, I suppose, of a Mary who said, before the angel could speak, "I already know."

You'll suspect that I'm overreading these photographs, and that is indeed a weakness. But to love photography is to love time, whether it's the instant in which the shutter clicks or the years that elapse after. In "A Technical Note," John Szarkowski has almost nothing to say about time, except to specify the number of minutes his negatives were developed. But he does make this one remark: he says that learning to photograph purposefully means learning "to be less like a sponge and more like a snare." Time is the only difference between the two — time, and a certain guile.

Preface to the 1958 Edition

THIS BOOK IS ABOUT MINNESOTA NOW. But as the mature man carries on his face and in his bearing the history of his past, so does the look of a place today show *its* past—what it has been and what it has believed in.

Or consider the glaciers' scratches on the face of the rock, showing the direction from which the past came, and the direction in which it went.

I have tried to show the land and its people and their work, in such a way that the whole would fit together to give a lively and an honest sense of what the place is really like. But all the important facts could not be shown in a thousand books. It is necessary to select a few isolated images which seem to make sense together, so that one picture which is present will recall the many others which were never made, or which were made and discarded. The selected pictures are not necessarily of "important" subjects. (As when someone is trying to make you remember an old friend: he may tell you the old friend's height and weight and income and business and his wife's maiden name, but you will not remember him until you are reminded that he always looked at people over the top of his glasses.)

There are many important Minnesota images which are not in this book—Lake Minnetonka on a Sunday in July, covered with white sails; or Paul Bunyan and Babe the Blue Ox, at Bemidji; or Mille Lacs in winter, covered with ice-fishing houses. But if those who know Minnesota will be reminded of these things, and if those who do not know it can imagine what these things might be like, then it is a good book.

It would have been impossible to do this book without the help of literally hundreds of Minnesota citizens, who welcomed me into their homes and factories. Their friendliness and frankness and humor made the project a complete pleasure. I wish I could thank them individually. It is also impossible to acknowledge individually the many libraries, historical societies, departments of government, University departments, public relations officers, scholars, waitresses, policemen, and gas station

operators for the invaluable information that they have provided. I must specifically thank the staff of the Quetico-Superior Wilderness Research Center, who generously put their facilities and knowledge at my disposal.

My deepest thanks go to Mrs. Helen Clapesattle Shugg, who conceived the idea of doing such a book as this, and who worked to make the idea a reality.

The four historical sections have borrowed heavily from the standard Minnesota histories. Particularly valuable have been the works of William Watts Folwell, Theodore Blegen, and Grace Lee Nute.

It has been a pleasure and a privilege to be associated with the staffs of the University of Minnesota Press and the Minnesota Statehood Centennial Commission. I should like to thank both organizations for their generous assistance and their valued advice. Special thanks are due Marcia Strout of the Minnesota Press, for her assistance in editing the text. However, the best advice from both staffs may have been that which, after serious consideration, I rejected. The faults of this book — excesses, omissions, lapses of taste, inaccuracies, or bad jokes — are entirely my own responsibility.

This project has been an exciting and deeply rewarding experience. I shall cherish its memory.

J. S.

The Face of Minnesota

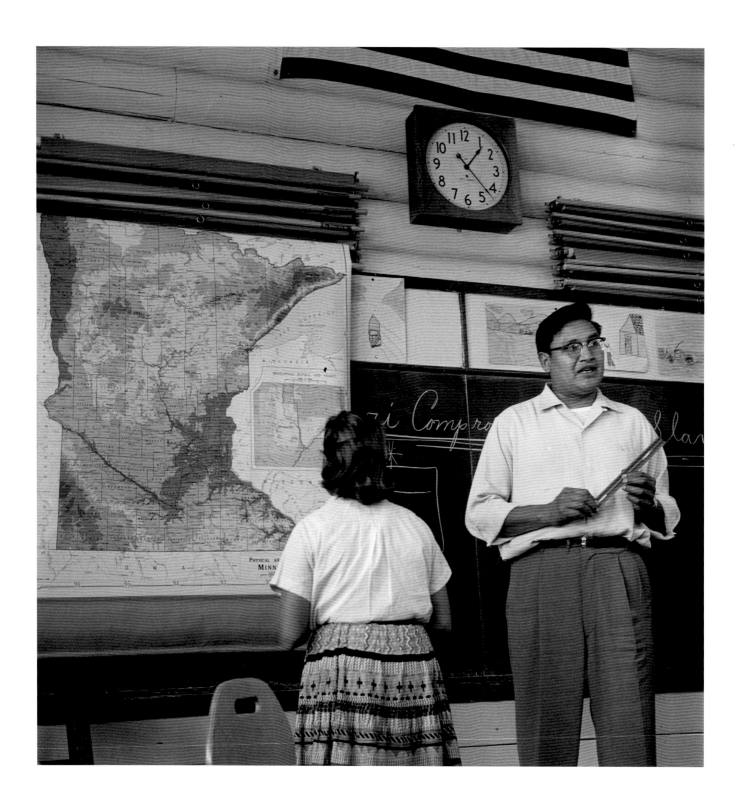

This is the state of Minnesota.

This is the center of the continent; here is the gentle crest of land from which great rivers begin their flow. The rains and snows that fall here shed north to Hudson Bay, or southward down the Mississippi, or eastward through the Great Lakes, over Niagara to the ocean.

. . . Here is the oldest land on the face of the earth, and land that is very new, newer than man.

. . . Here during twenty million centuries were formed an abundance of nature's good things, the conditions of human survival: water to drink and to travel on, rich lands to grow food on, forests to hunt in, trees to build with, and under the ground, minerals that would make tools.

This was a favored land; it is still a favored land, though its gifts have been spent freely to establish a new nation, to entrench a new people.

Now the days of entrenchment are over. This was a wild land, and the land held man in the cup of its hand; but now the land has been conquered. Now man can use the land as he will.

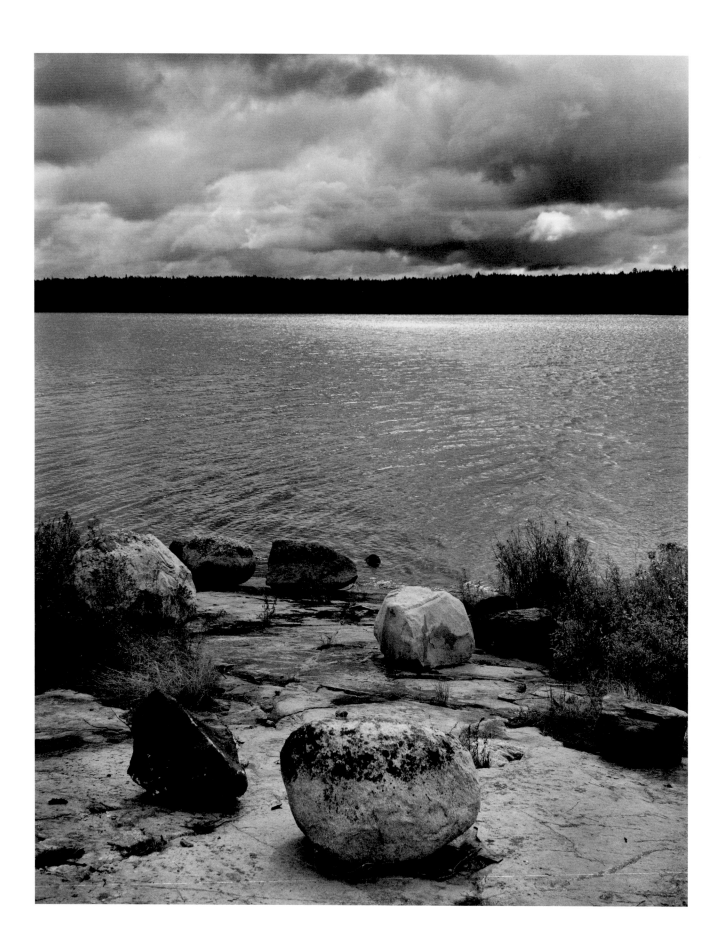

IN THE EARLIEST DAYS the world was featureless and plastic, covered evenly with a shallow depth of water. As the earth's surface cooled it crusted, enclosing the forces of the hot turbulent interior, until these forces grew strong enough to burst through the shell, spewing out molten rock and lifting great ledges of land high above the waters. In those days, north of present Lake Superior, great mountain ranges arose, the beginnings of the continent.

Time and the seasons wore the mountains smooth. The surf, the current of rivers, the seeping leaching ground waters, the ice in the pores of the rock, the wind and the abrasives that it carried — these split and ground and scoured the stone, until the seas were filled with pulverized rock, and water again covered most of the land. And in more time new forces in the interior found new weaknesses in the crust, and lifted new land outcroppings above the seas.

Ten times the seas submerged the land, and then retreated. In the rock deposits of each era were preserved the life records of that era: first came the primitive plants, and the earliest animals: the amoebae, the sponges, the jellyfish. Many millions of centuries later came the fishes — the first vertebrates; then came the amphibians and the reptiles and finally the primitive mammals.

Two million centuries ago came the flowering plants. One million years ago came man.

This has taken a long time, a time beyond the power of man's comprehending. Now the ancient mountains have eroded to smoothly rounded hills or rock.

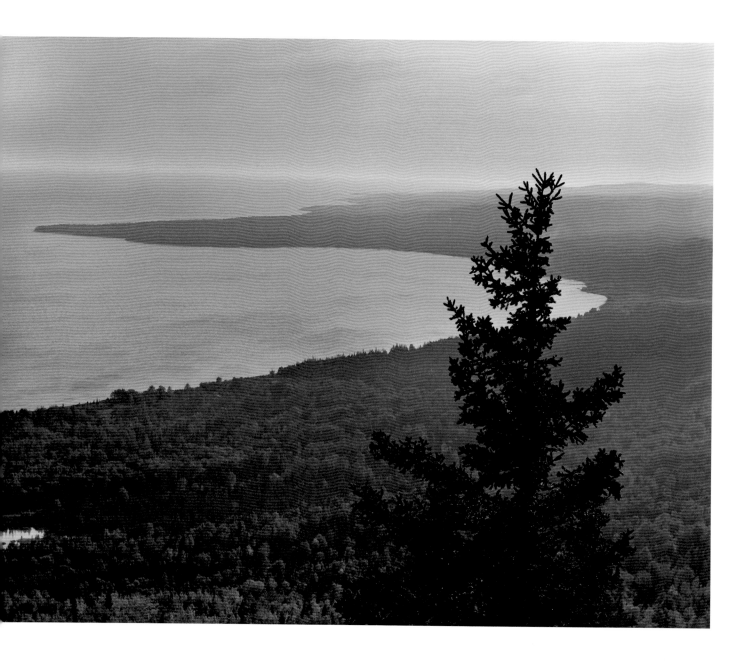

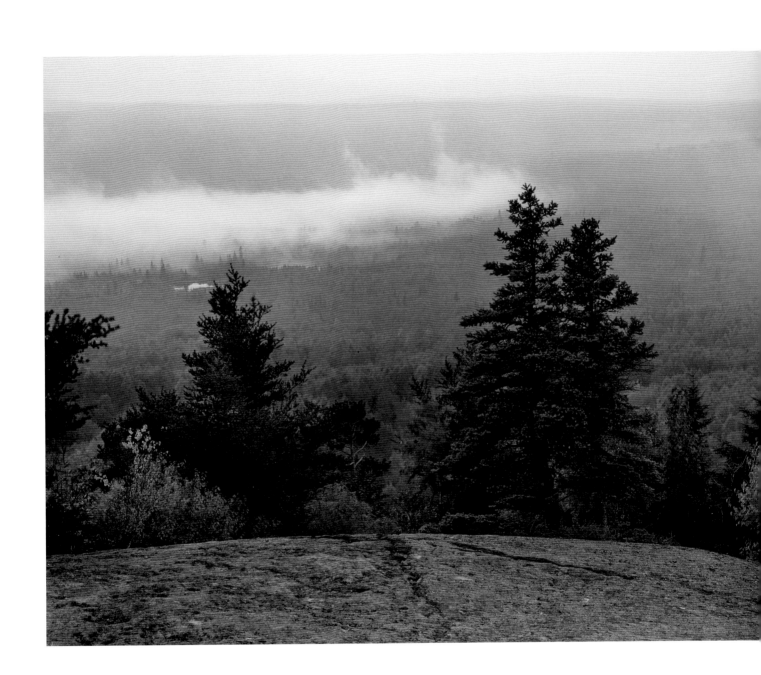

IN THE EARLIEST DAYS *there was water everywhere, and no land. Minabozho sat in the middle of the water on a raft with various of the animals, discussing what should be done. The animals asked Minabozho to make them some dry land, so that they might sometimes come out of the water. It was decided that the animals who were the strongest swimmers should be sent down to bring up some land, with which the earth might be begun.*

First the otter was sent down, and although he was gone a long time, he finally returned exhausted without having found the land below. Then the beaver tried, and he too was unsuccessful. Finally the muskrat was sent, and he remained under the water for several years. When he finally reappeared it seemed that he was drowned, and that he had failed like the others. But while he lay unconscious on the raft, a few grains of sand were noticed under one of his front claws. Minabozho took these precious grains, and working very carefully, molded them into a small ball. He laid the ball on the stern of the raft, and from time to time he would look at it. The first two times he looked it had not changed at all, but the third time it was a large boulder, and the fourth time it was as big as the earth, with high mountains, and forests on their sides, and rivers running down to the sea.

ALGONQUIAN LEGEND

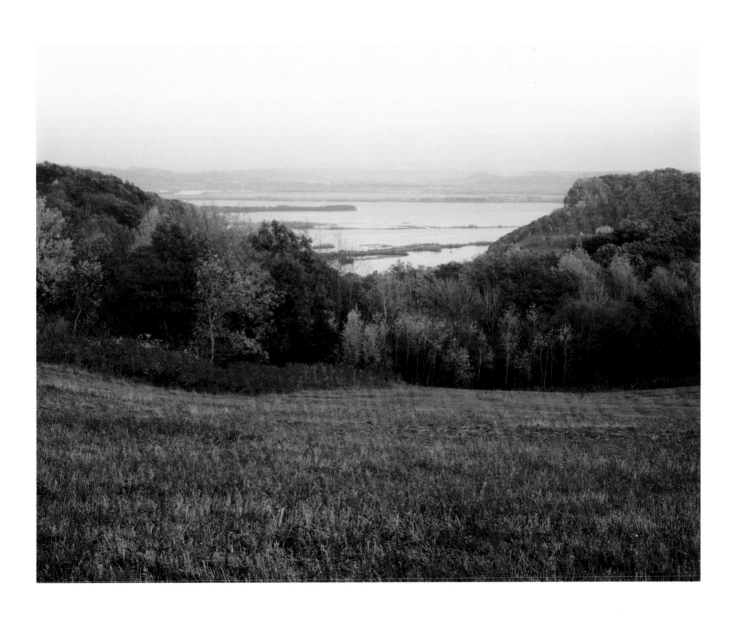

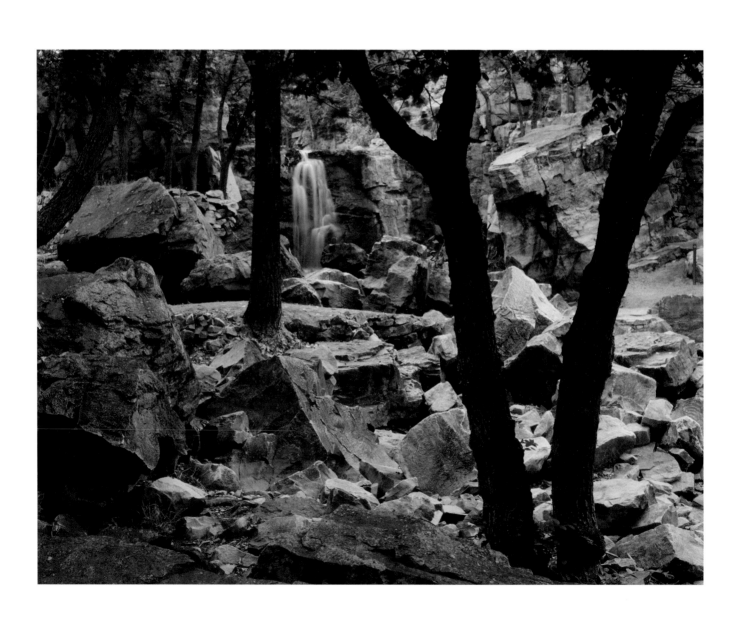

I do not know much about gods; but I think that the river
Is a strong brown god — sullen, untamed and intractable.
Patient to some degree, at first recognized as a frontier;
Useful, untrustworthy, as a conveyor of commerce;
Then only a problem confronting the builders of bridges.
The problem once solved, the brown god is almost forgotten
By the dwellers in cities — ever, however, implacable,
Keeping his seasons and rages, destroyer, reminder
Of what men choose to forget. Unhonored, unpropitiated
By worshippers of the machine, but waiting, watching and waiting.
His rhythm was present in the nursery bedroom,
In the rank ailanthus of the April dooryard,
In the smell of grapes on the autumn table,
And the evening circle in the winter gaslight.

T. S. ELIOT
"The Dry Salvages" *(Four Quartets)*

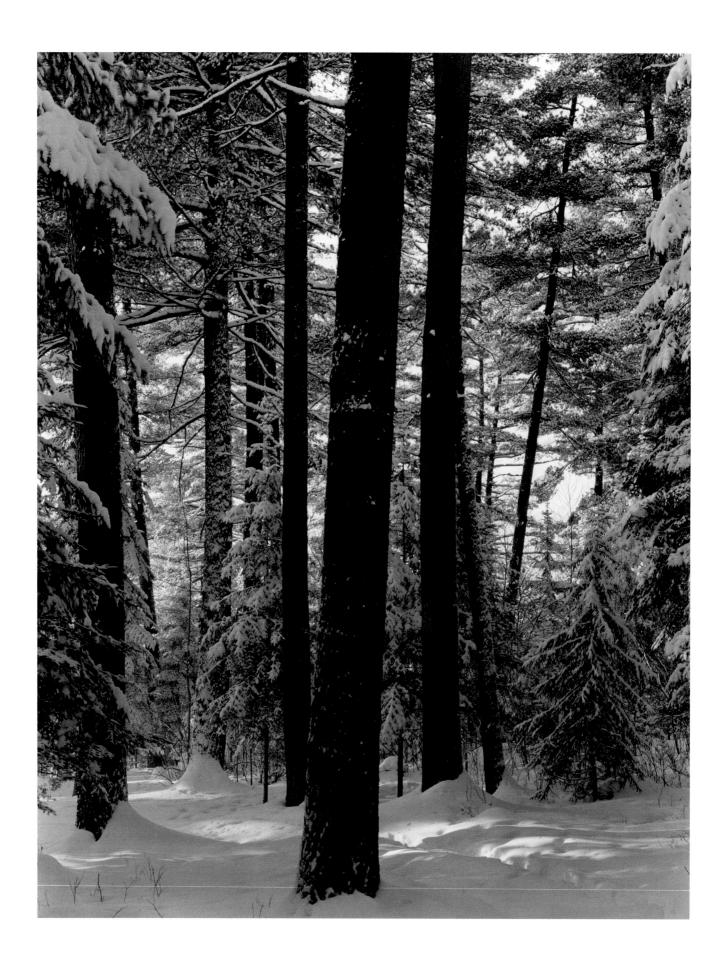

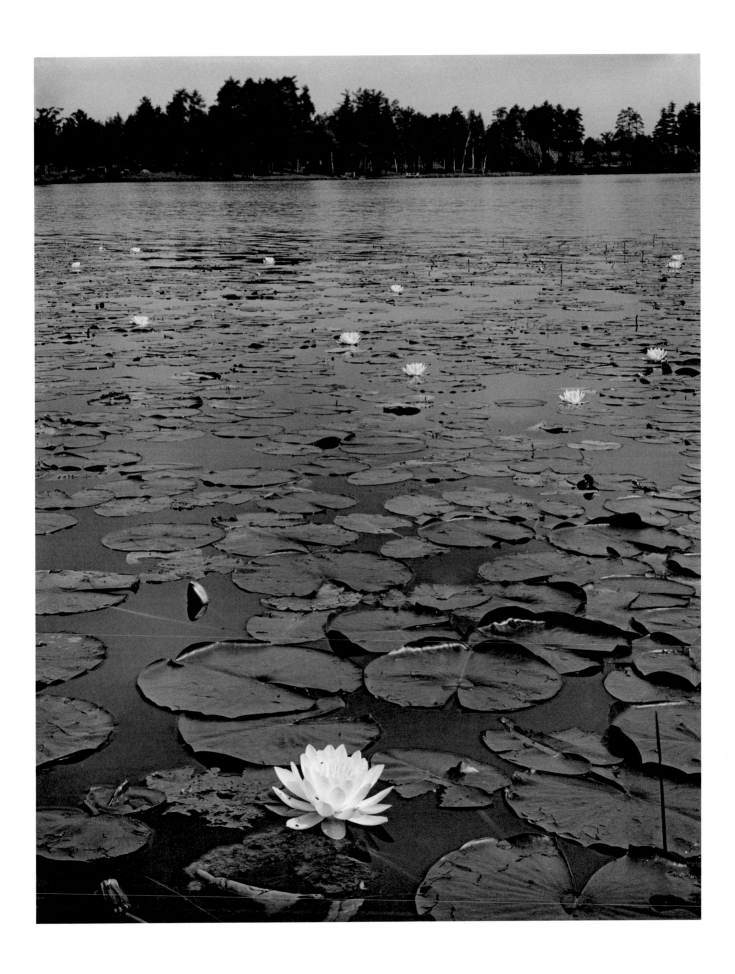

LONG AFTER THE WORLD BEGAN (after the coming of the fishes and reptiles, even after the birds) came the first flowering plants, the first trees to bear fruit and to drop their own replenishing seeds. Where a tree grew, it changed the environment it grew in: it cast shade, and used moisture from the ground, and changed the soil with its own decaying debris. And as the environment changed, new species of trees developed to exploit new conditions. Slowly, experimentally, over the numberless years, one forest would replace another, as living things strove for advantage on the changing earth. Finally evolved the climax forests — the associations of plants and animals that could reproduce themselves unchanged, until the climate itself changed. In these associations each living member was in delicate balance with its whole environment.

Southward, in the lime-rich soils of the Mississippi valley, were the hardwood forests, the Big Woods. Closest to the sky were the elms and basswoods and butternuts, then the burr oaks and ashes and maples. Below were the ironwood and sumac, the dogwood, the thorn apple. Covering the ground were anemones, hepaticas, bloodroot, trillium.

In the North at that time were the coniferous forests. In the lowlands grew the black spruce and lacy-textured tamarack, which shed its needles in the winter like a hardwood. On higher land were the balsam fir and the white spruce, and on the site of an ancient fire, or on land too rocky for any other tree to grow, were the jack pines. Towering far above them all were the majestic stands of red and white pine, with trunks stretching straight and clear to a canopy of green far overhead. The deeply shadowed forest floor was cushioned with pine needles, the undergrowth was sparse; and a bull moose with the widest antlers could move easily among the trees.

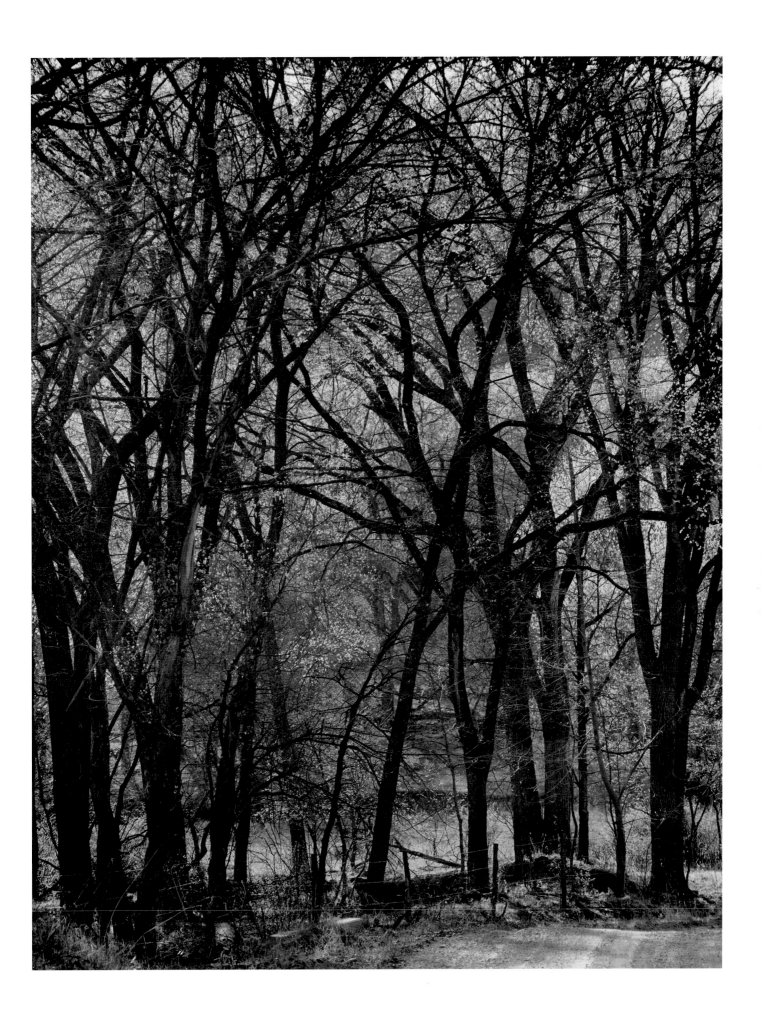

OF ALL THE FORCES which have shaped Minnesota's landscape, the most powerful was that of the glaciers, which intermittently for perhaps a million years moved down from the North. The climate of the Northern Hemisphere changed many times in the countless centuries of pre-history, and during the long periods of arctic cold, snow accumulated in the far north to the depth of many thousands of feet. The weight of these immense drifts compressed the snow to ice, and when the downward pressure became great enough the bottom layers moved slowly outward in all directions. The tongues of ice, a mile and more thick, sometimes covering millions of square miles, scraped great quantities of rock and soil off the land as they passed over, and dug deep channels which would become lake and river beds. Boulders embedded in the ice made the glacier a huge abrasive, and left the marks of its passing in the deeply scarred bedrock.

As the glaciers advanced into warmer climates they melted and produced great lakes, like Lake Agassiz, which covered all of northwestern Minnesota, and much more territory to the west and north. At its largest, Agassiz was bigger than the present Great Lakes combined. Its normal watershed would have been northward, but this course was blocked by the great dam of ice, so the lake drained southward by the glacial River Warren, cutting the mighty valley down which the Minnesota River now runs.

The mass of debris which was carried by the glacier was deposited along the edges of the ice, and at the far extremity of its path, and when the glacier's rate of forward movement was exceeded by the speed of its melting, the ice receded, leaving behind it a deep layer of virgin soil.

The last glacier receded from Minnesota some eleven thousand years ago, and the landscape then looked much as it does now. Minnesota's lakes had been dug and filled, its topography had been smoothed, its drainage largely determined. But not permanently. Geological forces are no respecters of civilizations; the patient forces of water and wind have lost none of their power, the center of the earth is not yet cool and spent. And geologists speak not of the last, but of the most recent, glacier.

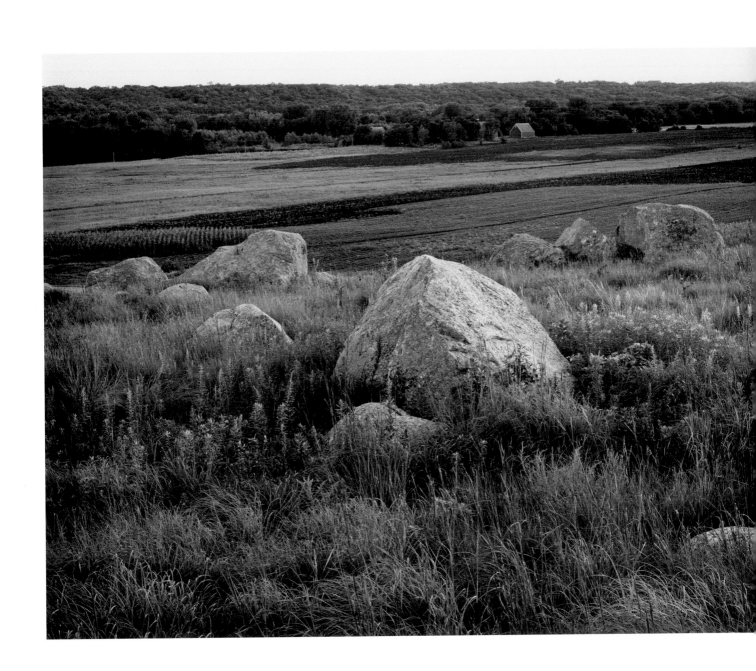

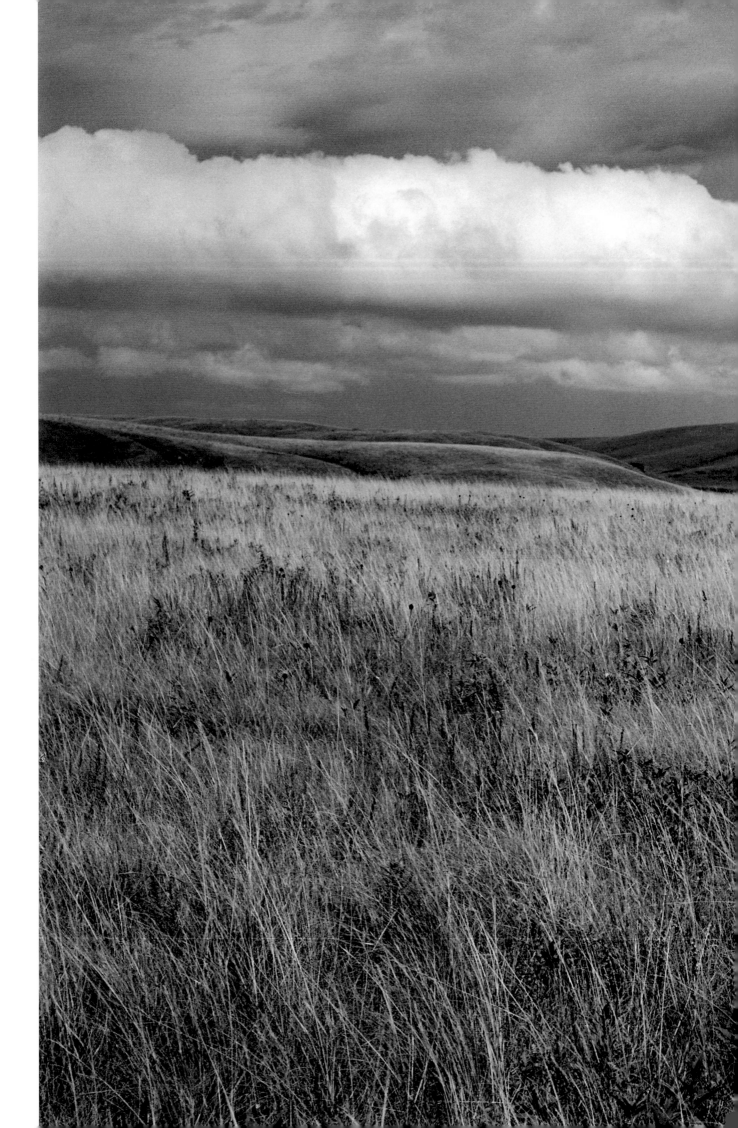

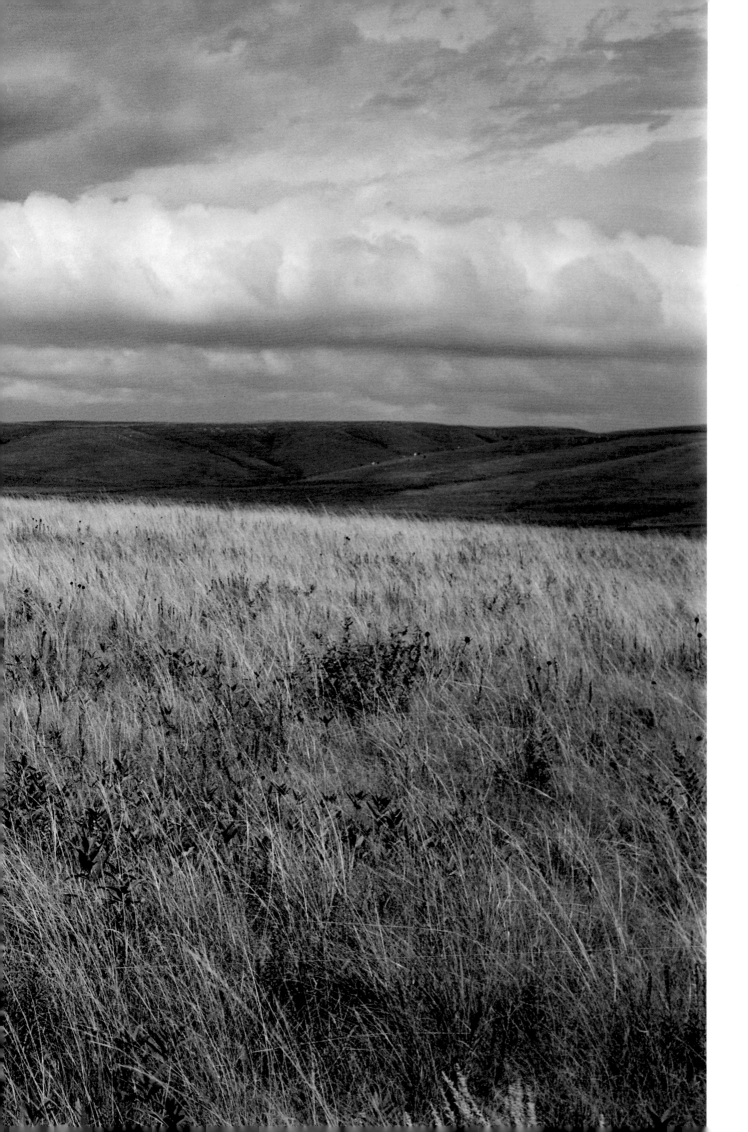

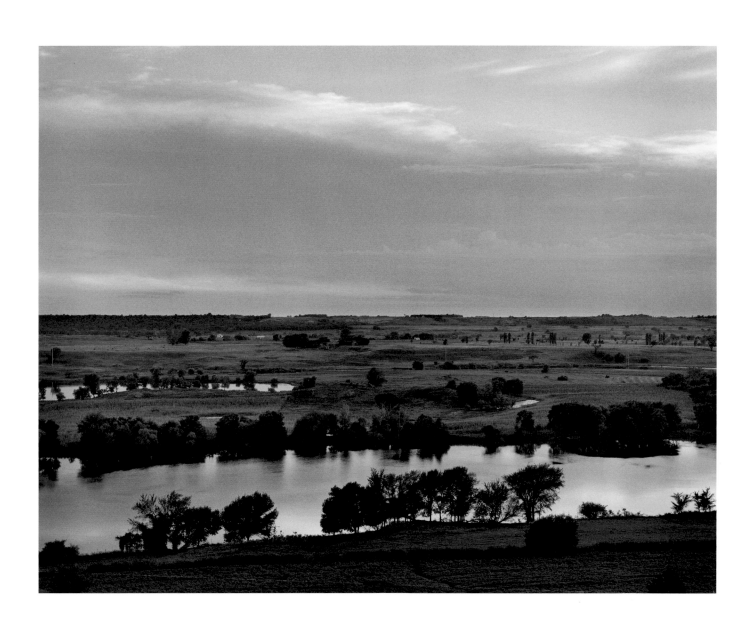

ONE HUNDRED CENTURIES after the melting of the last great glacier, European man came to Minnesota, and though he knew little about geology and glaciers, he understood much of what he saw. He could see the great highways of lakes and rivers which would carry him into the land, and which would carry his produce or his plunder out. He could see the great forests which would build his house, and many cities of other men's houses, and in the forests he saw the animals whose pelts would be his first cash crop.

And in the west and south, along the path of the River Warren and southward, he saw crop land. Here the glaciers had pushed aside the ancient leached-out rock waste from the surface of the land, and had deposited a fresh drift rich in mineral and organic matter. The steep and rugged hills had been scraped smooth, and the deeply eroded valley had been filled; the glaciers had left a gently rolling, easily tillable prairie.

Modern man saw these things, and according to the way that he believed, he could feel that nature had spent her ages preparing this scene for his arrival, or simply that his luck had finally turned. For here was a brand-new land, and it lay wide open.

The Nature of the Place

TO THE EARLY EXPLORERS of the Minnesota country, the waters were more important than the land. The waters were the way in — the fissure in an otherwise impenetrable wilderness. And in the beginning they were the main reasons for coming. The canoes were lured westward by the promise of beaver pelts and Red Men's souls, but perhaps most of all by the dream of the Passage that would lead through the fresh waters finally to the salt waters, and to China. At the explorers' prodding, every ancient Indian remembered boyhood stories of rivers running westward to the sea and cities of gold and turquoise; and so the dream persisted, even when each great lake led only to a greater one.

But while the explorers hoped for silks and spices, they discovered the otter and the marten and the mink — and a trade of great profit. Earlier, the Indians had brought the furs east to Montreal, where a prime beaver pelt was worth a pint of brandy; but when war among the Indians disrupted their spring journeys down the Lakes, the French traders pushed westward themselves. The first to reach what is now Minnesota were probably Radisson and Groseilliers, who are thought to have penetrated as far as Knife Lake in 1660. From that trip, they returned to Montreal with sixty large freight canoes packed with furs.

A few years later, in 1673, Marquette and Jolliet discovered the upper Mississippi, and paddled down to the mouth of the Arkansas. Now there was no doubt: these waters could only drain the heart of a great continent, and China was very far away. For a while the Northwest Passage was all but forgotten, as the new land gradually revealed its size and richness. Radisson wrote; "This I say that the Europeans fight for a rock in the sea against one another and contrariwise these Kingdoms are so delicious, plentiful in all things, the earth bringing forth fruit, the people can live long and lusty and wise in their ways. What conquest that would be at little or no cost, what labyrinth of pleasure should millions of people have, instead . . . of misery and poverty."

The explorers were heroes, all of them; brave and strong, of incredible endurance, drunk with the will to discover the key that would give order to the winding rivers, the uncountable lakes, the forever-beckoning bays, the hidden portages. There was Sieur du Luth, who came from the court of Versailles to live in what is Minnesota and keep a kind of peace among the Indians. There was Hennepin, who told highly poetic versions of the truth, and named St. Anthony Falls. There was La Vérendrye, who in the first half of the seventeenth century turned again to the search for the Northwest Passage. For twelve years he struggled westward, fighting floods and low water, backbreaking portages, man-killing rapids, and hunger and cold and harping creditors, and — in the summer — mosquitoes, ticks, black flies, deer flies, and nosee-ums, bad enough at times to drive the heavy-coated animals into the water for escape. La Vérendrye went from Lake Superior to the Pigeon River by way of the difficult Grand Portage, and northeast along the chain of border waters. The first year he and his company reached Rainy Lake, the second Lake of the Woods; then they went northward to Lakes Winnipeg and Manitoba and beyond, and also westward

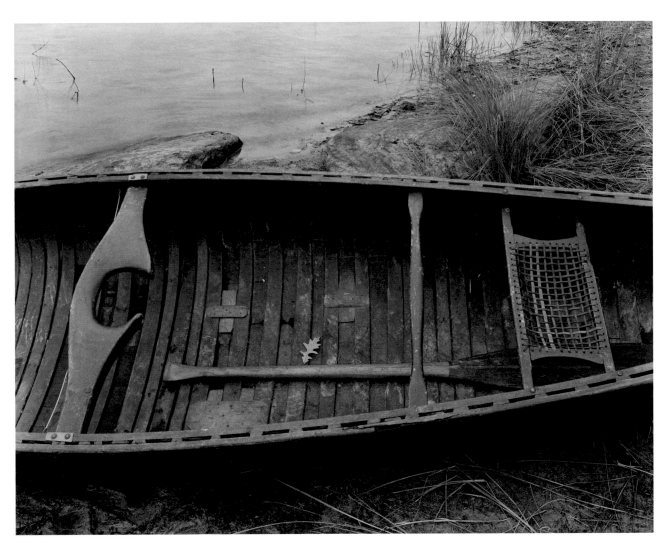

through the Dakotas. Vérendrye's nephew died, killed by the wilderness. His eldest son, Jean Baptiste, along with the Jesuit Father Aulneau and nineteen voyageurs, was killed at Lake of the Woods by hostile Sioux. Finally Vérendrye died, without having reached the Pacific; but he experienced what no man had before and what no man could again.

The French of the Minnesota country were defeated not by the wilderness nor by the Indians, but by Wolfe at the Battle of Quebec. Defeated in the East, France lost its foothold in the West. But when the French officials left, the independent, unlicensed voyageurs — citizens only of the wilderness — stayed.

The fur trade, under the loosely organized Northwest Company, centered around Grand Portage, an eighteenth-century metropolis at the entrance to Vérendrye's canoe route. Here eighteen log buildings inside a stout cedar stockade sheltered a world that included good wines, European music and fashions, and a police force. Every July the partners and clerks and shopkeepers were joined by the voyageurs from North and East. From the North came the winterers, who gathered the furs; from the East came

the pork eaters—eighteen in each huge canoe—who brought supplies and trading goods. Then there would be a party; Indians from all around would come to join in the gaiety, and for two weeks the wilderness quiet would be rent with an exhibition of hard drinking, hard dancing, carousing, and fighting, which rattled the battlements.

About 1803 the Northwest Company moved its headquarters eastward to Fort William and Grand Portage returned to silence. But the fur trade continued, with outposts scattered through the Minnesota country. After the War of 1812, Congress passed a law that only Americans could engage in the trade, and John Jacob Astor became the first business colossus of the Northwest.

During the first century and a half after the first Europeans came to this part of the world, legal ownership of the land was an academic issue. Since there was little law enforcement, it mattered little whose laws were officially in effect. The French explorers had claimed for their King lands to the headwaters of every river they had traveled, seen, or heard rumor of. The Treaty of 1763, after the French and Indian War, transferred all lands east of the Mississippi to the English. But the English came to the Northwest in relatively small numbers, and those who did come tended to insult the Indians, who in turn burned the English forts. Considerable territory in what had been New France was soon abandoned entirely by the British.

Jonathan Carver came to the Minnesota country from New England to make one more attempt to find a Northwest Passage. His project abandoned before it was really begun, Carver went to England and wrote a book about his experiences. A very good British explorer was David Thompson, who made the first adequate map of the Minnesota and Dakota country just before the end of the eighteenth century.

By this time the land east of the Mississippi belonged to the United States; Spain, who owned the land to the west, was about to give it back to France, who would in 1803 sell it to the United States. It was not until 1805 that the United States sent its first official representative into the area. Lieutenant Zeb Pike was told to find sites for forts and trading posts, make peace among the Indians, and explore the Mississippi to its source. Pike found Sioux at the junction of the Mississippi and Minnesota Rivers, and in a master stroke of imaginative diplomacy made peace between them and the rival Ojibwa while there were none of the latter around. Further north, he completed the ceremony before an all-Ojibwa group. He also counseled the Indians not to trade with the British, assuring them that the Americans would doubtless soon build trading posts of their own, offering better prices. With peace and rights of United States trade secured, Pike continued up the river and found what he thought was its source. On his way home, he watched a game of lacrosse.

Almost fifteen years later, in 1819, the United States government again entered the Minnesota country, this time to stay. Fort St. Anthony (later Snelling) was built at the spot that Pike had recommended, at the meeting of the two rivers, and immediately became the focal point of American entry into the upper Mississippi valley, a center from which settlement could begin. In the thirty years that followed, the exploration

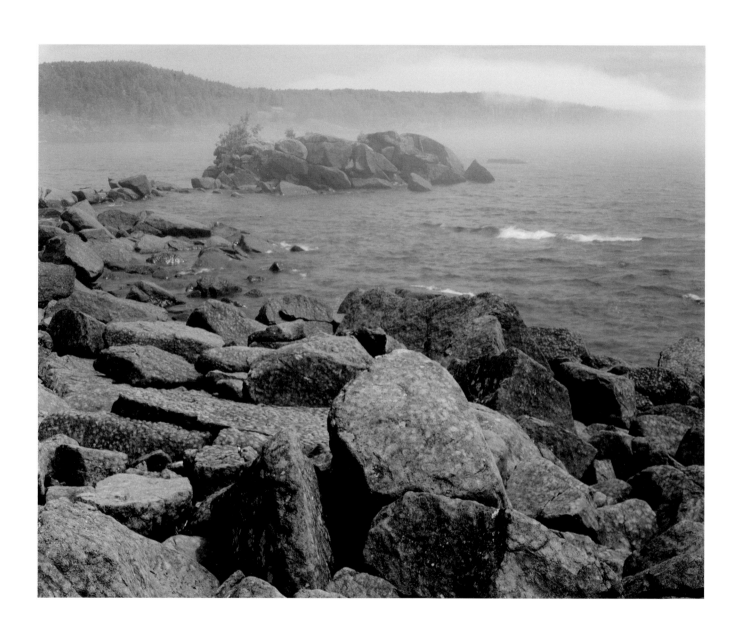

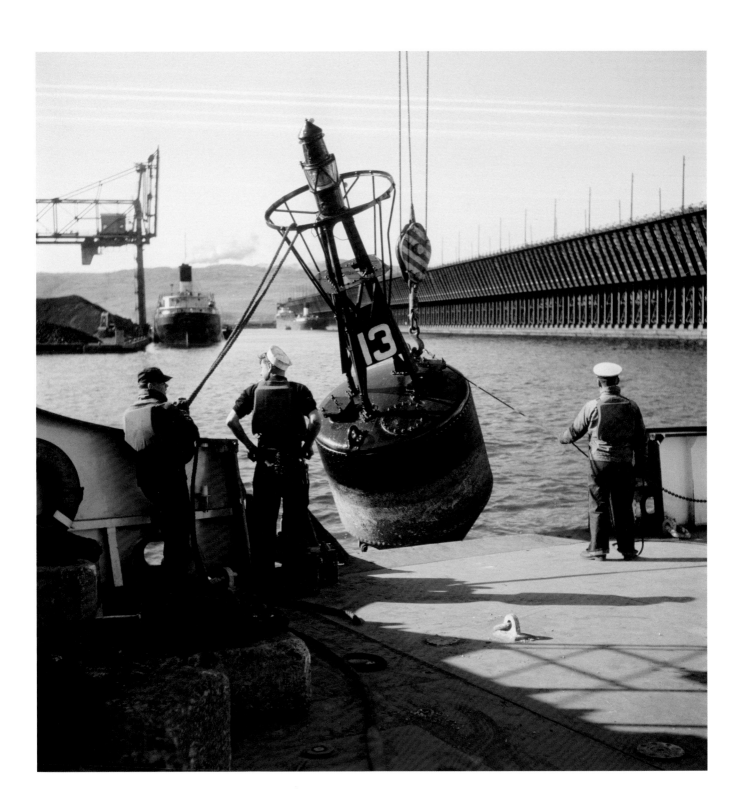

of Minnesota was largely completed. The Mississippi, Minnesota, and Red Rivers were explored and mapped. The international boundary was precisely determined. Finally, the southern third of the state, long neglected because of its lack of navigable waters, was explored.

The first steamboat — the *Virginia* — reached Fort Snelling in 1823. When the blast of its whistle first drowned the silence of the great river, the open spaces of Minnesota country were hardly better known than they had been to Hennepin a hundred and fifty years before. The meaning of the strangers' coming was not yet clear; but the *Virginia*'s whistle was a signal, and the Indians and the animals ran terrified into the woods.

The French were the heroes of the early years, and their teachers were the Indians. It was the Indians who knew the directions of the rivers, who had traced the routes of travel and worn smooth the portages. It was the Indian's highway — and also his canoe, his snowshoe, his corn or pemmican, his snare, and his knowledge — that made life and travel in the wilderness possible. In exchange he was given gunpowder, brandy, glass beads, cloth, flour, and a half dozen new religions. In telling the Ojibwa about France, Father Allouez had said that the King had warehouses containing "enough hatchets to cut down all your forests, kettles to cook all your moose, and glass beads to fill all your cabins." Allouez had spoken rhetorically, but his picture became a prophecy when the Americans arrived.

As the Ojibwa, with superior knowledge of steel tools and rifles, were pushed out of the East, they in turn pushed the Sioux back to the Mississippi country. There, in eastern Minnesota, the two tribes battled for almost two centuries. Simultaneously they fought the more hopeless battle against sharp traders, whiskey, conflicting authorities, smallpox, competing missionaries, corrupt officials, newspapers, private land, and, finally, double-talking treaties. When, in the mid-nineteenth century, the Sioux finally rose up against the white settlers, their war had long since been lost: this was the suicide of desperation. Chief Little Crow understood this. He said to his tribe: "We are only a little herd of buffalo left scattered. The great herds that once covered the prairies are no more. The white men are like locusts when they fly so thick that the whole sky is like a snowstorm. You may kill one, two, ten; yes, as many as the leaves in the forest yonder, and their brothers will not miss them. Count your fingers all day long and white men with guns in their hands will come faster than you can count. You are fools, you die like rabbits when the hungry wolves hunt them in the hard moon. I am no coward. I shall die with you."

Lake Superior, 1680:

It were easy to build on the shores of these great lakes an infinite number of considerable Towns which might have Communication one with another, by Navigation for Five Hundred Leagues together, and by an inconceivable commerce which would establish itself among them.

<div align="right">LOUIS HENNEPIN</div>

Duluth, 1869:

This is the point upon which all eyes in the northwest are now turned. It is, as yet, literally a town in the wilderness. At Cleveland I was told that five hundred houses were being put up in Duluth, this spring; at Detroit, the number was put down at three hundred, and as I proceeded up the lakes I could only hear that one hundred and fifty were being erected. By actual count, standing on the ground today, I find between seventy and eighty buildings, all told. . . .

<div align="right">*Springfield Daily Republican*</div>

Washington, 1871:

. . . Yet, sir, had it not been for this map, kindly furnished me by the Legislature of Minnesota, I might have gone down to my obscure and humble grave in an agony of despair because I could nowhere find Duluth. [Renewed laughter.] . . . But the fact is, sir, Duluth is pre-eminently a central place, for I am told by gentlemen who have been so reckless of their own personal safety as to venture away into those awful regions where Duluth is supposed to be, that it is so precisely in the center of the visible universe that the sky comes down at precisely the same distance all around it. [Roars of laughter.] . . .

<div align="right">HON. J. PROCTOR KNOTT
U.S. House of Representatives</div>

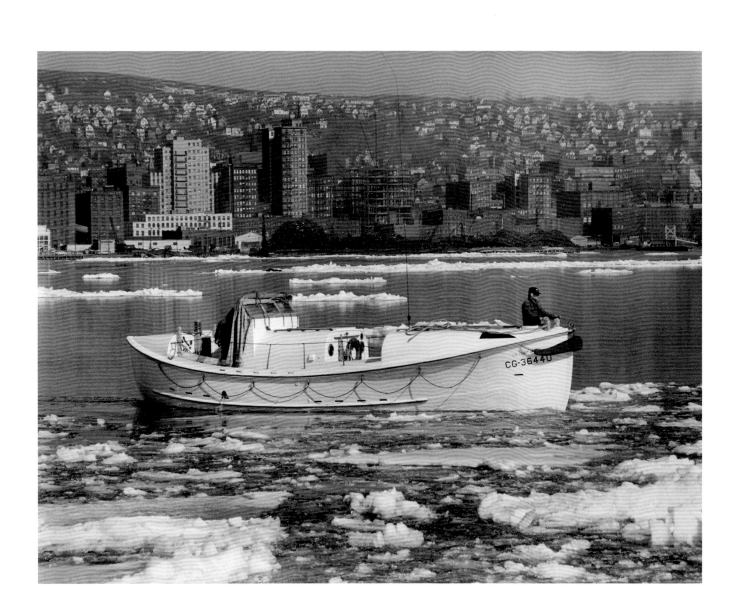

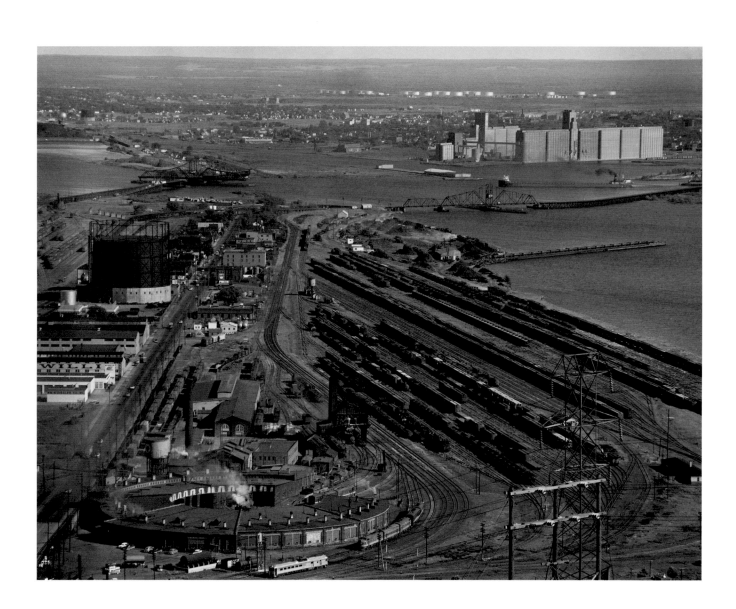

The happy friar Louis Hennepin indulged a strong taste for exaggeration. His accounts of his adventures were in fact sometimes less exaggerations than pure literary inventions; but if he was an unreliable historian, he was a remarkable prophet: his "considerable Towns" now do indeed line the shores of the Great Lakes. And the leading port among them is Duluth, the city at the Lakes' beginning.

For many years the tonnage of the port of Duluth-Superior has been second only to that of the port of New York. Among fresh water ports there is nothing like this anywhere else in the world; here, over two thousand miles from the ocean, sail freighters with thirteen thousand tons and more in their holds, carrying iron ore and grain eastward and coal back to the midcontinent. Perhaps to compensate for the four ice-locked months of winter, this commerce has developed an efficiency and precision of which its men are justly proud. The captain of a six-hundred-foot freighter smiles at the idea of using tugs to bring a ship to dock: he drives his vessel in as if it were the family car. Through ice jams, fog, and the famous Upper Lake storms, he threads his way through the narrow, island-studded shipping channels. His maximum cargo is determined by his vessel's draft at the Sault Canals; these calculations are so precise that the ship takes on an extra weight of ore, equal to the weight of coal that it will burn between Duluth and Lake Huron. The speed of loading seems fantastic to a salt water man: a ten-thousand-ton cargo is loaded in an average of well under four hours. One captain complained that from April through November he wasn't in port long enough to get his hair cut.

Since the latter days of the nineteenth century, there have been recurrent rumors of an even greater day to come. Real estate speculators at the turn of the century whispered to each other that soon the St. Lawrence Seaway would be begun, and that its twenty-eight-foot-deep channel would bring salt water shipping to Duluth's door: in a decade — two at the most — the city would outstrip Chicago as the metropolis of the midcontinent. The true believers bought land, formed lobbying associations, waited, and watched the news from Washington. President after president endorsed the project as sound and desirable; Congress after Congress debated the Seaway's meaning and decided to wait. The claims of the project's opponents were as extravagant as those of its supporters: the port of Boston would fall into the decay of disuse, New York and Buffalo and New Orleans would suffer terribly, and grass would grow on the nation's transcontinental railroad grades. Finally, in 1954, persuaded by Canada's threat of independent seaway development, Congress approved the controversial issue; now the work is going ahead.

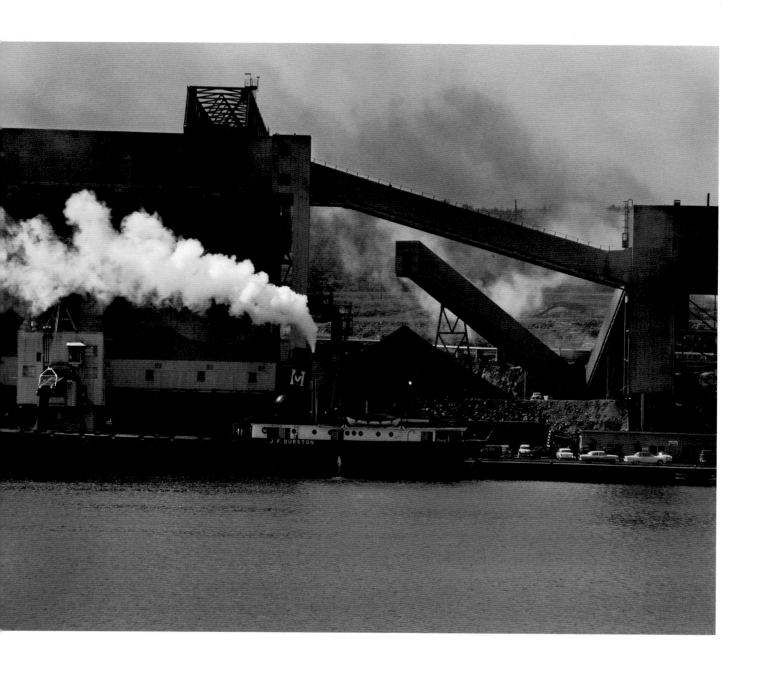

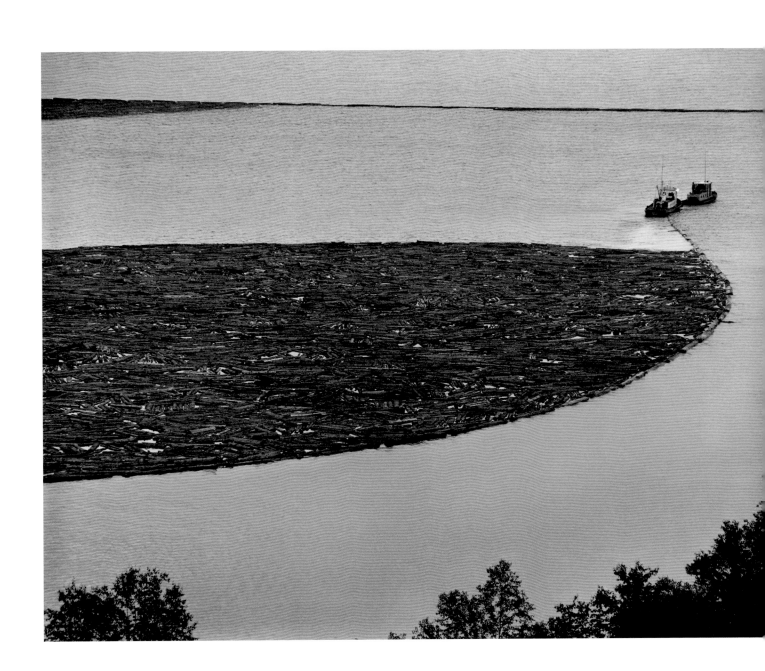

Too many people think of the Seaway as a magic elixir which, when produced, will cure all of the varied economic ailments and change the entire economic picture in the Middle West. . . .

Undoubtedly you here in Minnesota will have a future with the Seaway, and undoubtedly that future will be big. How big it will be depends upon how much work is done . . . and also in the mental effort expended in keeping the Seaway in its proper perspective. Think of it in its proper place, as a carrier of goods which still must be produced and sold. . . .

Your natural advantages should guide you in your choice of industry here; and above all, emphasize your water resources, your labor force and its good quality and trade skills, your proximity to raw materials and the ever-growing middle-Canadian market, and your available land, which is also becoming scarce for industrial purposes close to water and close to labor sources and close to adequate transportation sources. . . .

DR. N. R. DANIELIAN
Great Lakes–St. Lawrence Seaway Association

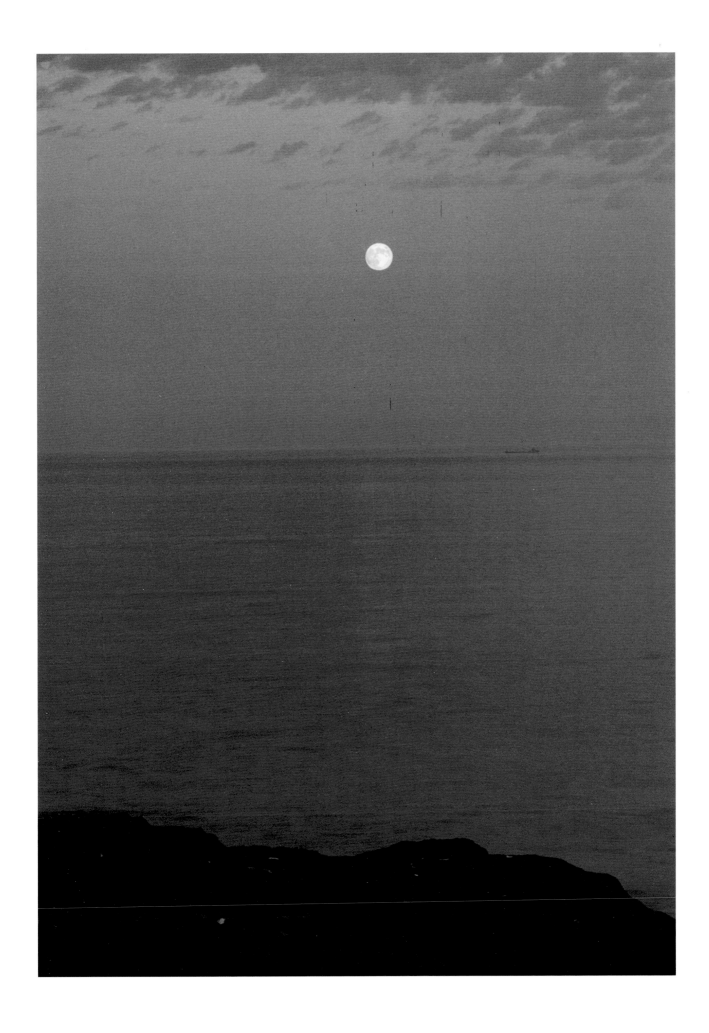

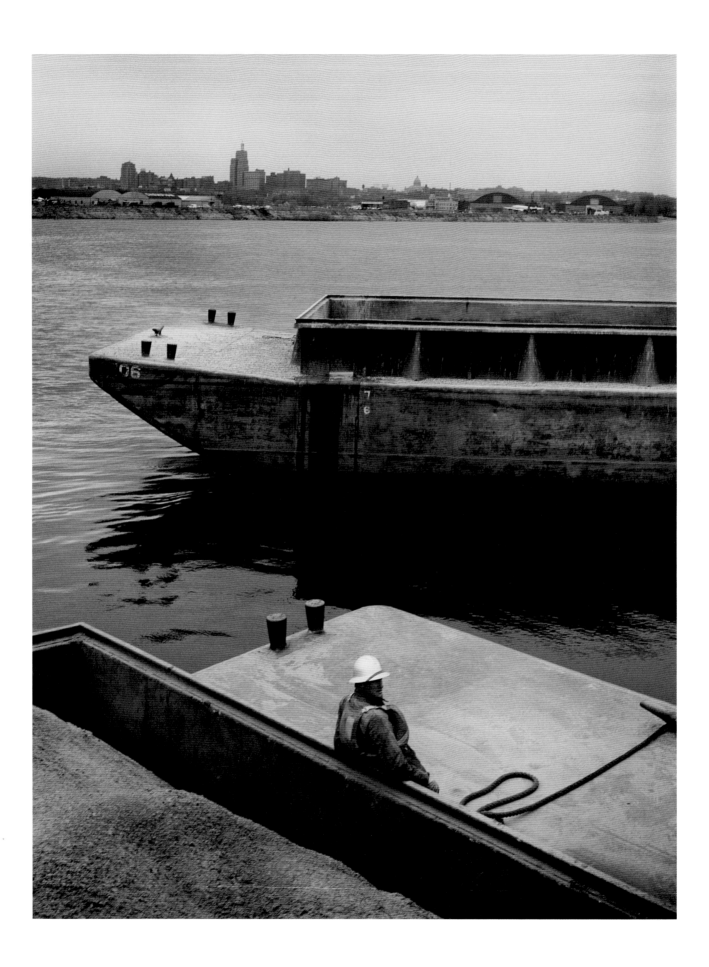

MINNESOTA GREW UP on the banks of its rivers. For many years the people who came here, and the stuff they needed to begin life here, came by river; and the furs and timber left by river. In the winter this was a remote and isolated place, but when the river opened and the first steamboat whistle was heard down river, it was again part of the older, larger world.

When the railroads came the rivers were all but forgotten, for a while; finally the federal government subsidized a resurrection of the Mississippi trade, and today the barge lines, again privately owned, carry important tonnages of coal and oil and grains. The rivers are important for other, noneconomic reasons. They are important in the spring because boys can launch homemade rafts on them, and later on, important because weekend captains can drive their boats up and down and across them, frightening the professional river pilots grey. They are important because they remind men of Mark Twain, and because they give a sense of direction, and a view, to the towns on their banks.

"It is kind of funny when you figure all the various adventures I had that I would end up here Mate on a towboat, shoving a bunch of coal barges from St. Louis to the towns along the Upper Mississippi that nobody every heard of like Dubuque, Cassville, Lansing, Genoa, Lake City, and Red Wing, but there is something about it which you might call Romance, or you might call it feeble-mindedness depending upon your age and state of mind, which gets under your skin and you can't seem to get away from it; somehow there is one hell of a lot of charm, as the travel folders say, about the Upper Mississippi . . ." (RICHARD BISSELL, *High Water*).

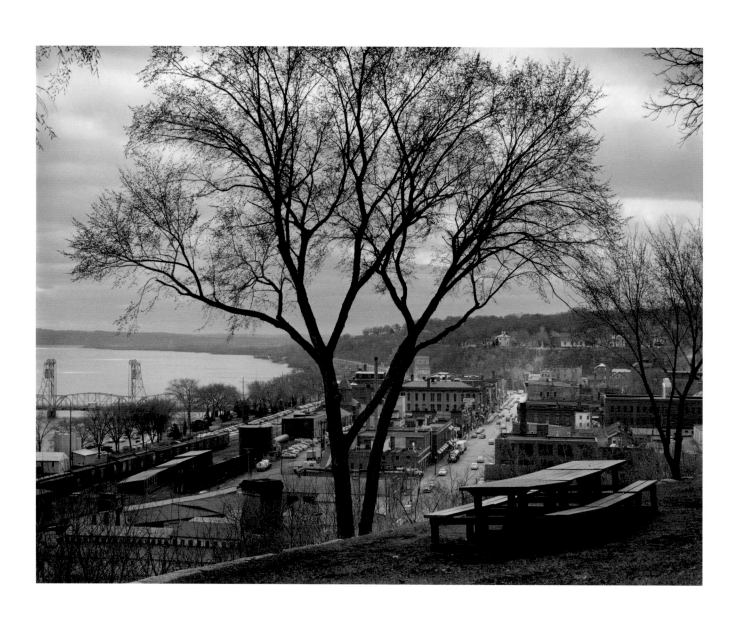

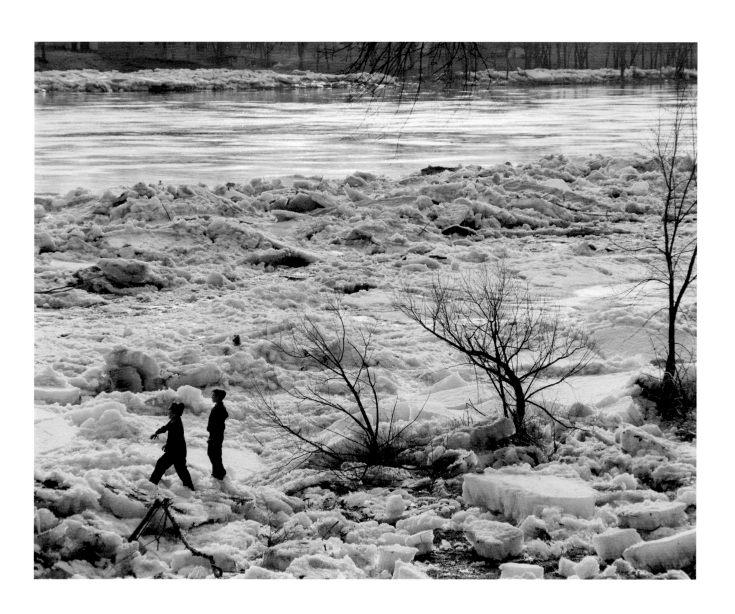

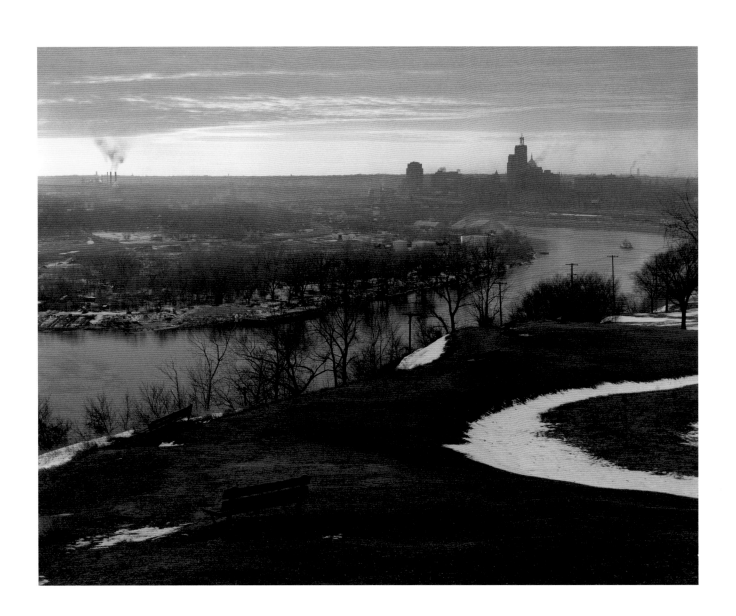

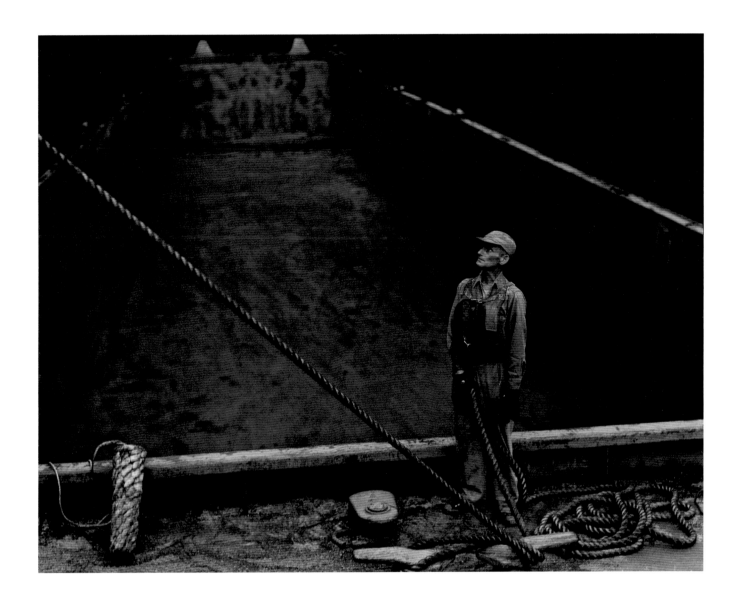

The people

who first learned to use the lakes and rivers, who named the waters, and traced their paths for the Europeans—these have not prospered from the changes they helped bring about.

An old Minnesota Indian, too proud to be pitied, and sometimes too tired to be proud, and many times confused, told how he had been taken to Minneapolis to attend a recent conference on Indian affairs:

"We were real sorry how they treat some of the Indians there, on different reservations, especially way out west. But in Minnesota, Indians—this is a great place, right here, in Red Lake Indian Reservation. Us here in Red Lake—Indians, Chippewa Indians—I think we are better off than the rest of the Indians in United States. We got all kinds of land here, we got all different game here, we got all kinds of different kinds of trees here, in our Reservation.

"Now, we are just *free*—with hunting grounds here in Red Lake, in the Reservation. I don't think that there is any other reservation that they could do that—they could hunt when they feel like it. But we fish here; any of that. Wherever the fish in Red Lake, they are ours.

"I think we are—we think we are *somebody* here."

The old man remembered his boyhood, remembered the winters when he had camped out all season with his family, hunting. He remembered the numbers of bear and moose there had been.

Then he remembered that those days were gone, and that he was old now, and sick.

"I quit working. All I do is just lay around the house. No more work for me, just wait for my meals every day. I'm living on Aid to Dependent Children now. I got five of my own kids and couple of stepdaughters. We're living pretty good now. At the time of my young days we used to live on just corn and fish and potatoes. Once in a while we used to eat bread. They called it—Indian bread." (*The Tree Is Dead,* film, ALLEN DOWNS and JEROME LIEBLING)

44

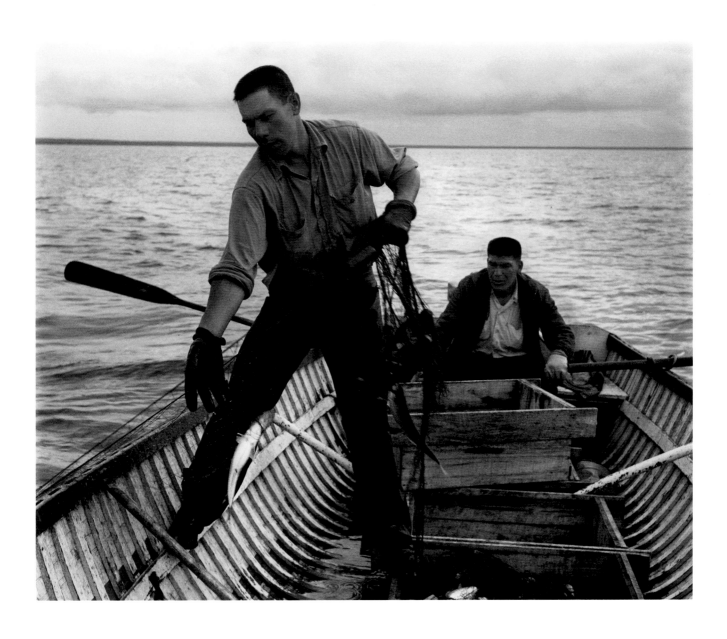

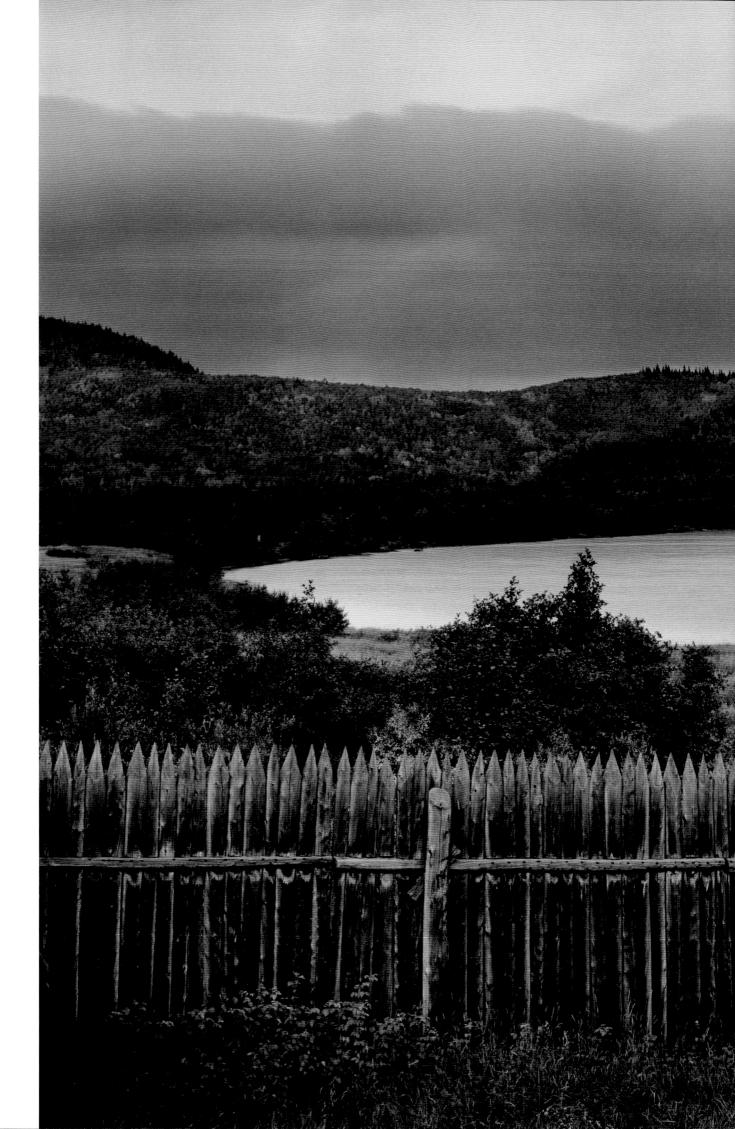

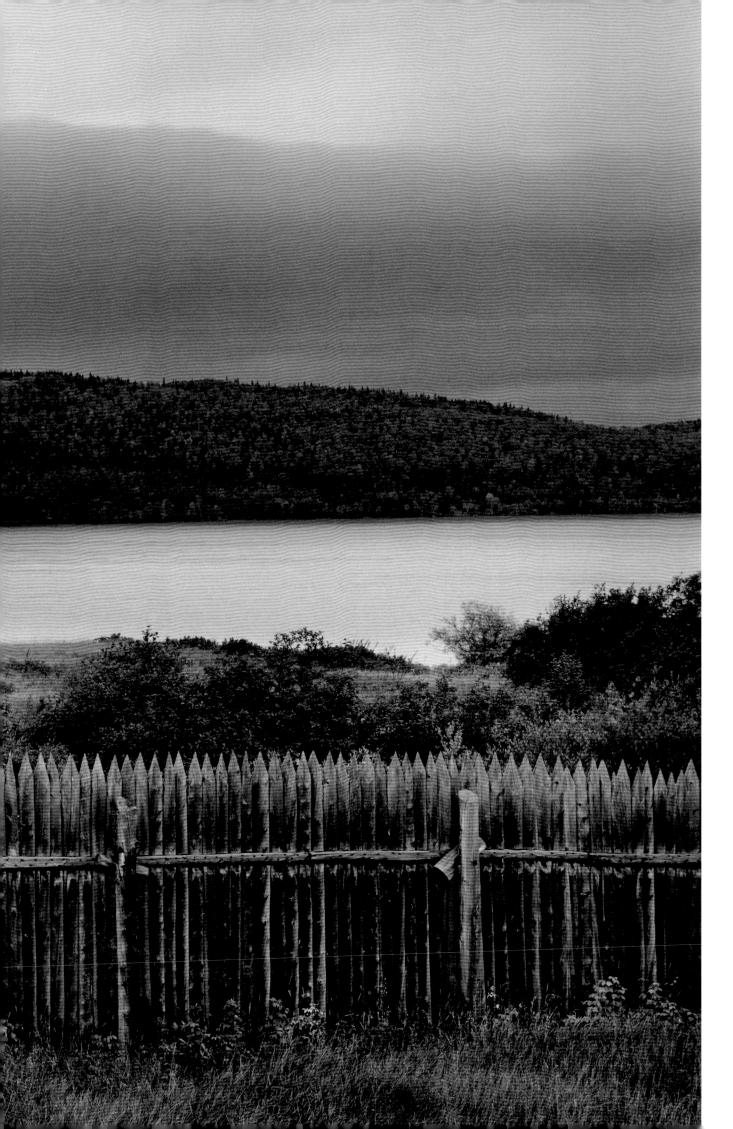

A YOUNG WOMAN from the Red Lake Indian Reservation talked of the tourists, and of her work:

"Most of the tourists are all right. But some of the things they say make you kind of mad. One man came up to where we were hanging up the nets, and he raised his hand and said 'How . . .' At first I thought he was going to ask some question, so I waited for him to finish. Then I got it; so I said 'Hi,' and walked away. . . .

"Some people say fishing is hard, but I don't think so. I enjoy fishing; I don't find it hard. The only thing I find hard is something I can't lick."

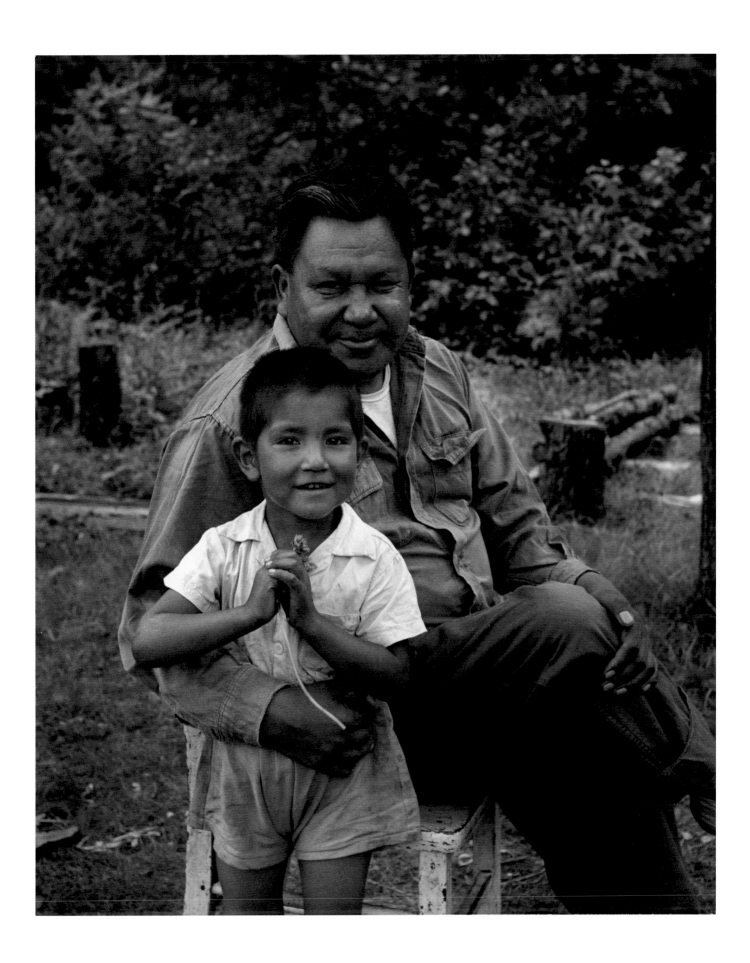

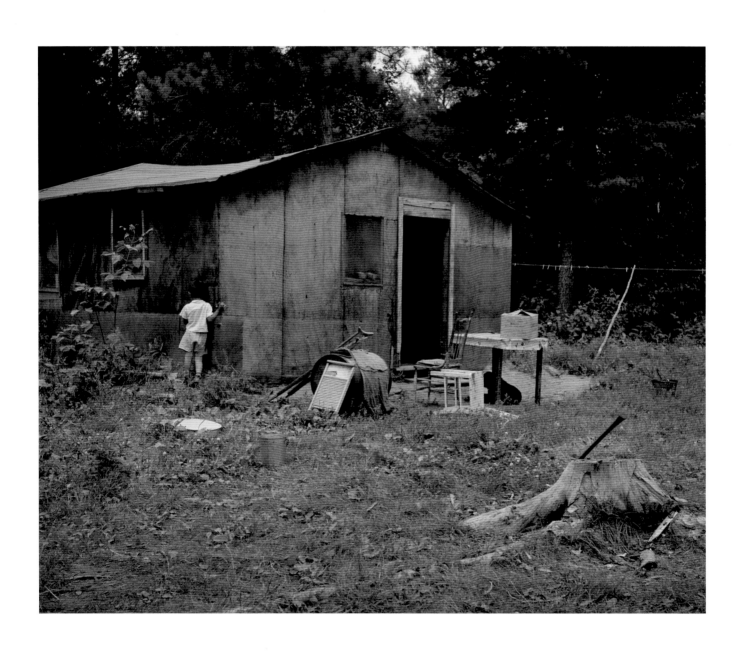

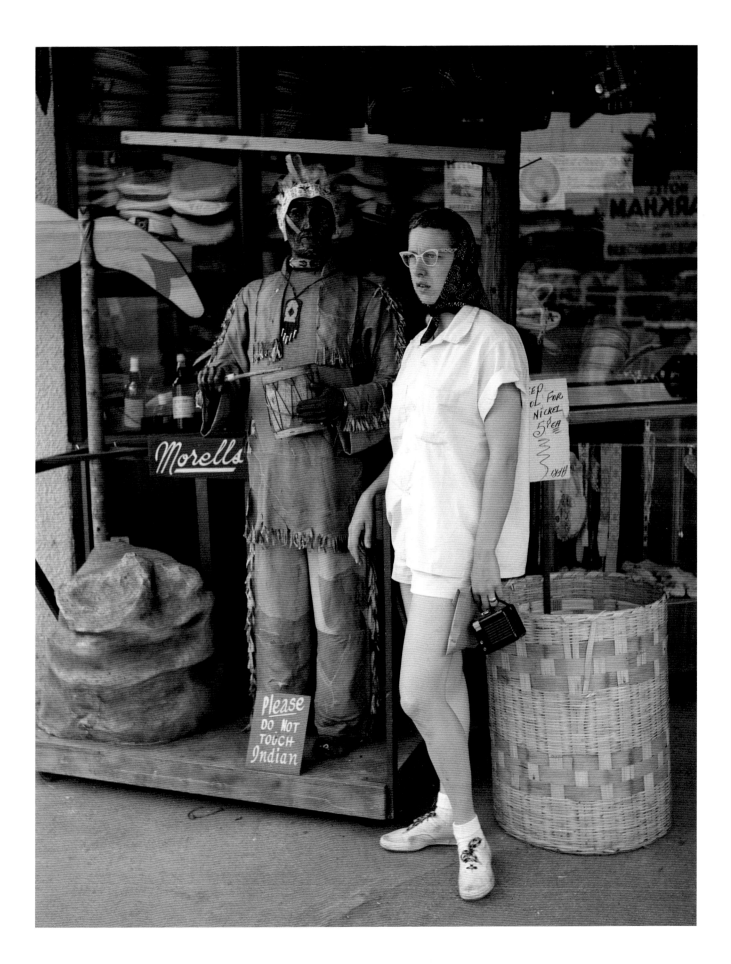

Fur trapping

was the biggest business in the Minnesota country until about 1850. For many years the Northwest Company had twenty-four posts within the future state's boundaries, and the Red River post alone shipped twenty thousand pelts east in a single season. But a partner in John Jacob Astor's American Fur Company, testifying before a Congressional committee in 1838, claimed that there was really never much profit in the fur business: it was just one of those businesses that was very hard to get out of. Why? Mostly because the men who had tasted the trapper's life refused to quit it for the civilized tedium of farm or office or factory.

Q: What inducements . . . had the . . . traders to prosecute a trade apparently so unprofitable?

A: . . . Several of the principal traders, previous to the war, had made some money; for then there was less opposition, and game was more plenty. Most of these continued after the war, for various reasons, viz; future hopes of less opposition, better hunts, or better prices for furs. . . . So long as such could purchase supplies on credit, they continued a mode of life which, above all others, suited their tastes and habits . . . Many of them had, also, taken Indian women for wives . . . and got attached to that mode of life; for *it* had its pleasantness as well as privations. A man is at liberty to live and act pretty much as he pleases; he has fishing and hunting in abundance, and commands all about him, unless *"the grey mare should prove the better horse."* (*With Various Voices,* THEODORE BLEGEN and PHILIP JORDAN)

The product of Minnesota's professional trapper is now insignificant in the state's economy, but the country where the animals live, though now mostly deforested, and compromised by all-weather roads, still exercises a powerful pull on the minds and instincts of the men of this country—the men who have turned, with a troubling sense of regret, to the farms and offices and factories.

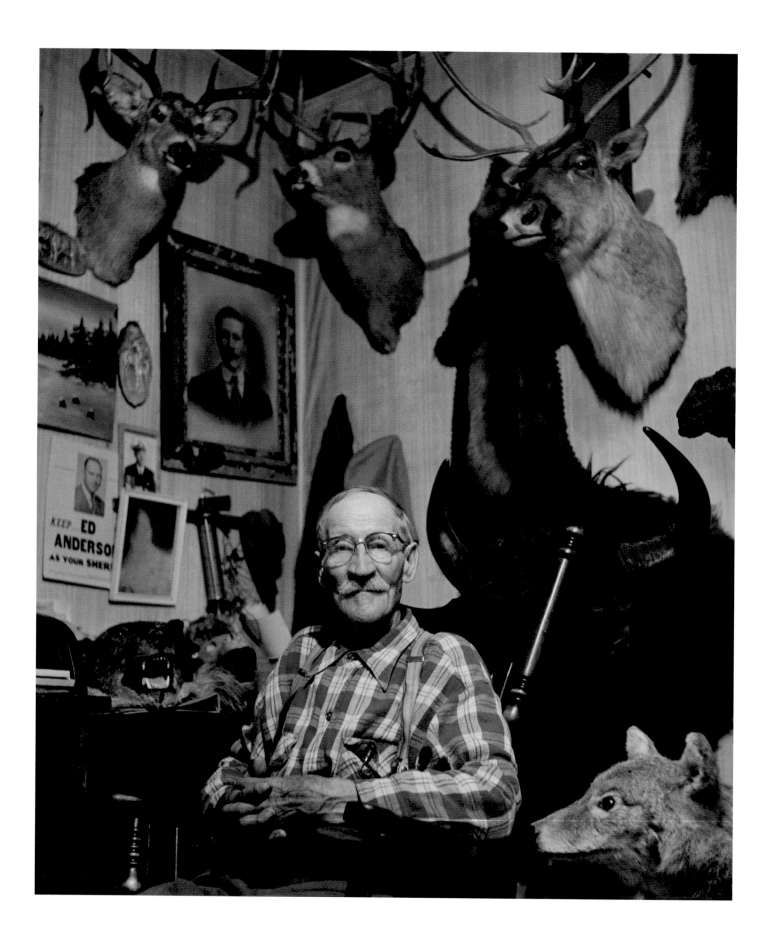

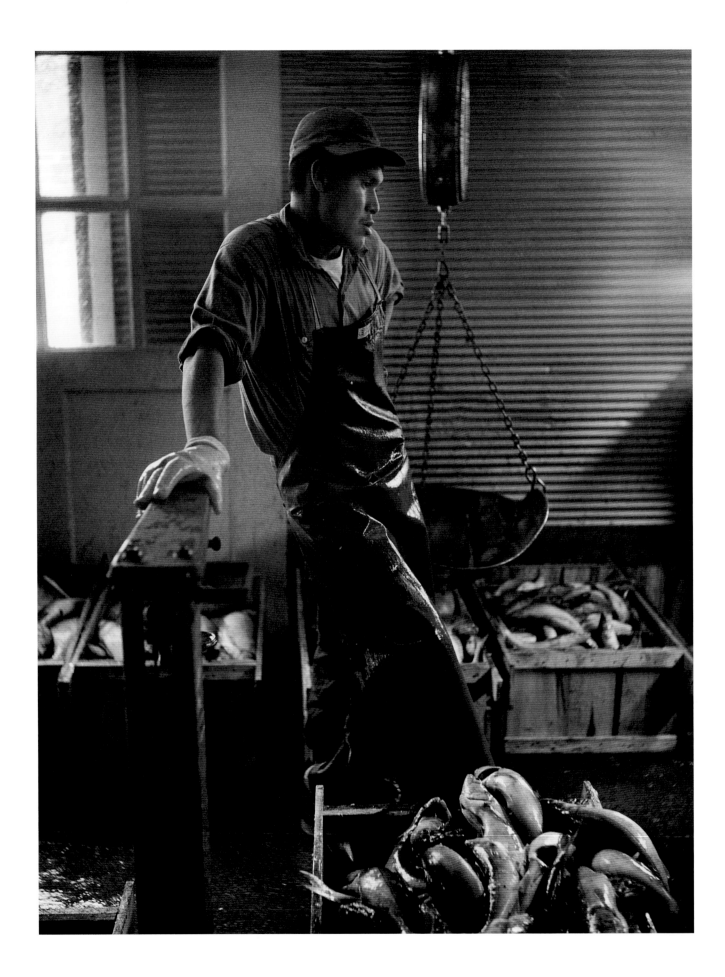

An old fur dealer of the northern border said:

"I have told many people about the animals that were here when I first came. I can tell that they sometimes think I exaggerate. There are not many people now who remember; some who saw the last few think that they know, but there were many more. I do not know what happened to all of the animals, but it is foolish to say that the wolves killed them, or that the Indians shot them. When I first came there were many more Indians hunting and trapping, and many more wolves, and the woods were filled with animals. Many were trapped, but not all, and the caribou and the moose were not trapped. I think that mostly it was cutting the forests and damming the rivers. When the wild rice is drowned out there is no need to shoot the ducks or the moose; they will starve, or go elsewhere if they can. The caribou was a forest creature, and the moose is also; they cannot live in little plots of brush, like the deer. When I first came there were very few deer.

"A caribou was seen here on the Minnesota side not very many years ago. Perhaps it was fifteen or twenty years ago. It was shot by a hunter, who mistook it for a deer. He called back to his guide and said, 'Come here quickly, and tell me what I have shot.' That was the last one that I know of."

SOUTH, in the farming country, there are four seasons. The farmer invented them, and they are for planting, for growing, for harvesting, and for resting.

But in the North there are only two seasons, the open and the closed seasons. Spring is a moment at the time of breakup; the unwary will miss it completely, and find summer on him, unannounced. Fall begins in the last week of August, when a single confused maple turns red on the shore. But *true* fall is Indian Summer, and some years it doesn't come at all. It is improper to think of Indian Summer as any fine weather after Labor Day; Indian Summer comes only after Squaw Winter, which is a reasonably protracted period of cold, with snow or cold rain. Before Indian Summer comes the ducks must be mostly gone, and the leaves mostly fallen, and the buck's antler scraped clean of velvet, and the bears fat and ready. Then, as when the party is prepared and the first guest not arrived, there is a pause; the sun comes out, and the wind dies down, and the woods are quiet of their summer noises. Then for a few days, or a few hours, it is Indian Summer.

MOST OF THE WORLD'S PEOPLE live near the sea. As important as the ocean's freedom of travel is its influence on climate, for away from its tempering influence, the interior becomes too hot—or too cold or too dry or too humid. The interiors of the great land masses are largely uninhabited, and often uninhabitable. People bred within reach of the sea breeze claim that the American midcontinent is no exception, and indeed, here is weather to satisfy the adventurous. But the weather that tries the human constitution is the same that produces sixty bushels of corn to the acre, or forty bushels of barley, or two rich crops of alfalfa in a single season. And it is the weather which brings the waterfowl migrations twice a year, and swimming and ice fishing three months apart, and quick relief from the snows of winter and the mosquitoes of midsummer. It brings a spring of the tenderest, most gentle green, and sweet cold water to the trout streams, and after the summer the wild heart-touching beauty of autumn.

Minnesotans—most of them—defend their climate with vigor, and claim that the seeds of decay are at work in the man who would voluntarily give up three months of skiing and skating and ice fishing. Only occasionally, and often inadvertently, do they allow the shadow of doubt to cross their minds. One such moment of weakness was eloquently recorded by two questions asked of the Minneapolis *Tribune*'s Mr. Fixit.

> Q: (1) What is the coldest recorded Minneapolis temperature? I claim that it was forty below.
>
> (2) I am tempted to plant some pineapple. Is it at all feasible?

The questioner was presumably bucked up by hearing that the temperature on the city's coldest night, twenty-odd years back, was only thirty-four below. Even so, small hope was held out for the pineapple.

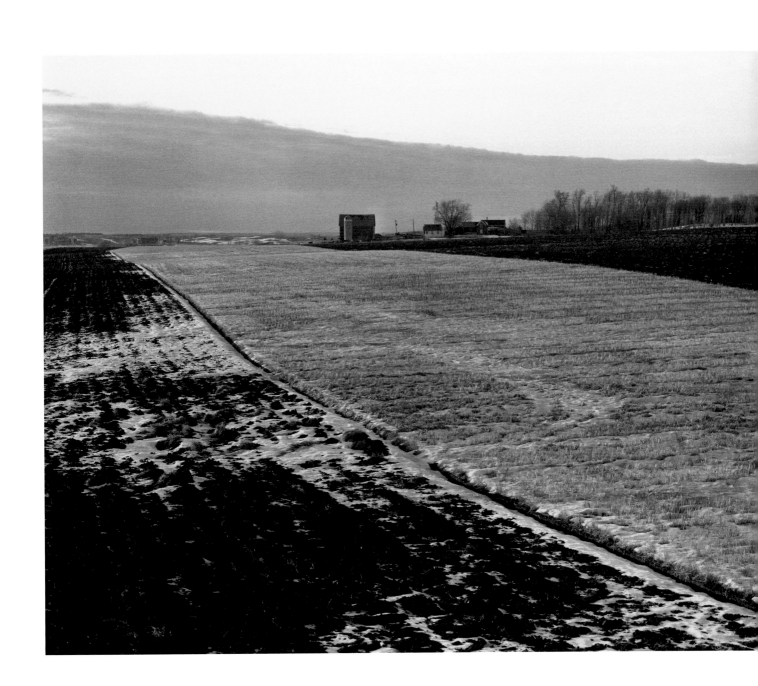

EVERY CORNER OF THE WORLD enjoys its own distinctive, indigenous snobberies. Especially prominent during a northern Minnesota winter is the kind labeled the We've-Got-It-Worse-Than-Anybody snobbery. Although widely exercised anywhere north of Mille Lacs Lake, its purest expression is to be found in the bitter rivalry between the cities of International Falls and Bemidji for unchallenged right to the title ICEBOX OF THE NATION. Partisans of the two towns have even implied that their rivals may occasionally stoop to foul play—such as dipping their thermometers in alcohol and dry ice—to break a dead heat of minus thirty degrees.

But the *really* cold days come only to remote and isolated areas, beyond the reach of official weather stations; and these days, like visions, are experienced only by the fully initiated, never by a visitor from outside. A woodsman from the northern border, on being asked the standard January question, replied that he wouldn't really call it cold—chilly perhaps, but not really cold: "Now in '44, there was a cold winter. For a few weeks there it got so cold that a man working in the woods had to run full speed backwards in order to spit."

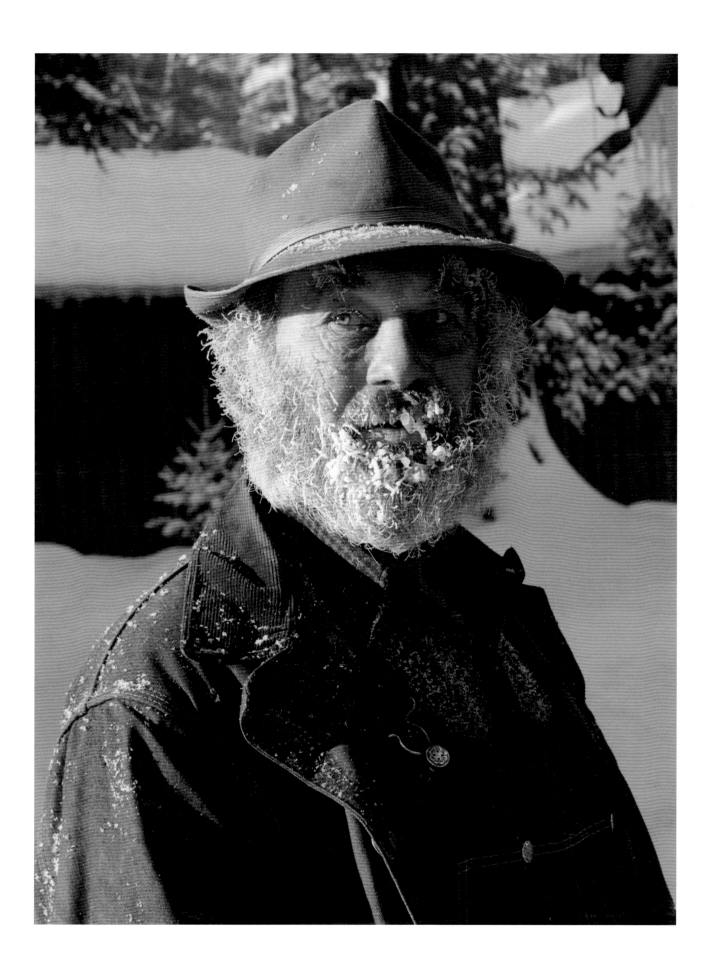

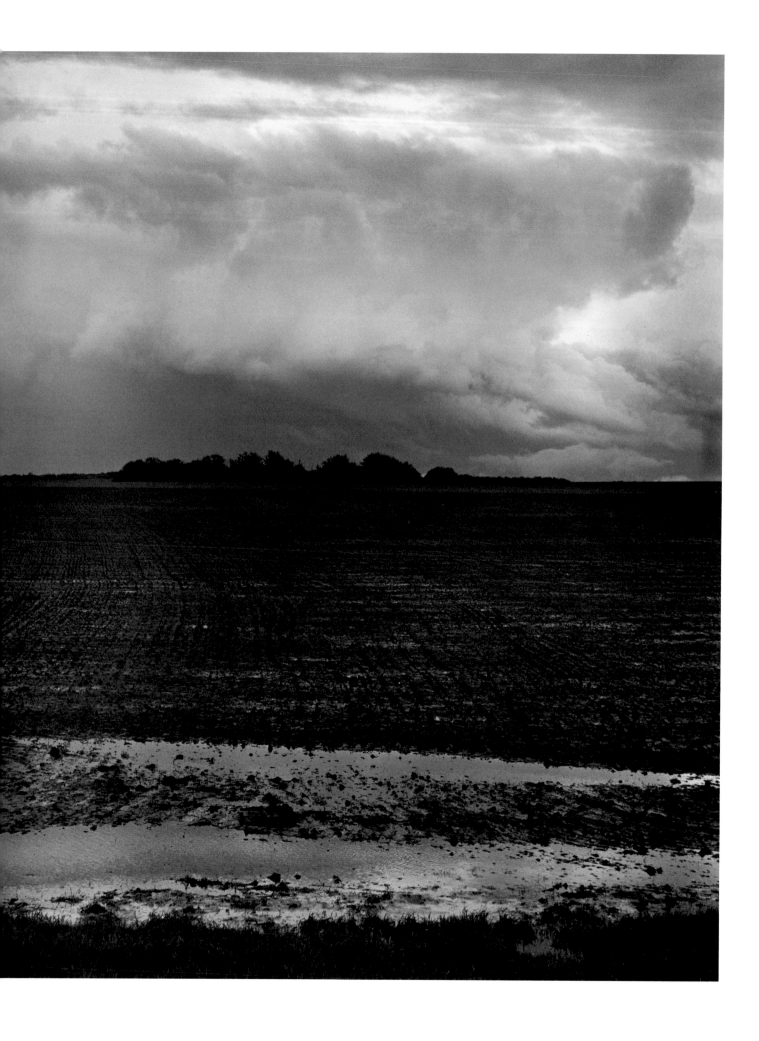

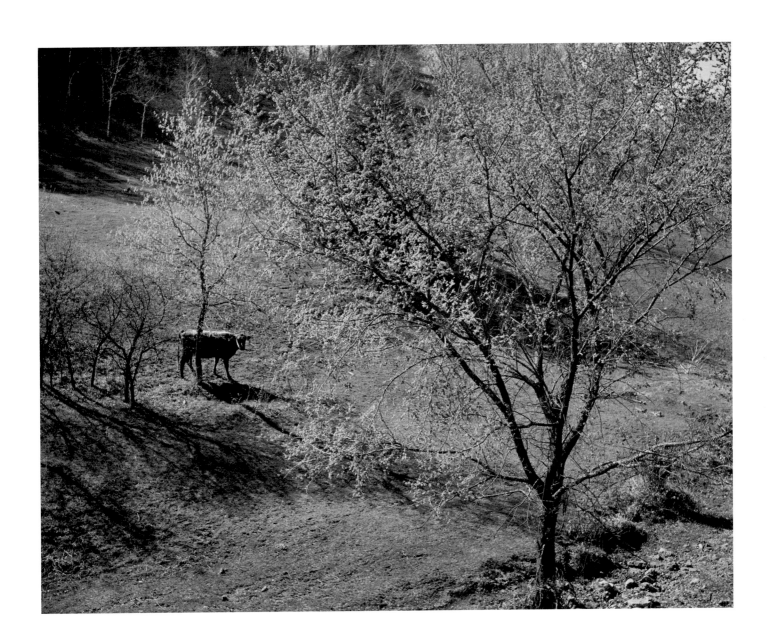

Foothold

THE EXPLORERS had accepted the wilderness, had bent themselves to fit its patterns, had, like the Indians, lived not only in nature but with it. But the pioneer settler had a different attitude: he came to compete with nature, to master it and demand its compliance, to tame Minnesota as Ohio and Pennsylvania had been tamed. And he did it, in a half century. Thirty-five years after Minnesota became a territory, its last herd of buffalo turned north in a final migration and were killed at the Red River by five thousand buffalo hunters. Floods and drought and grasshoppers and hail and loneliness would still win occasional battles, but the issue had been decided. The settlers had won.

For the most part it was a guerilla war, fought by individual men and individual families. In the Red River wagon trains or during an Indian uprising the group would become important; but generally the closest neighbor was not too close, and most people preferred it that way. It was a time for rugged individuals like Paul Bunyan, and the lumbermen who hired him; like the pioneer editor Goodhue, who said what he pleased, and the man who knifed him for saying it; like the promoter Nininger, who tried to build a metropolis out of thin air and optimism, and almost succeeded.

In the war against the wilderness, the forests came first. They were there for the taking; and as more and more of the cream was skimmed from the stands of Maine and Michigan, they were in demand. The Indian treaty of 1837 opened the land between the St. Croix and the Mississippi. As the Indians filed out, the loggers entered. By 1850 Stillwater was a thriving sawmill town. One hundred and thirty-three mills operated in the valley before the cutters turned, in the early fifties, to the Mississippi and Rum River valleys. By then the annual product was worth two and a half million, and it increased each year. But this was nothing; this hardly scratched the surface; the lumbermen could still weep like the Walrus to see such quantities of trees. But with the perfecting of techniques and the rising demand, the cutting went faster each year; and with bogus homesteads, bought legislators, and general apathy,

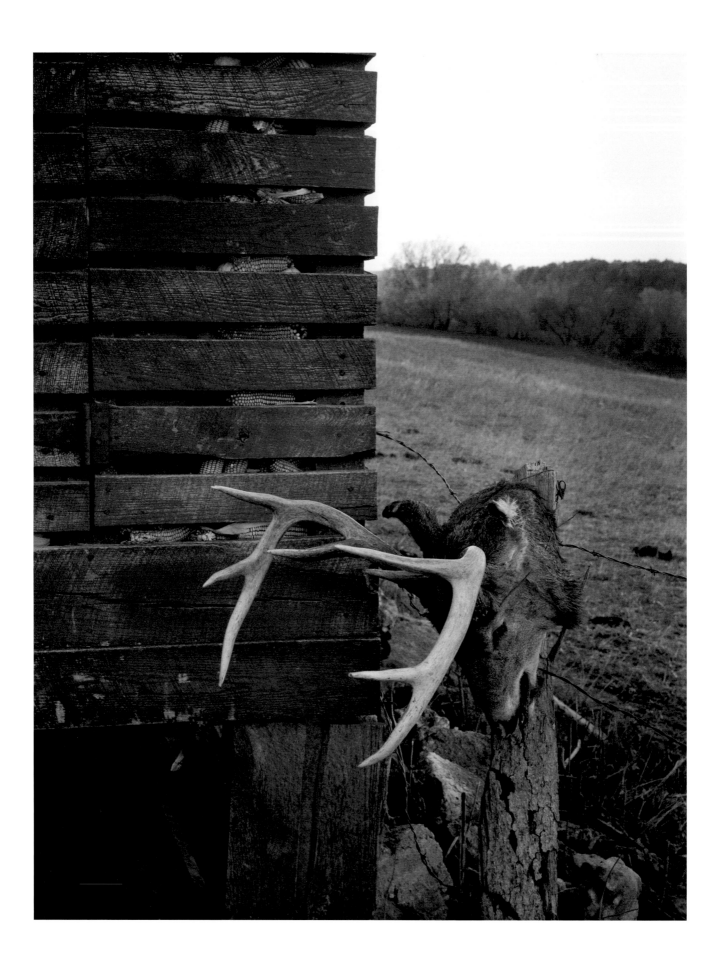

there were always fresh forests to cut. Plain and fancy swindling was always pres-
ent on the frontier, but nowhere did its techniques achieve a nicer refinement than
in the lumber industry. Whole townships were acquired under the Homestead Act;
when the lumber had been cut the "settlers" would move to the next cut, build a new
lean-to, file a new homestead claim, and again sign the new land over to the lumber
company—for a modest fee. William Watts Folwell said, "Indeed, so numerous and
influential were those engaged in the operation that it seemed not merely innocent
but positively meritorious. It was 'business.'"

In the mid-nineteenth century Minnesota contained thirty million acres of virgin
timber. The cutters began slowly: four thousand men were in the woods in 1870,
forty thousand in 1900. The peak year was 1905: nearly two billion feet were cut, 98
percent of it white pine. Ten years later the yield was half as big; twenty years later, a
fifth. Then the forests were gone Remaining were the tales of Paul Bunyan, who lev-
eled a section of pine when he sneezed.

Farming progressed more slowly. Before the harvest came the plowing and plant-
ing and tilling. The land had first to be cleared, since the early farmers settled not on
the prairies but in the wooded river valleys. Horses and oxen were scarce, and plow-
ing was slow. Before the Civil War, the produce of Minnesota's farms barely satisfied
local needs. The first farmers planted for the table, nor for the market: a vegetable
garden, a few chickens, a cow, perhaps a brace of pigs made up the typical farm in
territorial days.

The real importance of these people lay not in how much they grew, but in what
they were. These settlers were freeholders, wedded to the fortunes of the land and the
state. They would be there not until the timber ran out or the animals were trapped,
but as long as the land would support them. They were as tough in their own way as
the voyageur or the lumberjack, and they were also the foundation of a society.

The settlers' frontier was both a time and a place. In 1850 it existed at the conflu-
ence of the Mississippi and the Minnesota; half a century later it still existed in the
counties of the northeast when blacklisted Finn miners walked out of the mine and
into the cutover, returning to the farm life they remembered.

The first settlers were a handful of French Canadians and a few Swiss and Scotch
from the tragic Selkirk colony of the north. Then came the Yankees. For example,
one William H. C. Folsom. A man named Foulsham had come from England to
Massachusetts and built a generous oak house there in 1640. In 1875 the house was
torn down and made into souvenir canes and chairs for the family. But there was not
enough wood. The Foulshams (and Folsoms, Fullsoms, Fulshams, Fouleshames,
Folshams, and Fulsoms) had bred themselves across the country.

Then came the Norwegians, the Irish, the Germans, the Bohemians, the Swedes,
the Danes. An educated young Norwegian named Ole Rynning had led a group of his
countrymen to Illinois in 1837. The first winter he froze his feet, and while in bed he
wrote a book for the people at home, telling them how it was here, who should come,

what they should bring. Rynning, with most of his group, died of fever the following spring. But his little book brought many thousands to the American Midwest.

The great rush started with the land sales of 1848. In 1851 came the Treaty of Traverse des Sioux, ceding almost twenty-four million acres of rich farm land. After the Sioux Uprising of 1862, the Sioux were banished from the state and their former reservations became available. In 1854 the Ojibwa gave up their lands in the northeast; the next year, their lands at the Mississippi headwaters; in 1863, the Red River Valley. In 1862 the Homestead Act became law, and for a moment the state was filled with free quarter-sections. In 1850 there were fifty-three hundred settlers in what became Minnesota; ten years later there were thirty-three times as many; by 1890 there were a million and a third. At the turn of the century there were more Norwegians in Minnesota than there were in Norway. Late in the nineteenth century came the Poles and other Slavs, the Finns, and people from the Balkan countries.

They came rejoicing, it is said. Doubtless some did, and others at least sang to keep their courage up. Songs from Theodore Blegen's *Grass Roots History* reveal both the joy and heartache.

> *When first I left old Buckeye*
> *Location for to find,*
> *I heard of a distant country*
> *In language most divine,*
> *A land of milk and honey*
> *And water of the best*
> *They call it Minnesota*
> *The Beauty of the West.*

But Ohio had not been a home of centuries. The Norwegian poet and novelist Henrik Wergeland echoed a million tearful leavetakings in his play *The Mountain Hut*.

> *Farewell, valley that I cherish,*
> *Farewell, church and trees and home,*
> *Farewell parson, farewell parish*
> *Farewell kith and kin, my own,*
> *Lovely gardens, walks of beauty,—*
> *Would to God this were undone!—*
> *Home, you stay me in my duty,*
> *Calling, "Leave me not, my son!"*

There was reason for the trepidation as well as for the rejoicing. Life in the land of milk and honey proved very hard. In the sixties and seventies there were Indian wars and grasshopper plagues and loneliness; early in this century there were the company towns of the iron mines. But a woman who had come to western Minnesota in 1873 reread the diary of her trip fifty years later, and felt the need to finish it. She said,

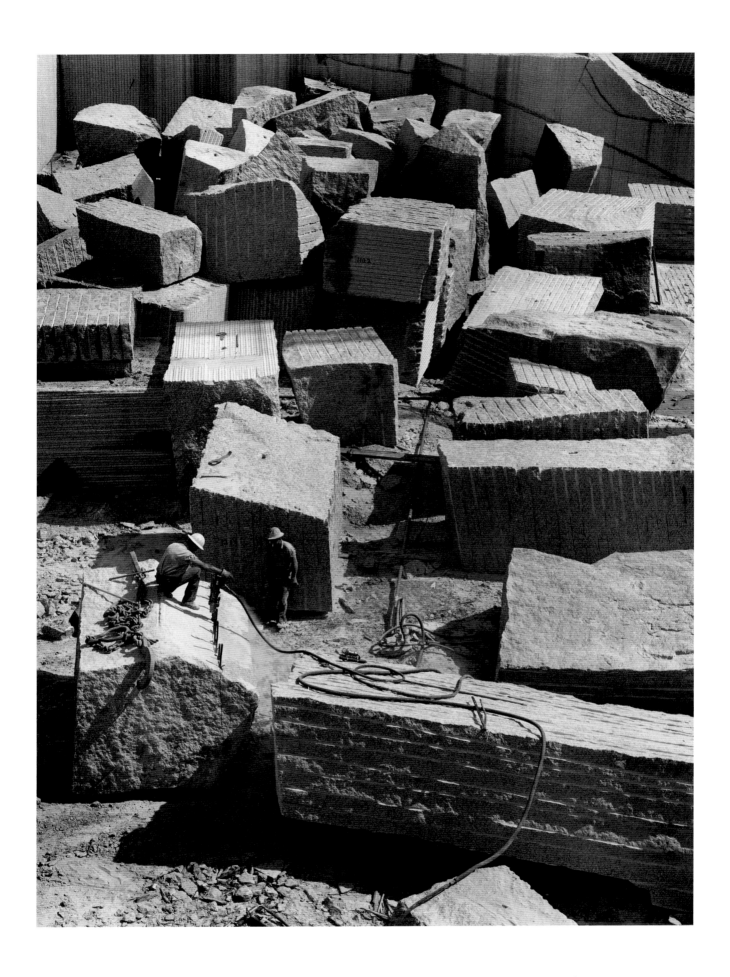

"I am now eightseven years old & have seen . . . the end of our trail grow into a beautiful thriving . . . city" (*Grass Roots History*).

Even before Minnesota became a territory, there were a few houses of substance — like the simplified Georgian stone house of Governor Sibley. But most the first houses were of logs, in the timbered river valleys, or of sod, on the prairies. If it had been possible, perhaps the settlers would have built houses like the ones they left behind, but by the time the first precarious years were over, and a more ambitious house could be built, the old forms had already lost some their meaning. So the new house was nondescript, without style.

The pioneer's attitude toward the wilderness was full of contradictions. While he fought for supremacy over it, he grew to love it. The pot hunter who killed a covey of prairie chickens with a single shot hunted for food and for money; but while he lay in his blind, he learned much about his prey, and sometimes he would later recall with wonder the strange mating dance, the wonderful display of plumage, the perfect, accelerating rhythm of the drumming. He and the lumberman and the bonanza farmer and the mineral prospector all loved the country, and by the end of the century many of them saw that they were killing what they loved best in it. People sang sentimental songs about cutting down the old pine tree, and on the walls of their houses they hung prints of the noble Indian looking down on the Pacific, at the end of the trail.

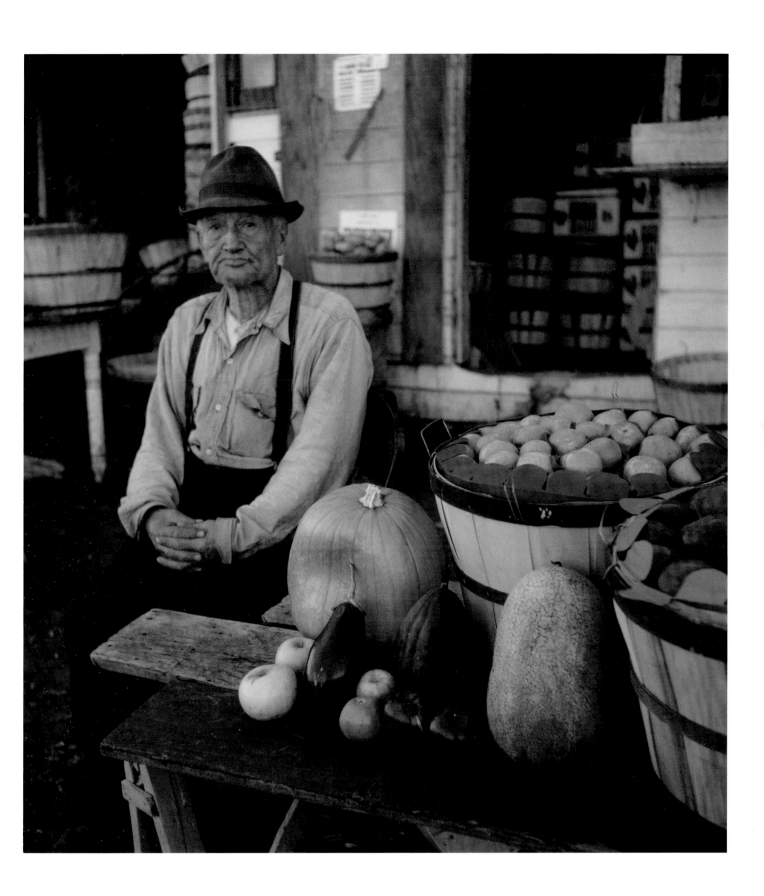

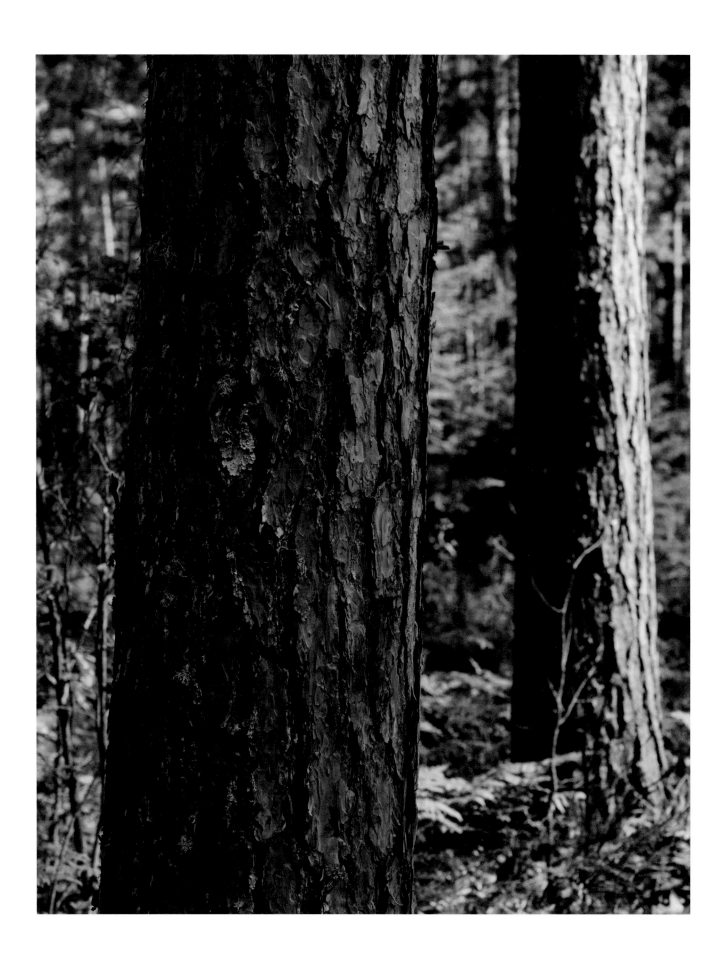

The virgin saw timber is gone from Minnesota.

The few remaining stands of large pine are souvenirs—remnants that have been preserved in parks or on the private lands of men who wanted to remember what the forest was like. These little islands of the past, surrounded by a hostile environment of cutover lands, will not replace themselves; and since Minnesota's forest industries are now geared to pulpwood rather than timber, it is unlikely that the original forest complex will be re-established to any significant degree by planting.

Yet in dollar value the forest products industry still ranks among Minnesota's most important. There is still a little white spruce in the woods, and plenty of balsam fir; but the backbone of the industry is now jack pine and aspen—the "weed trees" that grew up after the fires.

There have been changes in the loggers, as well in the forests. On most cuts today the logger eats at noon from a lunch pail, and drives home in the evening to his family. He knows who Paul Bunyan was—because everybody knows—but he may never have heard of Febold Feboldson or Little Meery. There are no more six-man muzzle-loading bunks, and no more two-man crosscut saws, and no more ox teams to pull huge sleds of timber along iced tracks. Some even claim that the quality of the old oaths has disappeared: it is difficult to curse a Diesel tractor with the spirit and inventiveness that a balking ox could inspire. But the Diesel tractor will haul more logs, and the gasoline chain saw will cut more trees faster, and closer to the ground.

Recent figures indicate that for the first time in many decades Minnesota is growing more timber than it is cutting, and it would seem that all is well in the forests. But the whole truth is more complicated and less encouraging.

"Timber quality is much too low. Only one third of the saw-timber is of the quality which will make standard lumber. More and more, the forests are consisting of small size trees. Thus the trend in the quality and size of the timber has been down. . . .

"The total volume of timber is nearly eleven per cent greater than it was seventeen years ago. But this increase has been in the low-value and less desirable hardwood species. . . . We have been heading toward trouble in the decline of softwood timber, such as spruce and red, white, and jack pine. The volume of these softwoods is now twenty per cent less than it was in 1936. This is a serious trend which calls for remedial action." (M. B. DICKERMAN, Director, Lake States Forest Experiment Station)

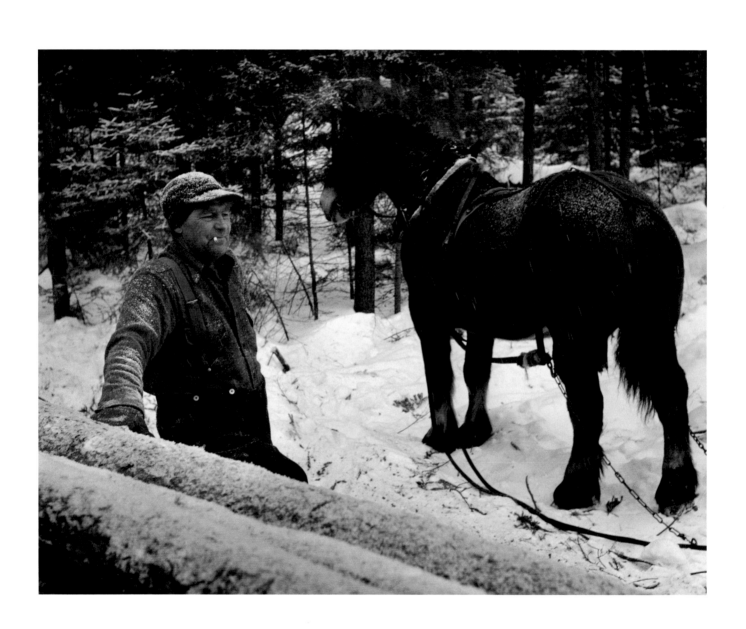

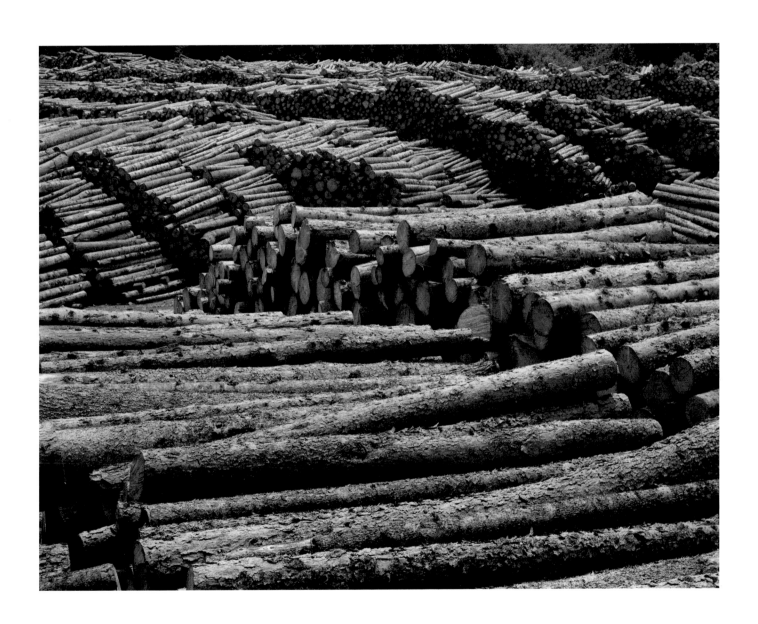

TODAY *everyone* agrees, in theory if not always in practice, that the forests are a resource to be harvested on a sustained-yield basis rather than mined. Conservation—the wisest use of available resources—is an ideal universally praised.

Still, the forest has different values to different people: long-term values and short-term values, obvious values and values which require imagination and foresight and self-discipline. Competition among the various philosophies of forest use is continual and sometimes bitter. And the forests themselves are away from the well-traveled highways, out of the sight of the only slightly interested. The field manager of what is perhaps the biggest cut in the state said:

"No, I don't want any photographs made on our cut. It's not that there is anything to hide out there, but it would cause trouble anyway. Too many people think that every tree in the forest should be left for the birds to build nests in. You say that if we have received unfair publicity, we should welcome having the story told straight, but that isn't the way it works. Every photograph of a cut, especially a clear cut, brings a half dozen committees of wilderness lovers down on our necks. Anyhow, we don't need publicity; we're not selling anything to the public.

"The way we feel, the less publicity our operations receive, the less trouble we're letting ourselves in for."

84

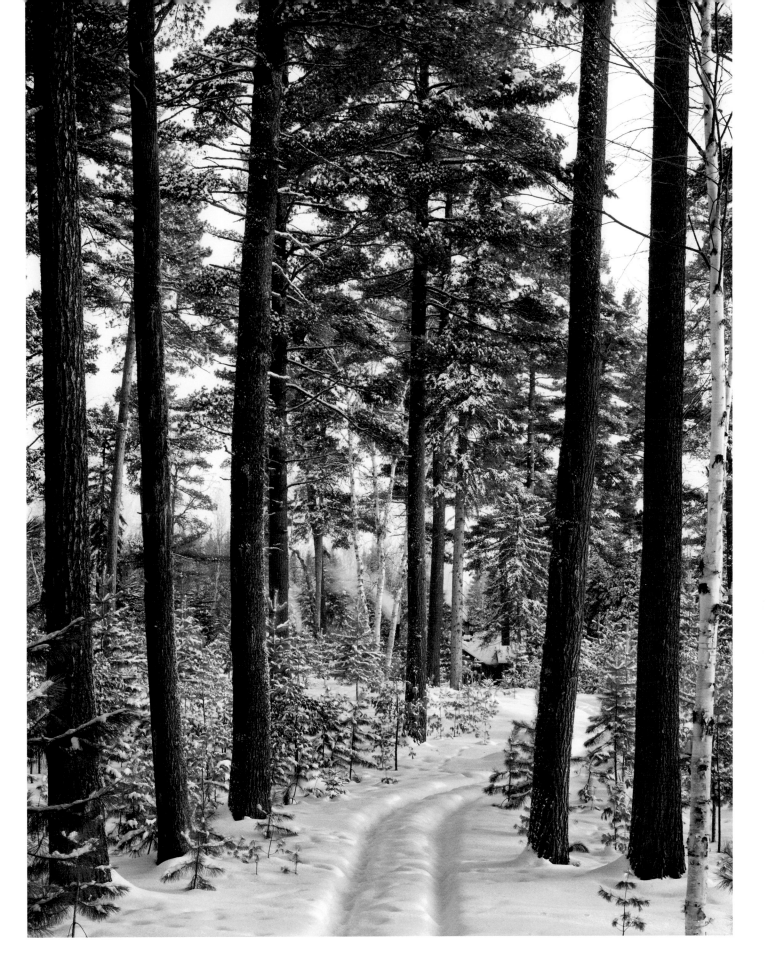

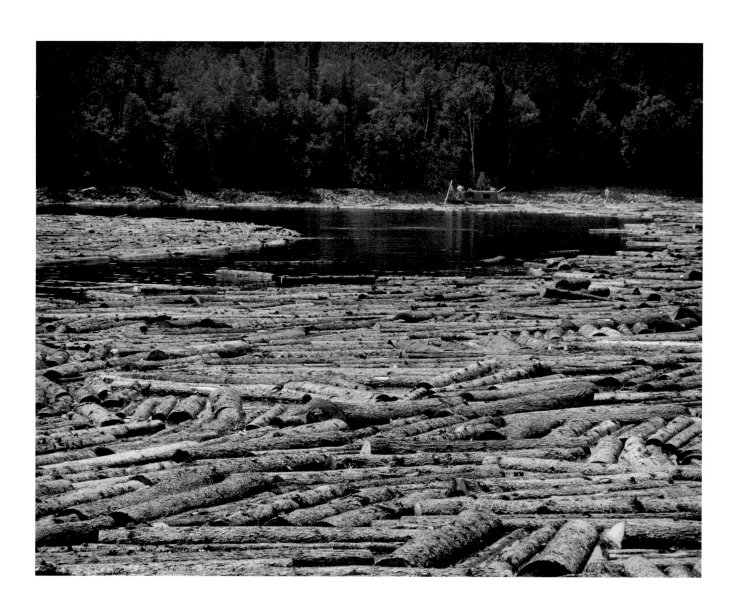

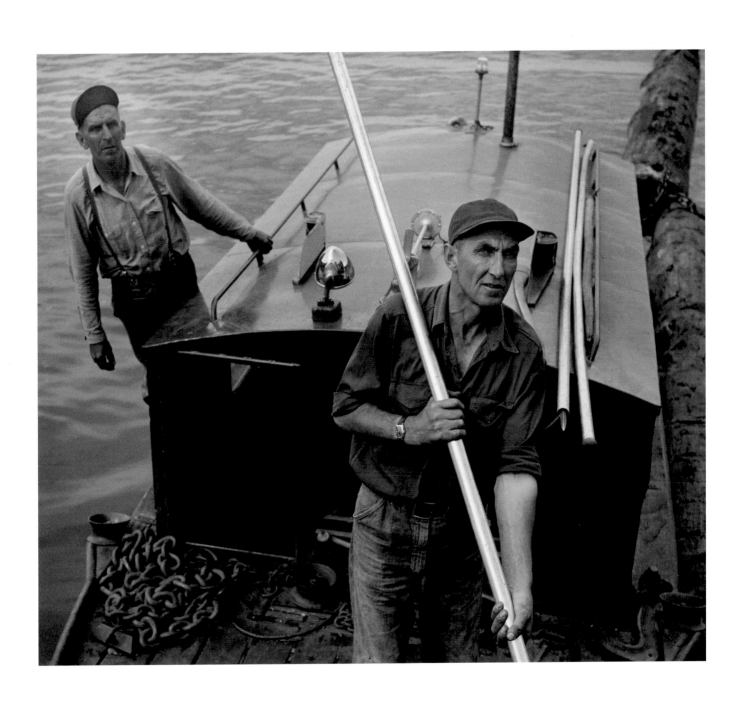

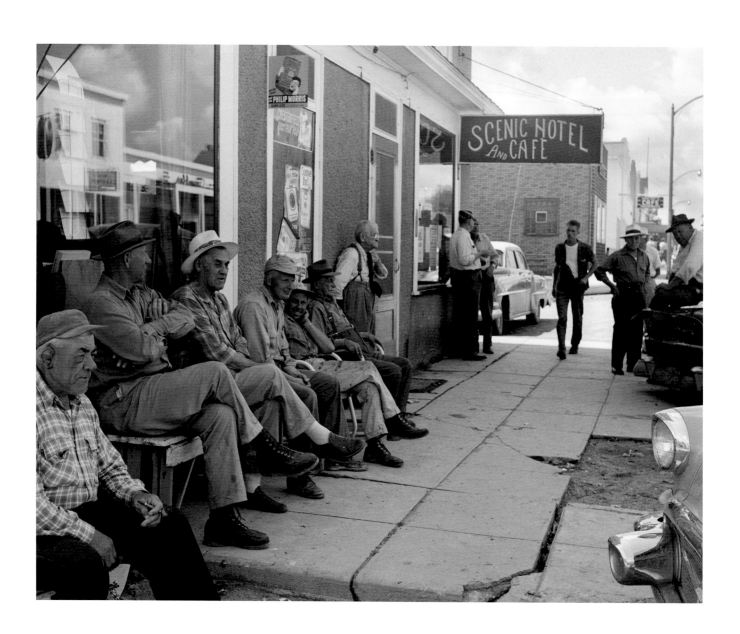

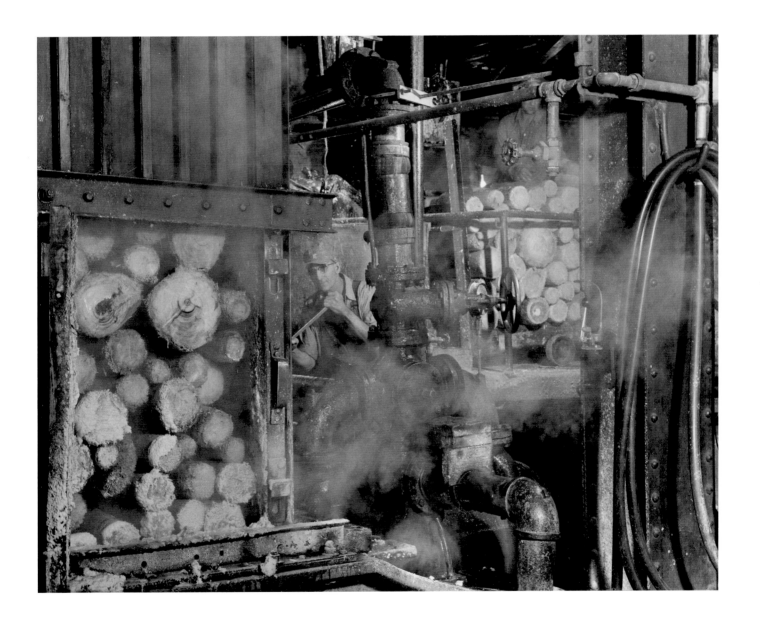

After the loggers came the farmers.

The farmers came to stay; they and their progeny, along with other American farmers, have done more than develop the techniques of growing incredibly rich harvests: they have nourished and redefined an age-old ideal of the good life.

An American scholar recently said of the Midwest farmer: "Like many other Americans he was possessed of a land complex. He loved to hear that (1) the farmer is the backbone of democracy, (2) the farmer is the salt of the earth, (3) the farmer feeds the nation and world, (4) farmers work harder than other people, and a variety of others notions." It is almost certainly true that most Minnesota farmers do hold these notions. What is more striking is the fact that they have so often proved them true. The farmer has practiced democratic politics as a serious art, especially on the local level, for in a township six miles square his vote has carried real weight; and unlike the doctor or the carpenter, he couldn't easily pick up and move if things developed in a way that didn't suit him. If he has indeed seemed the salt of the earth, perhaps it is because he has worked with his own family, in a joint effort which all have understood, and in which all have participated; or perhaps it is because he has never lost his sense of being part of nature, knowing that he needed rain after planting, and then sun, and after that, no hail. That he has fed the nation is obvious enough — perhaps, from the point of view of his own prosperity, he has fed it not wisely but too well. Whether he has worked harder than other people is open to question, for many people have worked very hard, and if the farmer has spent longer hours with no guarantee of profit, he has at least spent them in the clean open air, with no straw bosses looking over his shoulder. And while he worked he could watch the land change under his hand, change not necessarily to something better, but to something new; from something eloquent and wild to something gentler, more in man's scale, more companionable, more human.

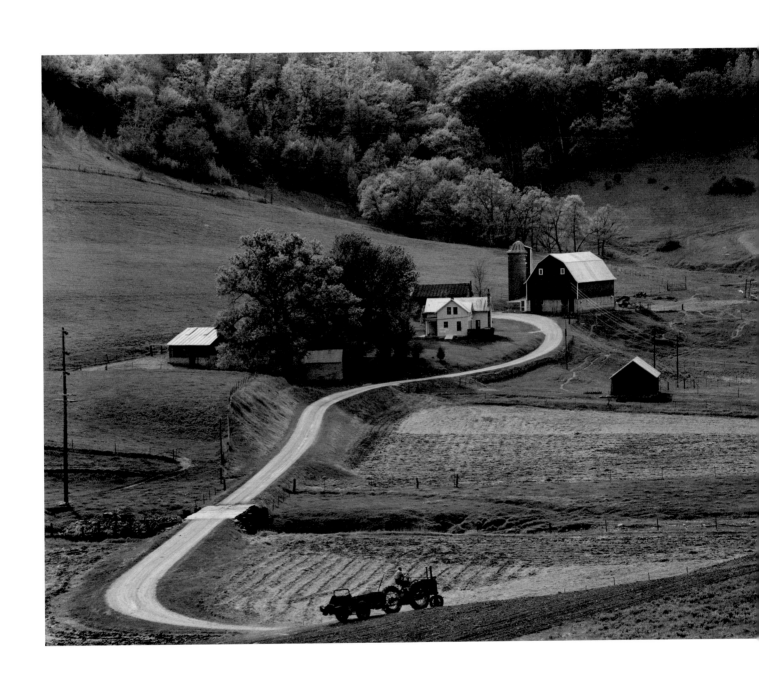

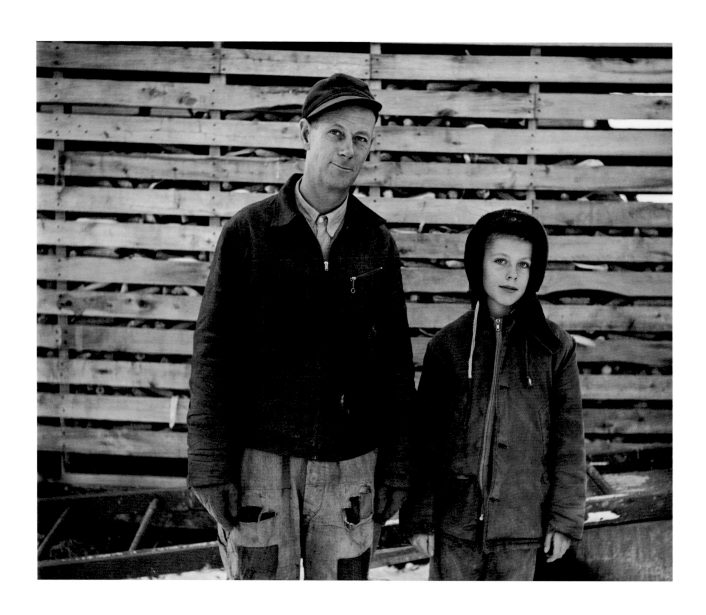

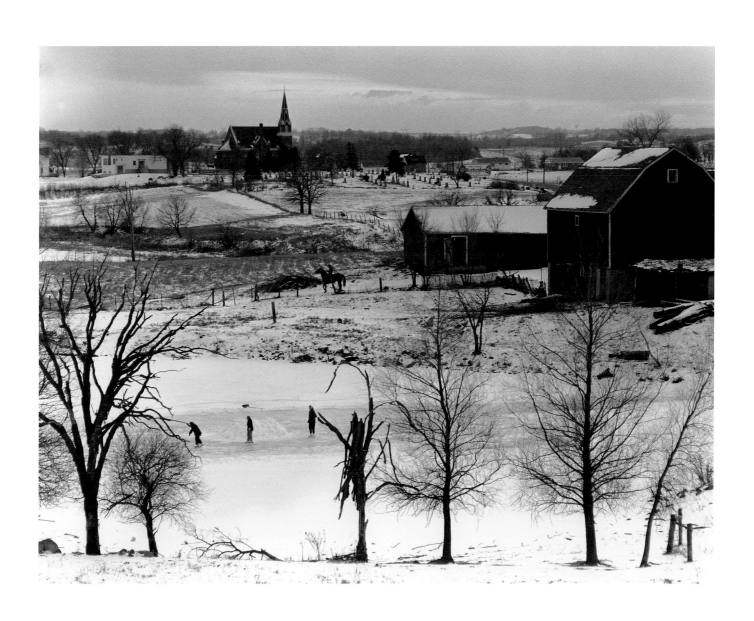

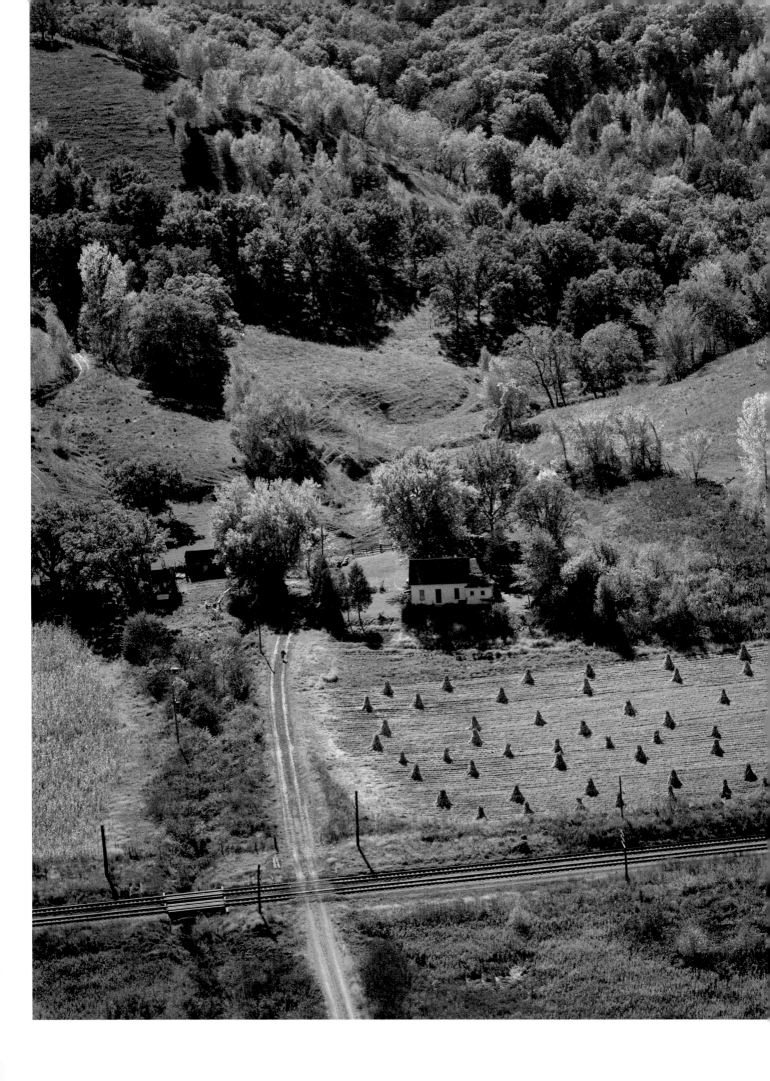

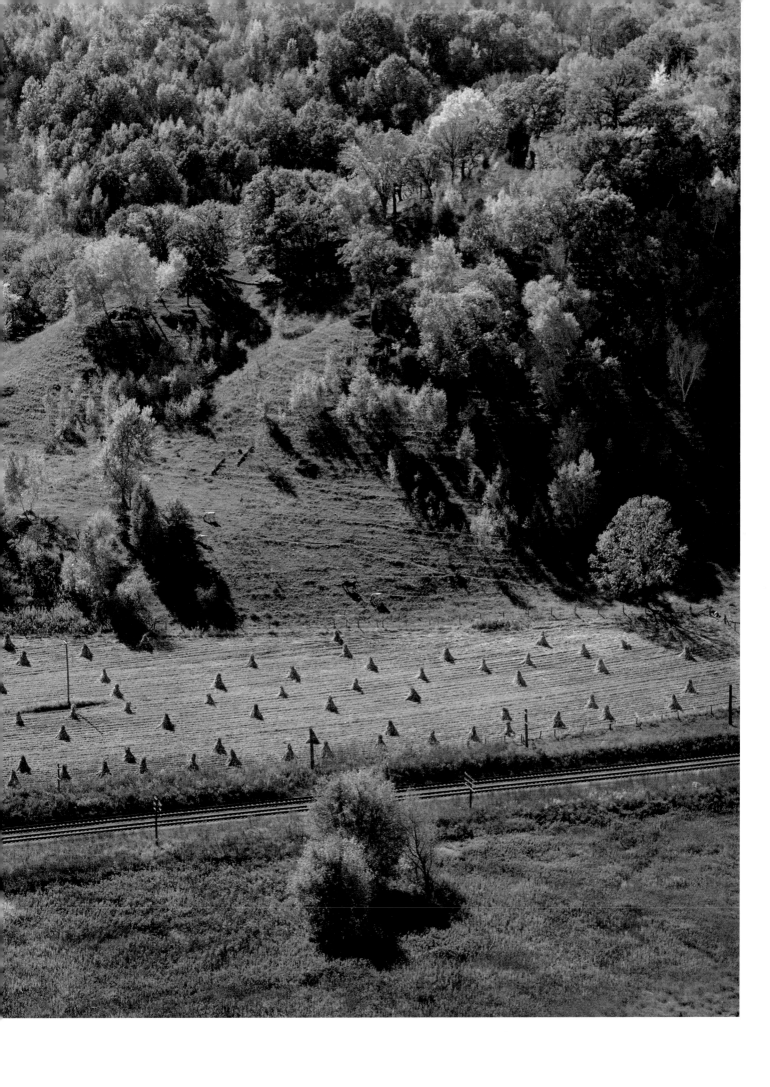

FARMING AS A WAY OF LIFE no longer necessarily means a frozen pump in the wintertime. If the farmer's attitude toward the ideal of farm life has remained constant, his actual style of living has changed enormously. Modern roads and automobiles have made his an increasingly suburban occupation. He has come to rely more and more upon the city — the machine shop, power plant, laboratory, and supply depot upon which his amazingly complex technical operation depends. And increasingly, the city is also the place from which he and his family get their entertainment, education, social life, news of the world. In the process, the farm family has adopted many of the standards of their urban relations. A professor at the University agricultural school summarized the change by saying that the real problem had become How are you going to keep the *girls* down on the farm? Progress toward achieving urban living standards has been amazing. On Minnesota farms in the decade after 1940, the number of mechanical refrigerators increased seven times; by 1950 there were also three times as many modern bathrooms, four times as many running water systems.

Doubtless Minnesota farm wives still have their problems and their unfulfilled desires. Today, however, if they happen to be included in one of the researchers' "carefully selected random samples," they will probably have a sympathetic ear to tell their troubles to. For example, a University class in rural sociology has recorded and tabulated the thorns in the flesh of farm women from Isanti County. The changes that a decade wrought in her ten top worries bear testimony to the nature of the revolution in farm life.

ITEMS WITH WHICH ISANTI COUNTY FARM WOMEN REPORTED BEING MOST DISSATISFIED

Order of Dissatisfaction	1940	1950
1	Savings	Children's job prospects
2	Bathroom	Savings
3	Vacations	Telephone
4	Sewage disposal system	Lawn
5	Living room furniture	Sewage disposal system
6	Travel	Living room furniture
7	Hours of work	Hours of work
8	Old age care prospects	Recreational facilities for self
9	Strenuousness of work	House
10	Refrigerator	Public library books

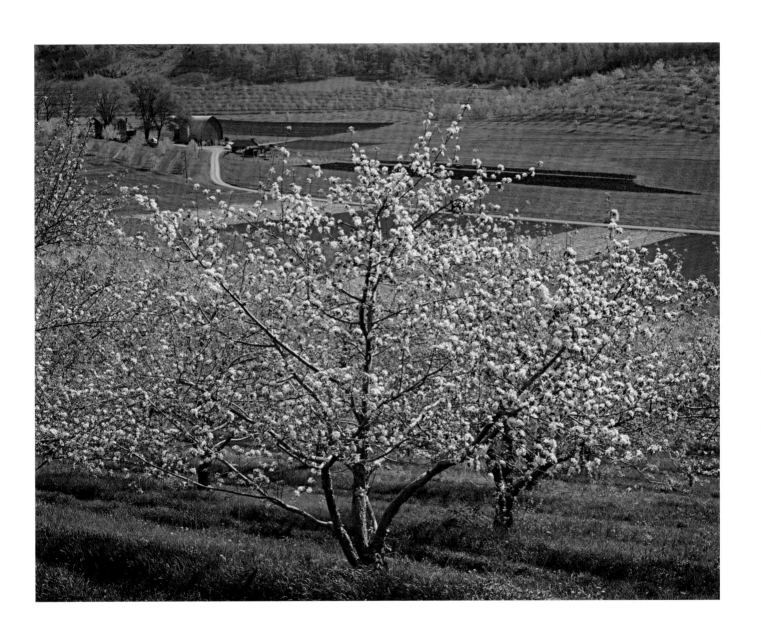

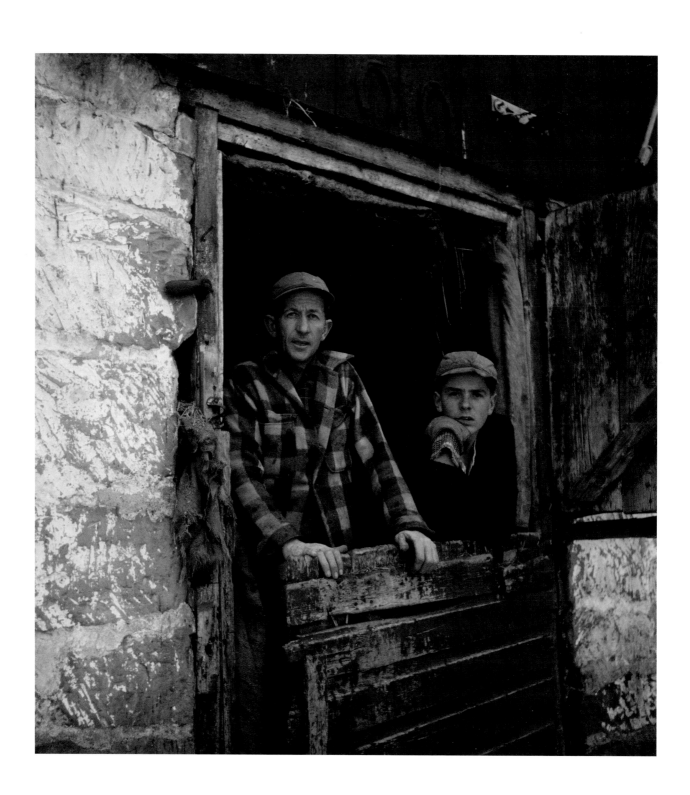

Job opportunities for her children are now the biggest worry of the Isanti County farm woman. This also worries her husband, and the children themselves. For the mechanized farm no longer needs their help—in fact it can no longer afford their help.

The worry is not only an economic one. Even if the farmer now has the same automobile and the same bathroom and the same television set as his suburban neighbor, he still regards farming as a special way of life, a way particularly desirable for himself and for his family. And while it is easy for him to understand that America might find itself with more Teletype operators than it needs, or more photographers, or spot welders, it is harder for him to understand how there can be too many farmers, because farming is a natural act of man, like walking or breathing, and because many people in the world are still hungry.

The farmer's son agrees with the farmer. Several hundred high school seniors from southwestern Minnesota were asked to rate their satisfaction with their father's occupation from *very satisfied* to *not at all satisfied*. Proportionately twice as many farm boys as city boys underlined *very satisfied*.

And yet now, in a great Malthusian farce, fewer and fewer farmers are needed to produce even greater surpluses of food.

A Minnesota agricultural economist, approaching the subject with all the bold abandon of a man preparing to eat his first dish of snails in garlic butter, suggested that a Soil Bank isn't enough; people too have to taken out of production: "I don't want to drive people off the farm. But if you have this lack of balance, the only way I know to cure it is to get an adjustment."

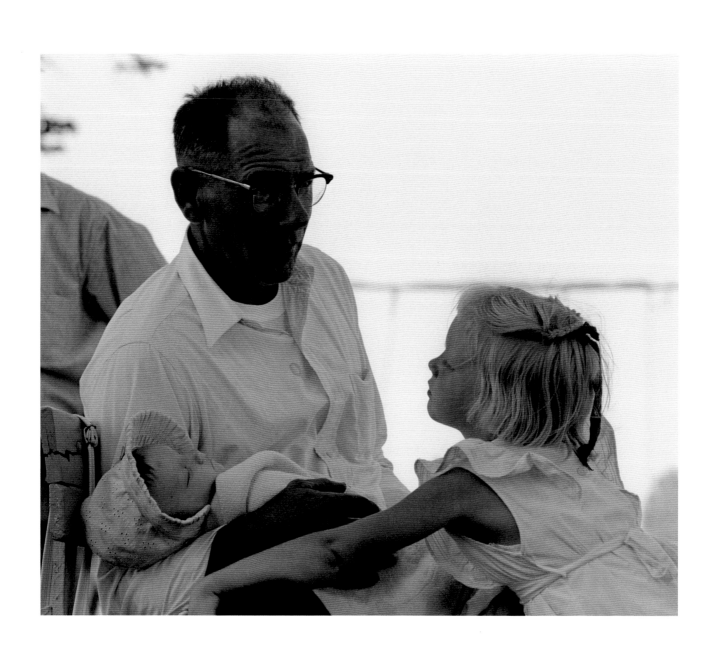

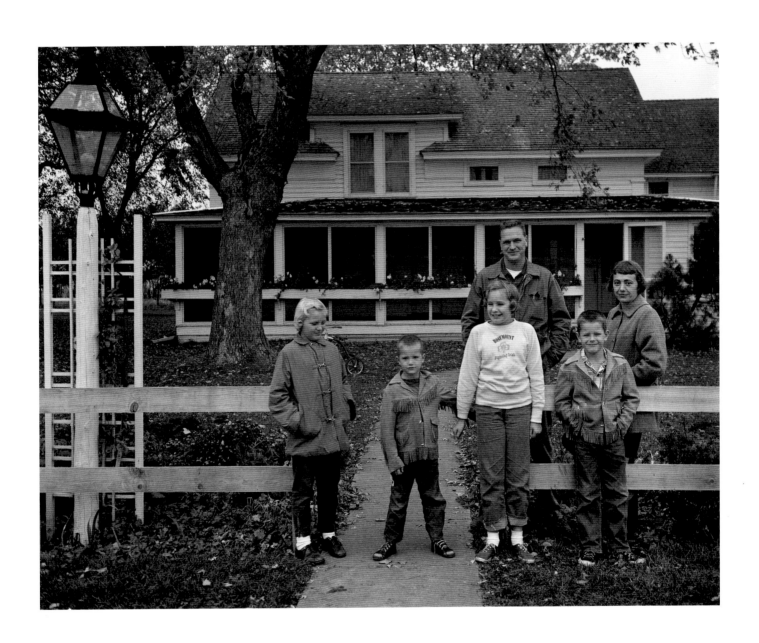

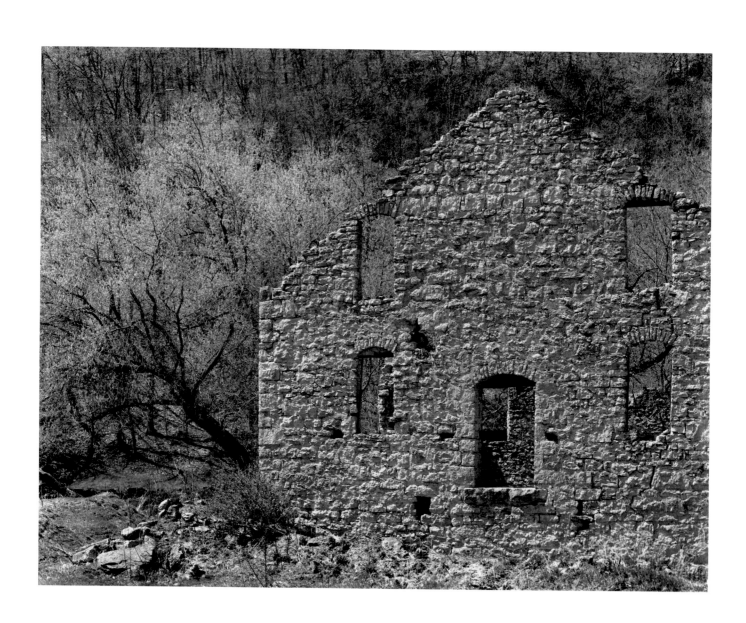

This was indeed a melting pot.

A little more than a century ago, the people began to arrive in force; for over half a century they came at flood tide, from every country, of every race, with every kind of previous experience. And now the distinctions have almost disappeared; one can tell a German-Minnesotan or an Irish-Minnesotan or a Norwegian-Minnesotan only by his name, and often not then. So we look for evidence of his lost uniqueness in his family's surviving works—in his grandfather's house, or his great-grandfather's tombstone—and we see that even in earlier times these things were more alike than different: on the frontier there was time to be proud of the parent culture, but there was little time to preserve it. It was the forest and the ledge limestone and the prairie storms and the new mill lathe that determined the shape of the settler's house, much more than his ancestral remembrance.

This was a melting pot, all right; of course the pot was not *always* at a boil. Other things being equal, Minnesota's settlers would have preferred the company and the manners of their own kind. The strait-laced Yankee Mitchell Jackson wrote in his diary that it was a sin against heaven and earth, the way the Irish were led around by their love of whisky; and what was worse they voted Democratic. But it can at least be said for Jackson that he confined such thoughts to his diary, and did not voice them on the streets of St. Paul. Thus if at first one's neighbor was not always well loved, there was generally room to distrust him with dignity, from a distance. And soon even this passive intolerance proved cumbersome.

Among the non-English-speaking immigrants, the parent language itself was often half-abandoned even by the first generation, when their school-age children brought the habit of English home to the supper table. As immigration increased, larger settlements of single nationalities became common, and here the parent culture fared better. But it was impossible to remain isolated for long. An American had to trade and vote and work with other Americans of different stripe; he would move to better land, get a better job, be thrown in with new people, perhaps even intermarry. Perversely, even the culture most assiduously preserved would soon change to something that often resembled a parody of the original. The European language would not have a word for the new American tool; the American garden would refuse to grow the ingredients for the European dish. So the people improvised and invented. And when after a lifetime in America the settler revisited the country of his childhood memories, he was amazed that it people's language and ways could have changed so much.

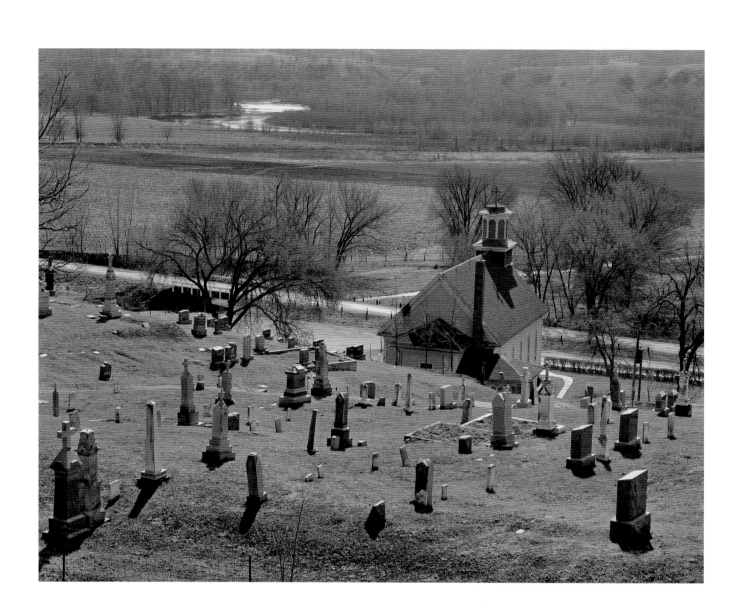

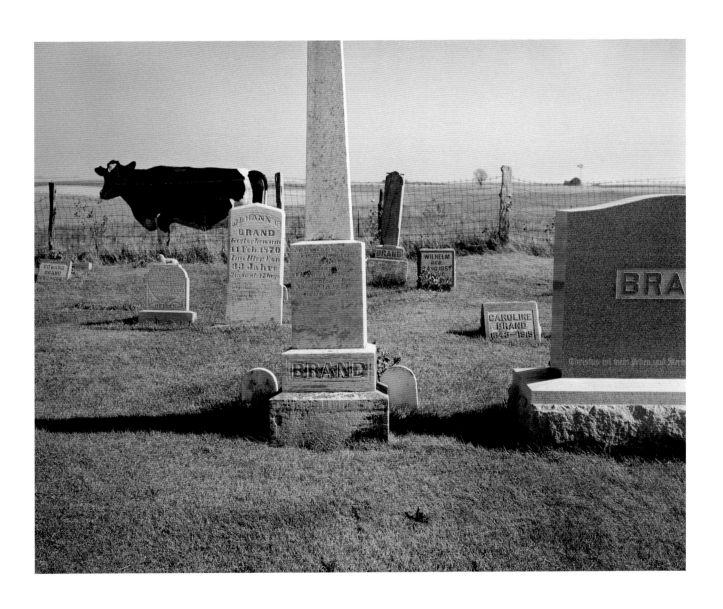

EVEN IF Minnesota was by and large a poor place to preserve an imported culture, there have been a few survivals. What a people loved most they would somehow find a use for, and a bit of it would survive, even if greatly changed in shape and texture. The French brought a language almost as beautiful as that of the Ojibwa, and with it they named the places that the Indians had not named beyond renaming: they named Lac Qui Parle, and even though the later settlers were tough about such things, they were not tough enough to change that to Talking Lake. The Lutherans brought Bach, and a love of good choral singing, and this they have retained in full strength. The Finns and the Danes brought the seeds of a revolution in marketing and distribution, and formed the cooperatives which today handle much of Minnesota's produce. The Swedes brought a table groaning with delicacies, served buffet style, and smörgås-bord has become a favorite word for Minnesotans of any stock. The Finns brought their sauna, the first great contribution to sociable bathing since the Romans, and they also brought the best log buildings that any American pioneer built anywhere on the continent. The Germans and the Bohemians brought their violins and cellos, and scandalized their neighbors by playing music on Sundays; soon they were the leaders in forming many early symphony associations. The list is long: each group retained a few things that still worked, and soon these were adopted by the others.

In addition there are the few isolated survivals, remaining even until now almost static, within the original group—in a Polish country church, a shrine to Our Lady of Czestachowa, the black Madonna, five thousand miles from home. And there are the souvenirs, fossils on the historical beach, that have outlived the identity of the original group—on the banks of the Minnesota River, a super-heroic monument to Hermann (Arminius), noble barbarian of ancient Germany, defeater of Varus in the dark Teutoburg forest.

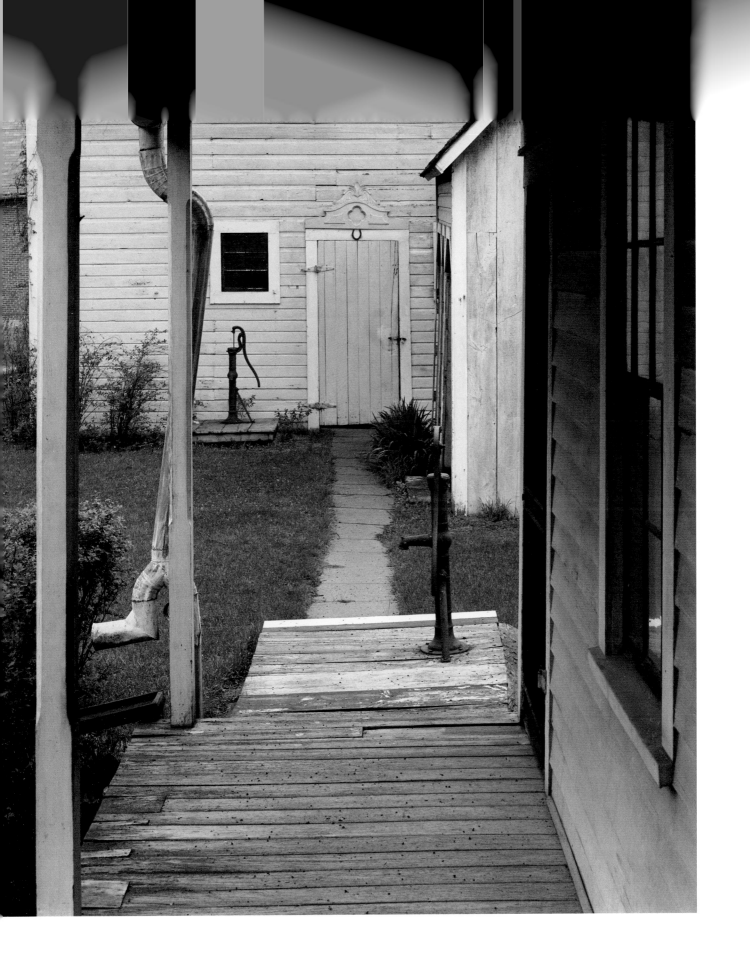

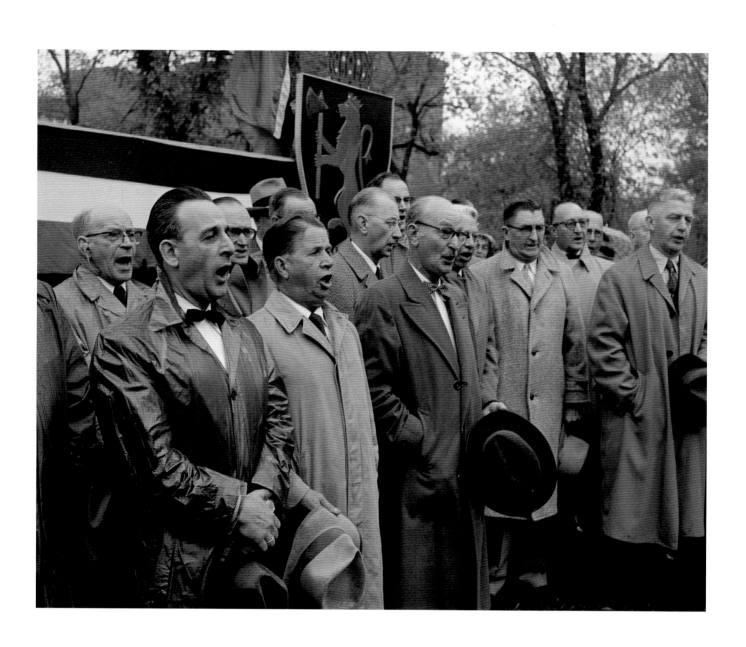

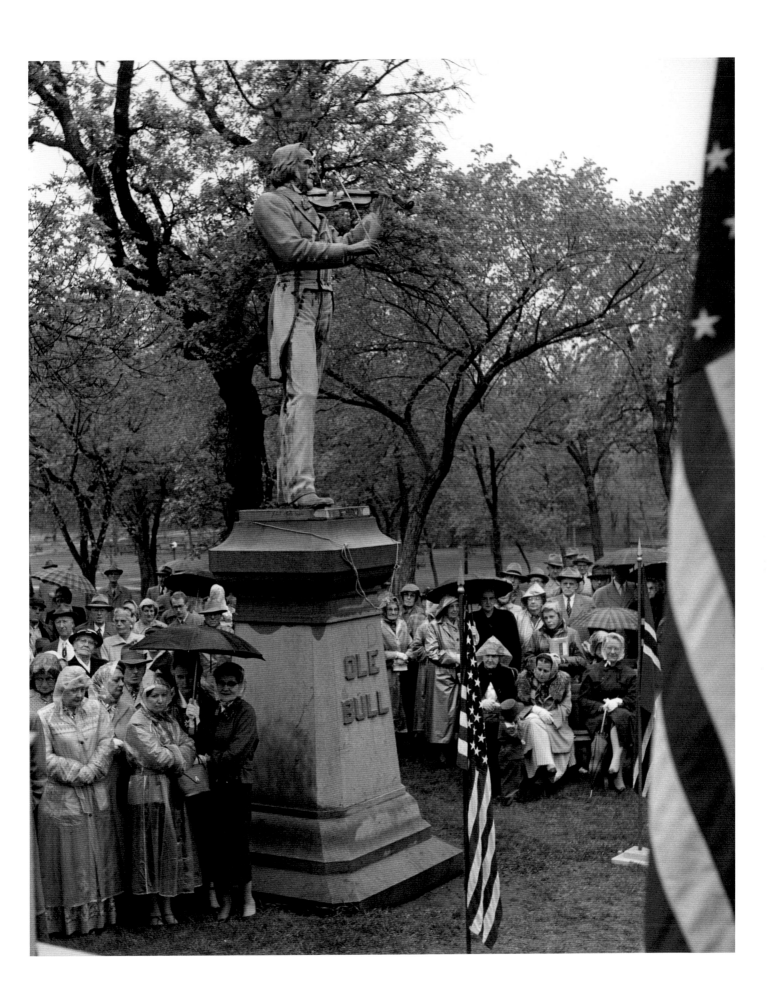

IN THE ETHNIC CHAOS OF AMERICA it was appropriate that the English-Yankee Longfellow, writing a poem about the native Hiawatha (Minabozho, really), should borrow his meter from the Finnish epic, the *Kalavala*. There is still many a well-worn copy of the *Kalevala* in the homes of Minnesota's Finns. It is a beautiful poem, even in translation:

> *When thy brother comes from plowing,*
> *And thy father from his garners,*
> *And thy husband from the woodlands,*
> *From his chopping, thy beloved,*
> *Give to each a water-basin,*
> *Give to each a linen-towel,*
> *Speak to each some pleasant greeting.*

Doubtless things were not *always* as nice as this, or men would not have emigrated from Finland.

But sometimes America too fell short of the settlers' great expectations. Much depended upon luck; for each pattern of background and skills there seemed to be one most propitious moment; a decade later the good homesteads might be gone, or the man's trade might be crowded, or the country might be in an economic depression. And yet it seemed that there was always reason to work, always hope for the future — if not for the settler, then for his children.

"We old timers are sentimentalists and often withdrawn. We long mostly for one another's company, for the younger generations no longer understand us. Even though life has given us little, we enjoy most of all recalling our past troubles, tribulations, and struggles, content in the knowledge that we are still able to leave to our children and their descendants a greater heritage than we ourselves received. We do not expect to be thanked or honored. We only hope that coming generations will recognize this. Then they will also understand us." (OSCAR TOKOI, Editor, *Paivalehti* (Duluth) February 24, 1948)

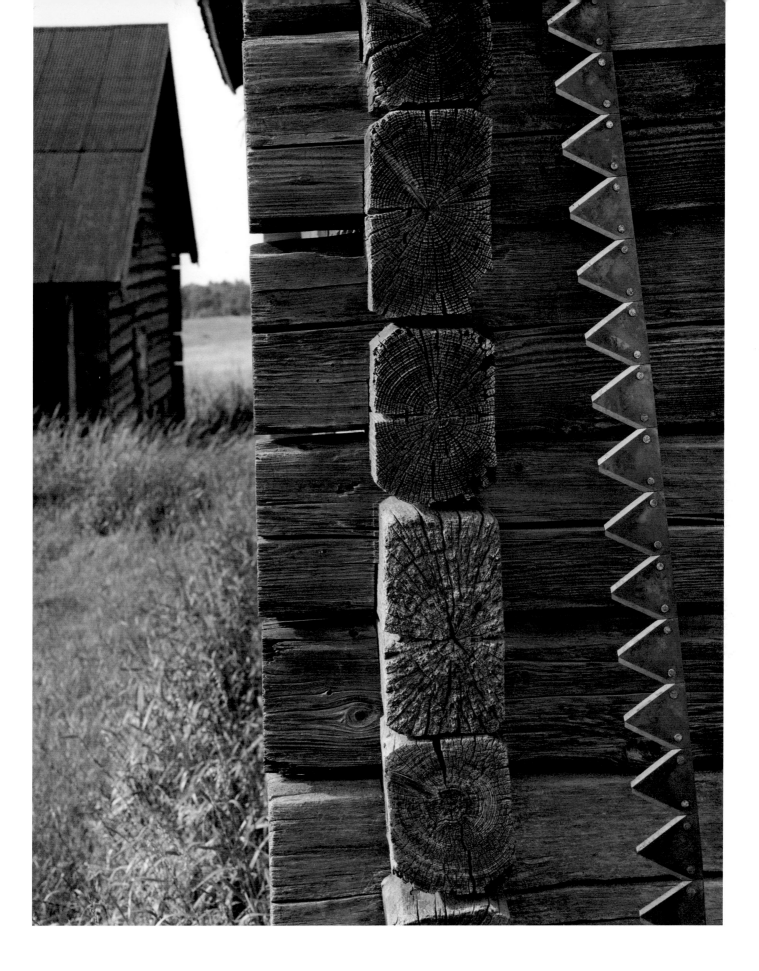

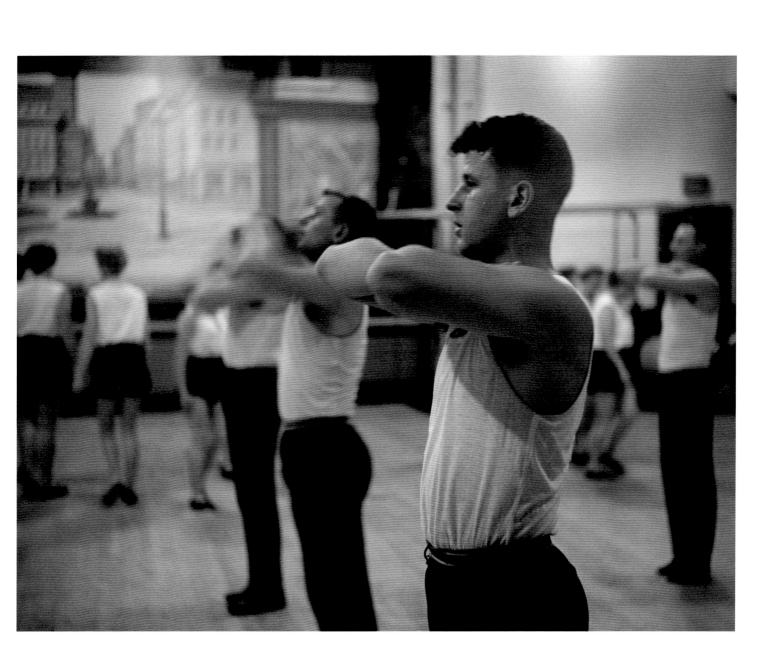

TIME DOES NOT CONSECRATE that in which she has been denied, and so to make good lutfisk for Christmas Eve you have to start on December twelfth. Probably earlier, since you must begin with four pounds of good dry lutfisk and a three-gallon crock, both of which may take some finding. On the morning of the twelfth, saw the fish into six-inch lengths and put them to soak. Change the water every day, and continue to soak the fish until the skin pulls off fairly easily (not *very* easily, or you will fall behind schedule). This should take five or six days, during which time you should proceed with your other work. Then remove the skin and bones. Next dissolve a heaping tablespoonful of lye (*yes, lye*) in a quart of hot water, put the water in the crock, and add cold water until the crock is half full. Add the fish, cover, and let stand for three days—maybe four days for the specially thick pieces. Then soak the fish in fresh water for three days, changing the water at least one a day. Barring miscalculations, this should bring you to Christmas Eve. Now place the fish in very salty boiling water, and boil for about fifteen minutes. Serve with melted butter, or a cream sauce made of butter, flour, milk, and lutfisk broth. (Note: if boiled too long, the fish will turn hard, in which case you can start over and aim for the Feast of the Epiphany.)

Along with the lutfisk should be served Swedish meatballs, potato sausage, herring salad, *småvarmt* (little hot casseroles), stuffed onions, omelets with creamed fillings, potatoes (creamed, scalloped, and boiled), and an infinite variety of cheeses, pickles, relishes, breads, coldcuts, and delicacies out of small cans. This of course does not include the main meat dishes, but only the smörgåsbord proper. There is no record of anyone's not thinking that these latter items are delicious, but those who have never tasted lutfisk might want to visit someone else's smörgåsbord before looking for the three-gallon crock. The recipe above makes sixteen large servings, which some people claim is better than a lifetime supply.

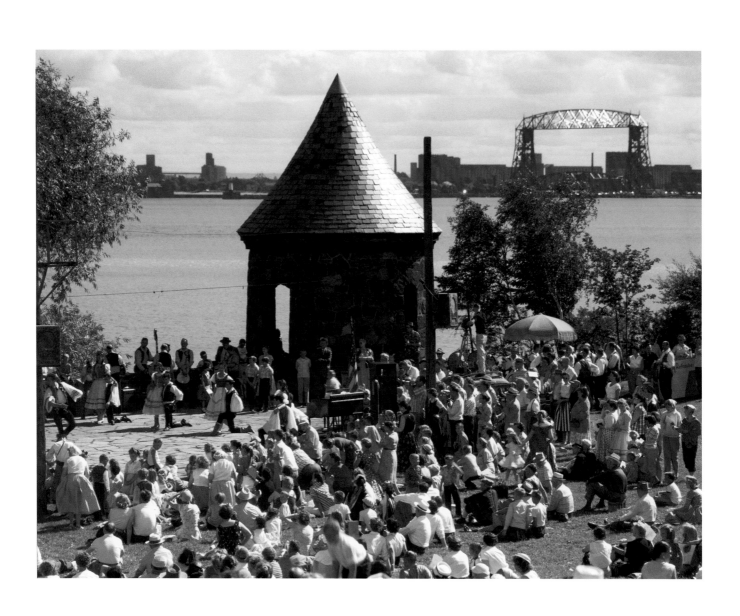

CARL SANDBURG SAID:

> *Five hundred ways to say, "Who are you?"*
> *Changed ways of asking, "Where do we go from here?"*
> *Or of saying, "Being born is only the beginning,"*
> *Or, "Would you just as soon sing as make that noise?"*
> *Or, "What you don't know won't hurt you."*

David Thompson, the explorer and map-maker, could speak some Ojibwa, and the Indians could speak a little English. Thompson asked the Indians the name of that bird that was always hanging around the camp looking for something to eat. The Indians told him that that was *weeskaijon* (which means he-who-comes-to-the-fire). And Thompson said, "Oh; Whiskey Jack." And so he gave the bird a little, and bird drank it and then walked off and had a long sleep.

This kind of misunderstanding kept going on for over a century. But not much anymore.

A young man said, "Certainly I'm an American. Of course, my father was an American too; but I don't have to work at it."

A sociologist said, "What the son takes pains to forget, the grandson seeks to remember."

The leader of the folk dancing festival said: "For three hundred and sixty-four days a year we celebrate our unity. Today we have come together to celebrate our differences." And everybody thought it was a very good idea. But there were few among them who could remember what the differences were.

I came to this country as a young man and settled just outside of Minneapolis. I had a dairy farm. By around 1905 the town was moving in on my farm, so I decided to move. Danes from this country and Denmark decided to form a settlement here at Askov, which was then called Partridge. That was just after the logging; the country was covered everywhere with burned stumps. It was very hard working up good farms here, but it was basically good dairy country, and the people understood dairying, and knew what was needed. We also had experience in the cooperative movement in Denmark, or at least had heard a lot about it, and it came naturally to us here, especially since we were all one group.

Years ago the cooperatives had a very hard time; they were not accepted by many. One year during a strike the farmers stopped the milk trains from Duluth and dumped the milk. Now we are protected by law and operate like other businesses, and the younger farmers sell to the co-op or to the private dairies as they choose; it isn't so much a matter of loyalty with them. But they are still glad that the co-op is there, as an alternative.

<div align="right">PETER NIELSEN, Askov pioneer</div>

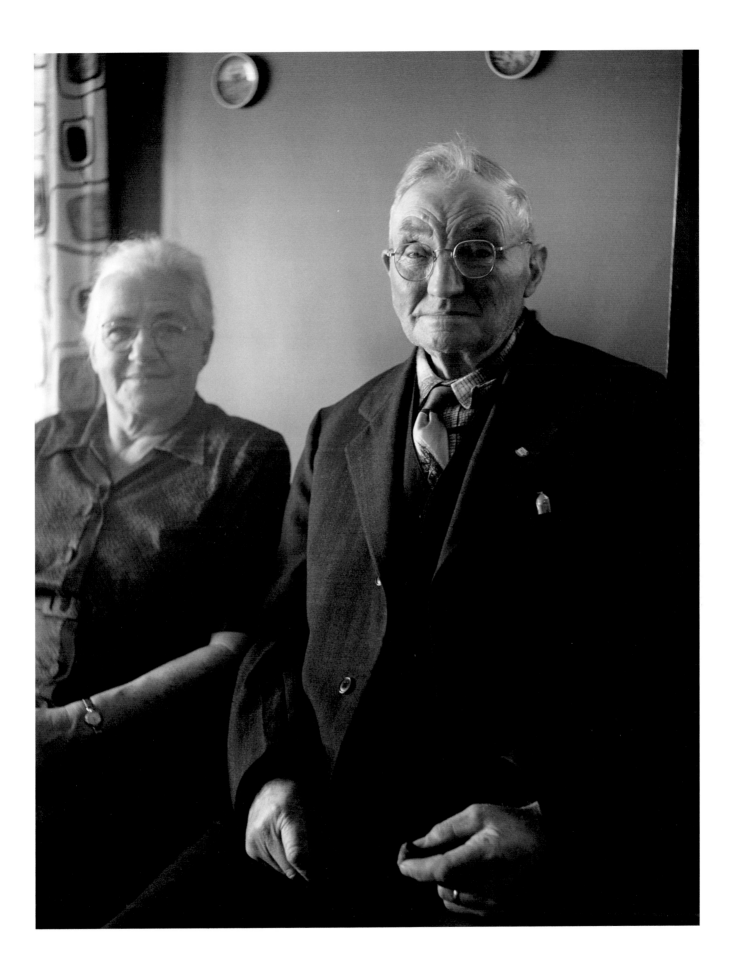

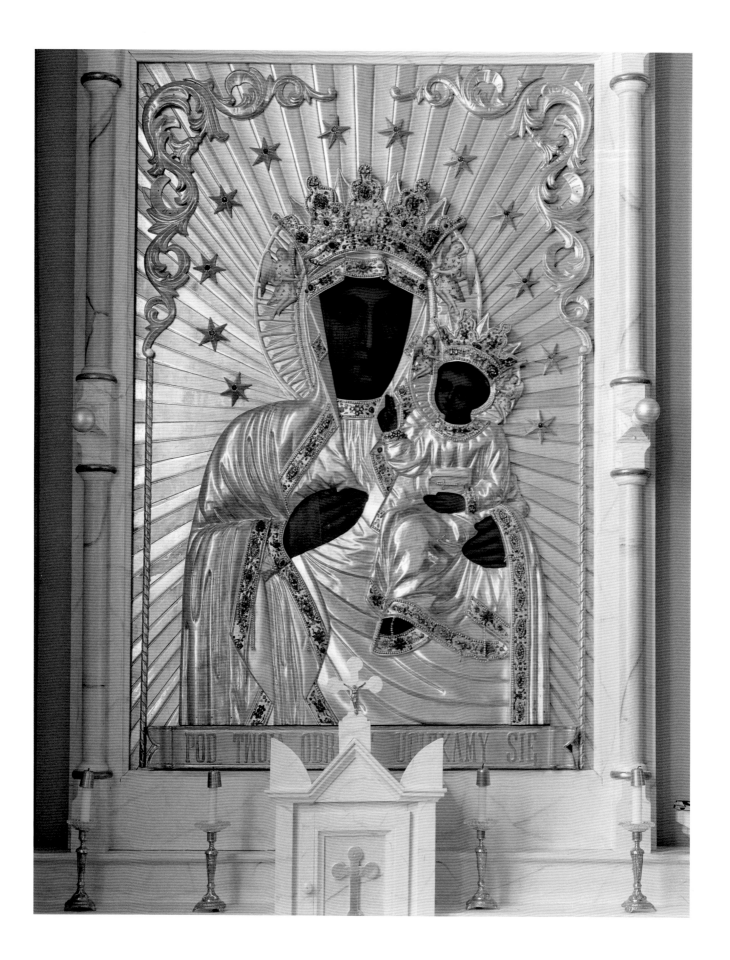

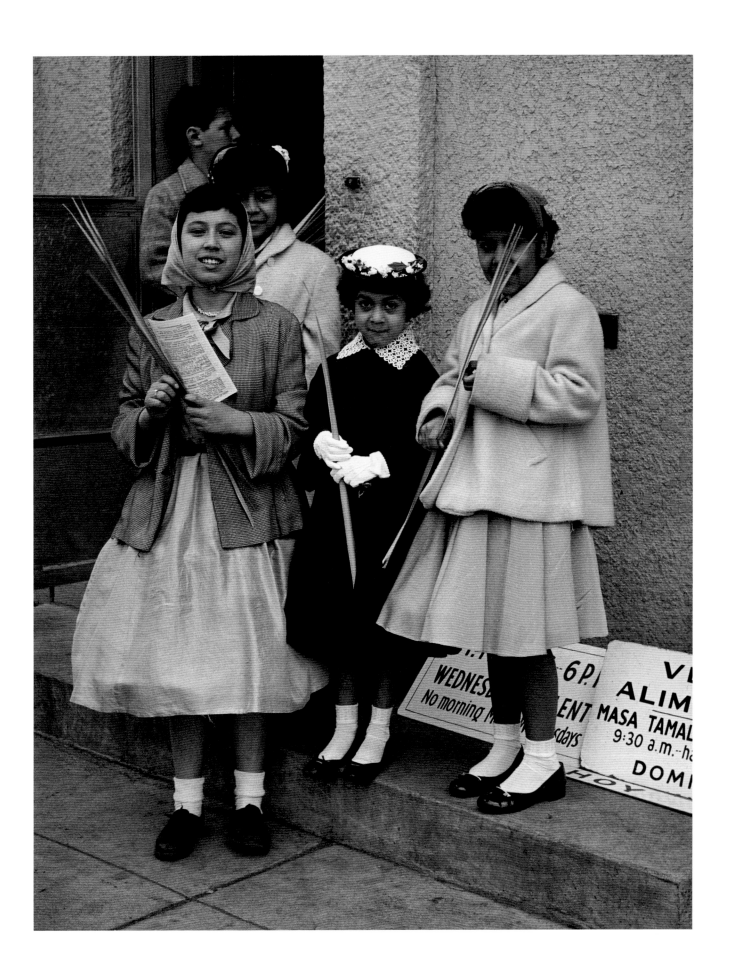

UKRAINIANS ARE MOSTLY ORTHODOX CATHOLICS, and their great feast of the Christmas season falls on January sixth. This is probably because the Julian calendar is now roughly thirteen days slow; but the issue is very complicated: Orthodox Christmas celebrates not only the birth of Christ but also his baptism, and also Epiphany—which the Western Christian churches *also* celebrate on January sixth. At any rate, Orthodox parents have been doubly afflicted by the emergence of Santa Claus as the season's leading character. Not only is he the wrong protagonist, but he comes twelve days early. In order to keep peace with their children, many Orthodox now make quite a celebration of the feast of St. Nicholas, at the approximate time of other people's Christmas. This system evidently works well, and might be worth considering for people of other churches, who could move Santa Claus Day forward twelve days to get it out of the way. People who would not consider it sacrilegious to take the Santa Claus out of Christmas might even be bold enough to consider changing his style a little. After the quiet dignity of the Ukrainians' St. Nicholas, all the bluff heartiness of the man in the red flannel suit seems a little forced.

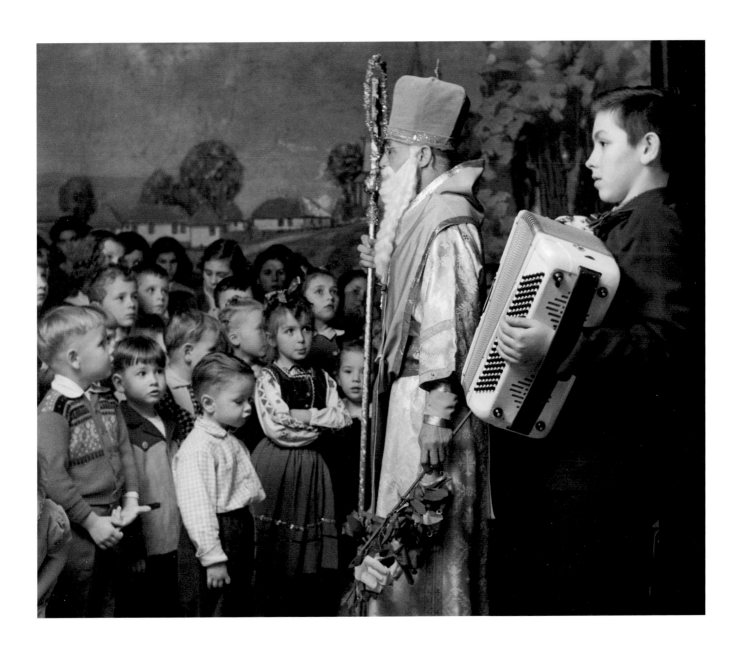

This is the ubiquitous prairie house, as much a part of the Midwestern landscape as the cornfields. Its balloon construction was a Yankee invention, but it was easy to build and it worked, so it quickly became a universal solution. This house certainly expresses no special kinship with the ground it was built on; it was the same on the open plains or in the wooded hills or on the town lot. It expresses no remembrance of European homes; nor does it express the needs of the life to be lived in it. It expresses simply the carpenter's technique. The easiest way of nailing two-by-fours together determined its shape; the standard mill lengths of timbers determined its dimensions; the standard products of the mill determined its detailing; what they turned on the mill lathes determined its ornament. This was the Model T among houses — truly prefabricated, although it was delivered in a great many pieces.

Most often it was built in installments. First came the single divided box, with gabled roof. The parlor was in front and the kitchen in back; an enclosed staircase led to two bedrooms. In hot weather the wood-burning cookstove made an oven of the whole house, so an open summer kitchen was added to the side, at right angles to the original structure. As the family grew and prospered, this wing was made two stories high; the summer kitchen became the permanent kitchen; now there was a front parlor for Sunday visitors, and a back parlor for the family, which doubled as a dining room on special occasions. Across the front of the new wing was built the porch.

The faults of this house were legion. But you could heat it — more or less — with a wood-burning stone, and in the summer the bedrooms were high enough to catch a little breeze, and it stood against the winds of the prairie storms. Besides, it was cheap, quick, and easy to build. By now it has been remodeled a half dozen times, and the mechanical contrivances it holds today cost several times as much as the house itself. But its basic virtues and faults are still those it was born with.

Speaking not of these buildings specifically, Frank Lloyd Wright said, "The true basis for any serious study of the art of architecture still lies in those indigenous, more humble building everywhere that are to architecture what folklore is to literature and folk song to music."

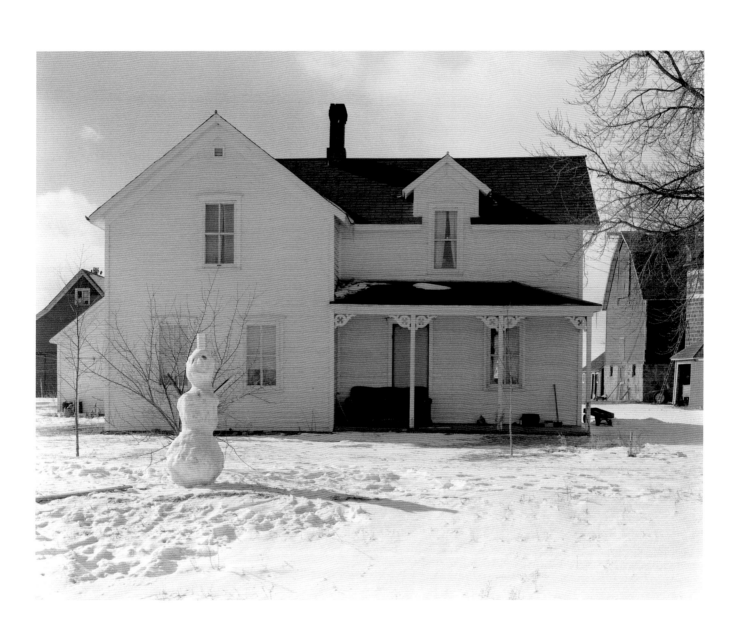

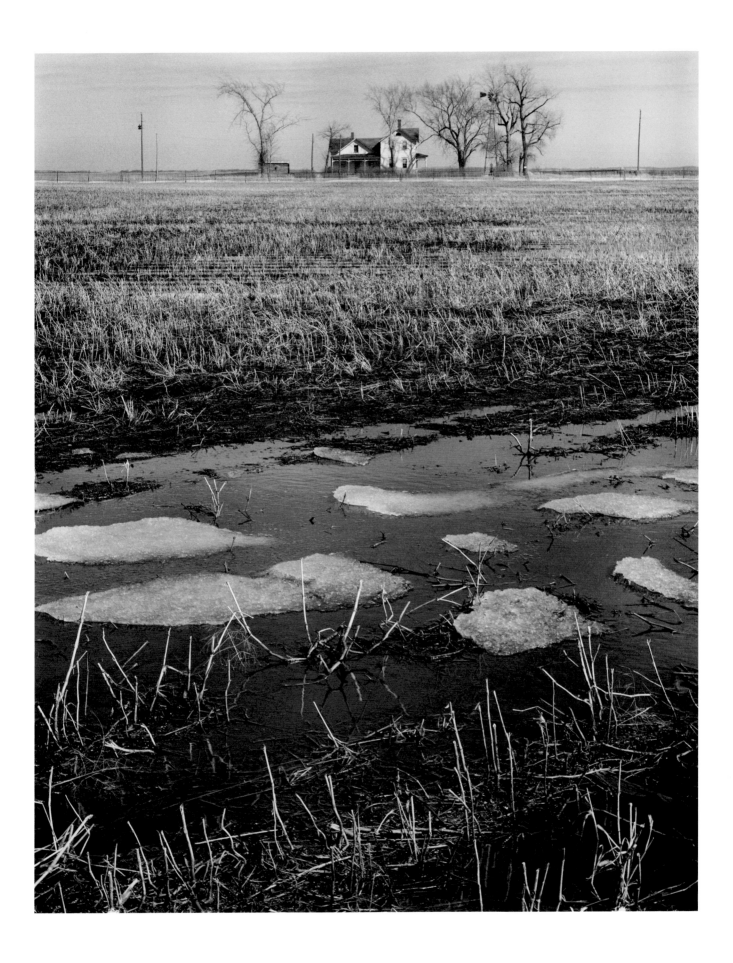

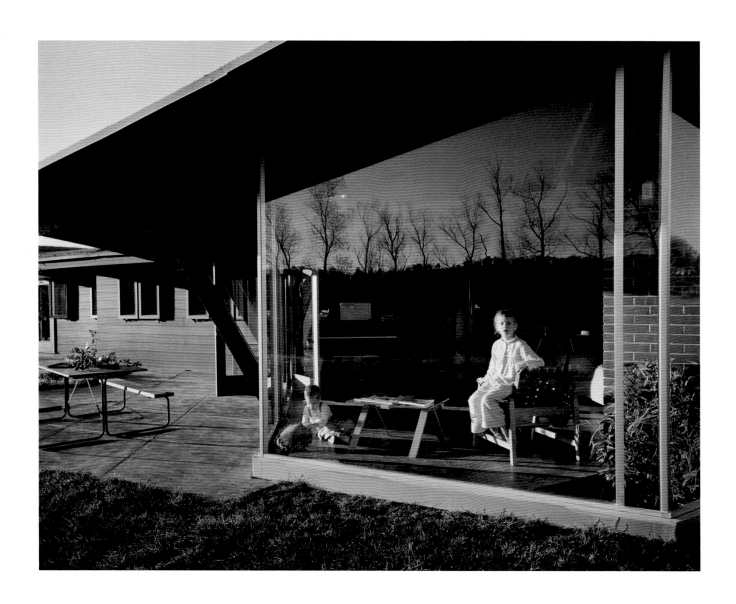

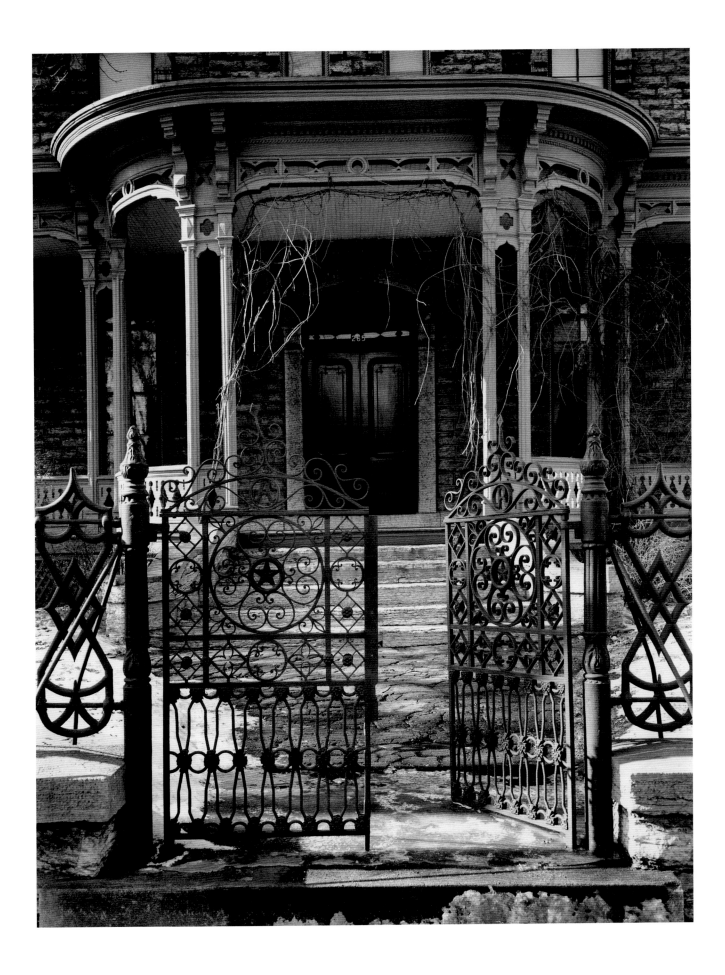

SHORT CONVERSATIONS *regarding the survival of ancestral cultures in Minnesota:*

Q: That is a beautiful afghan hanging on your line. Where did it come from?

A: Yes, isn't that a nice one? My grandmother gave me that; she brought it from Switzerland. At least I always thought she brought it from Switzerland, but maybe she made it here. Come to think of it, that may have come from her husband's family. They were Dutch. Well, mostly Dutch . . .

Q: What about that holiday that you people have where you hang a cat up in a sack, and then have the contest trying to get it out?

A: Oh, we stopped using a real cat years ago. The cat would pretty often get hurt, and people began saying that maybe it wasn't worth it; so somebody suggested using a teddy bear. Some of the old timers thought that this was pretty ridiculous, but we finally tried it, and it seemed to work just as well. But since the war we've abandoned the whole thing. Maybe the old timers were right; maybe it needed the real cat.

Q: No cacciatore either? If you're going to call this an Italian restaurant shouldn't you have something Italian besides spaghetti and pizza?

A: What did you have in mind, the Grand Canal?

Q: Those Hungarian dances were wonderful. Did you learn to do those dances as a child?

A: No, I learned them last winter at high school. Our square dancing club decided to branch out a little. Excuse me now, I've got to go change; in twenty minutes I dance with the Greeks.

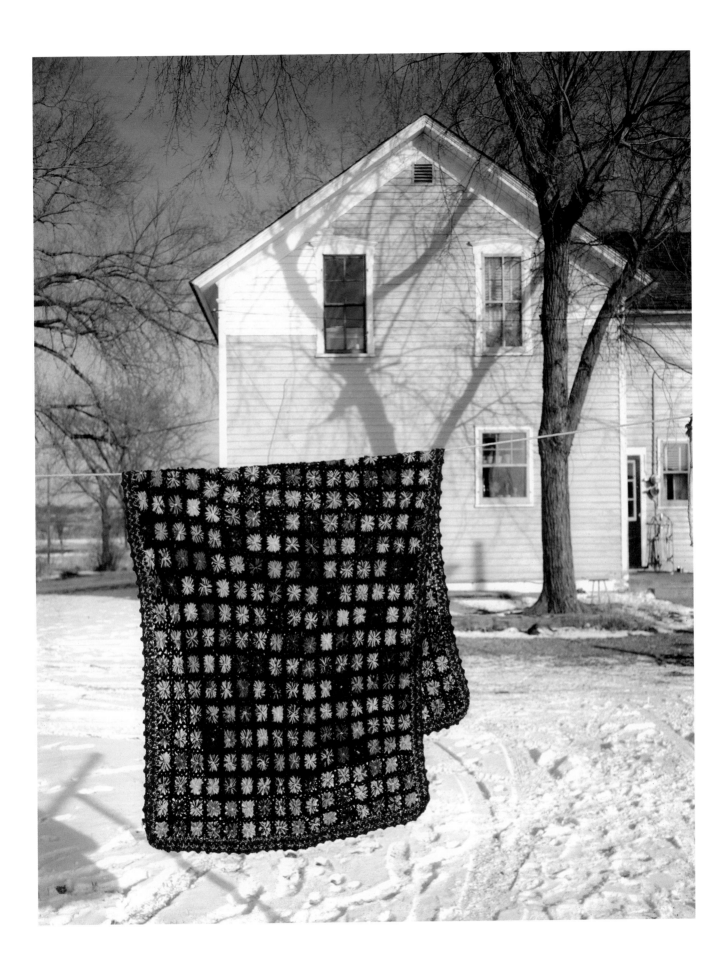

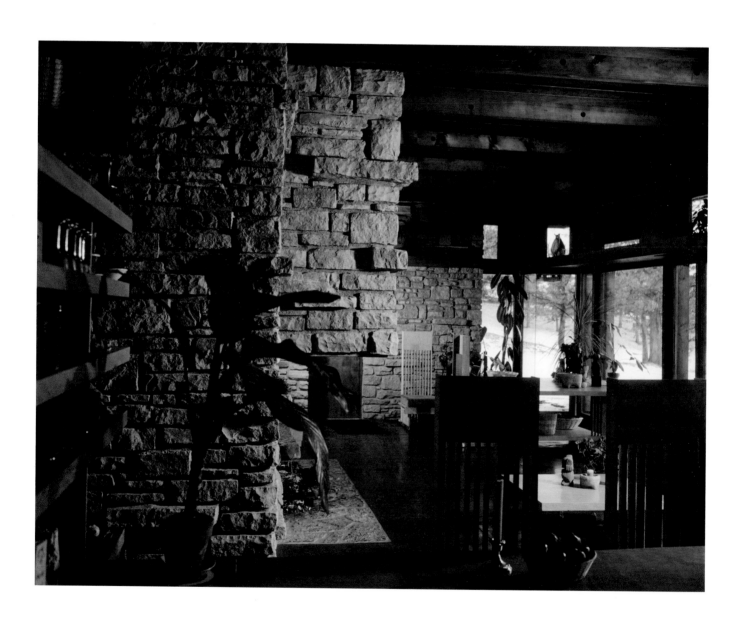

THE ARCHITECTS SAY that there is no longer any excuse for a regional building style. This is perhaps sad, but apparently true. Style in building comes mostly from the peculiarities of materials and methods, and today building methods and materials are the same throughout the United States. The efficiency of the American distribution system means that a Minnesotan can build about as cheaply with California redwood as he could with Minnesota white pine, if there was any. And if the builders of certain localities once had their special skills and loves, these have long since been homogenized in the architectural melting pot. About the most one can now say of the peculiarities of Minnesota houses is that they exhibit a mild traditional preference for wood construction, and that because of the climate they tend to be closed in plan.

It is true, however, that Minnesota has been a progressive state, architecturally speaking. This is not to say that it is rich with architectural masterworks, but simply that it has been relatively free in trying new solutions. One reason for this may be that at the time the modern experiments began, there was in the state no impressive body of traditional work to define what was proper. Another reason may lie in the tradition of agrarian functionalism, which means build it solid and don't worry what it looks like. In the environment of this spirit, the architect could sell almost any style as long as he didn't use the *word* style, and kept secret his concern for beauty.

There are occasional dissenters from the idea that architectural style should be fundamentally the same wherever methods and materials are the same. Some architects think, for example, that climate is not just a problem to be overcome, but an experience to be sought out and enjoyed. One architect said that a fine model for house building in Minnesota is the house of the Japanese tent caterpillar. This house is small and solid in the winter, but in summer the caterpillar comes out and spins around this core a great translucent gossamer tent.

Architects who think that the houses of human beings should be as interesting as the houses of caterpillars are generally referred to as romantics.

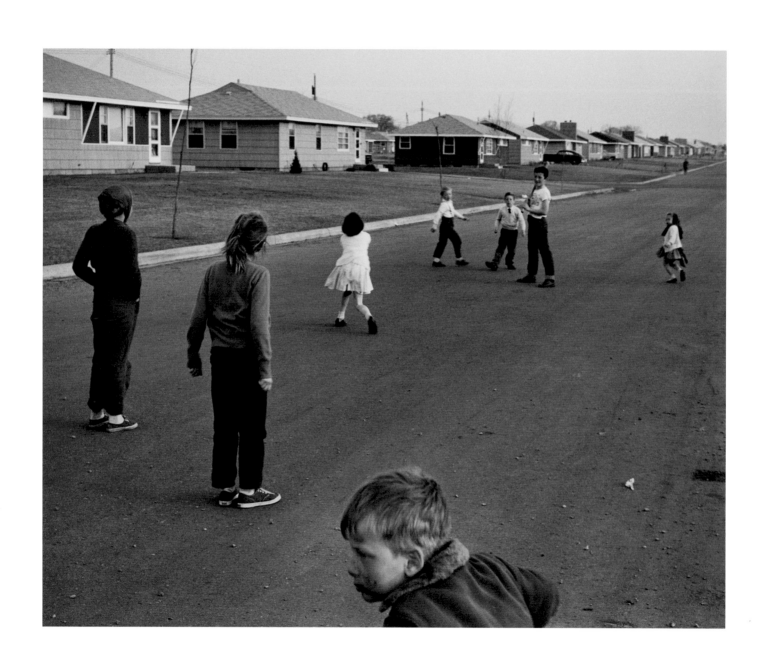

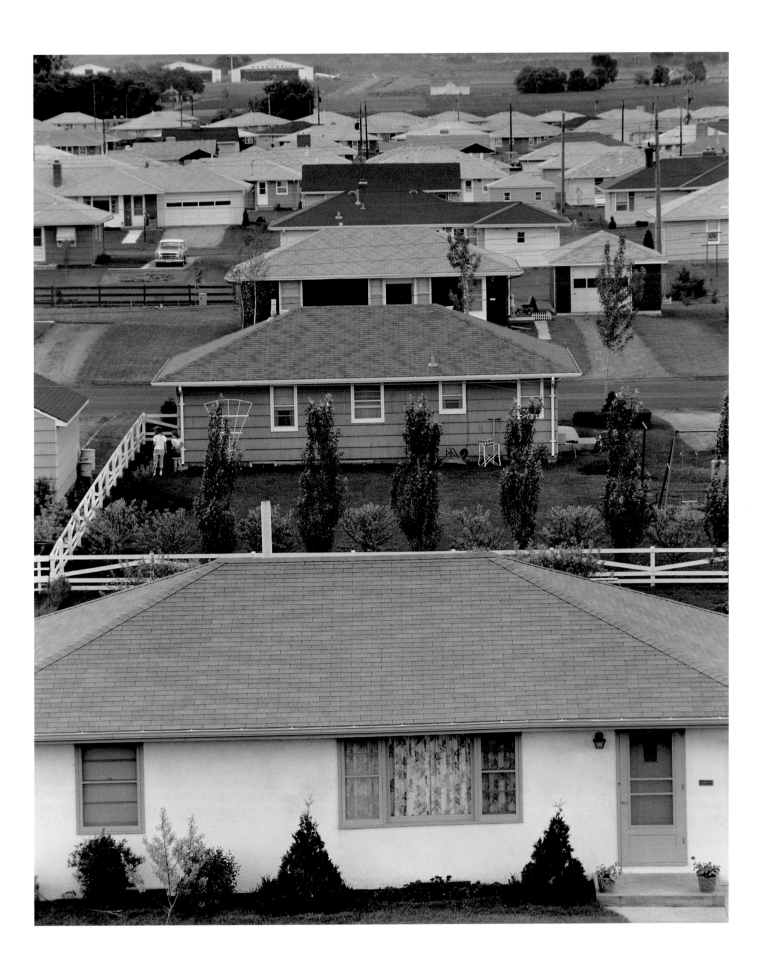

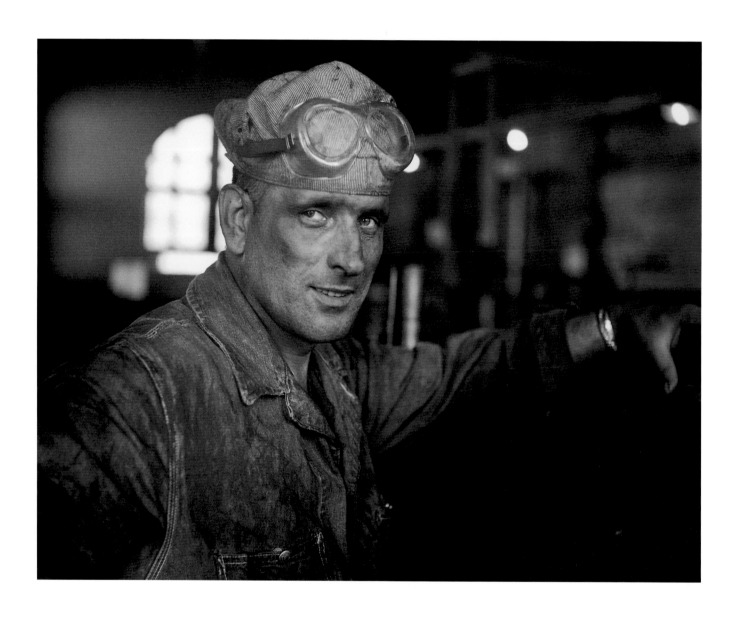

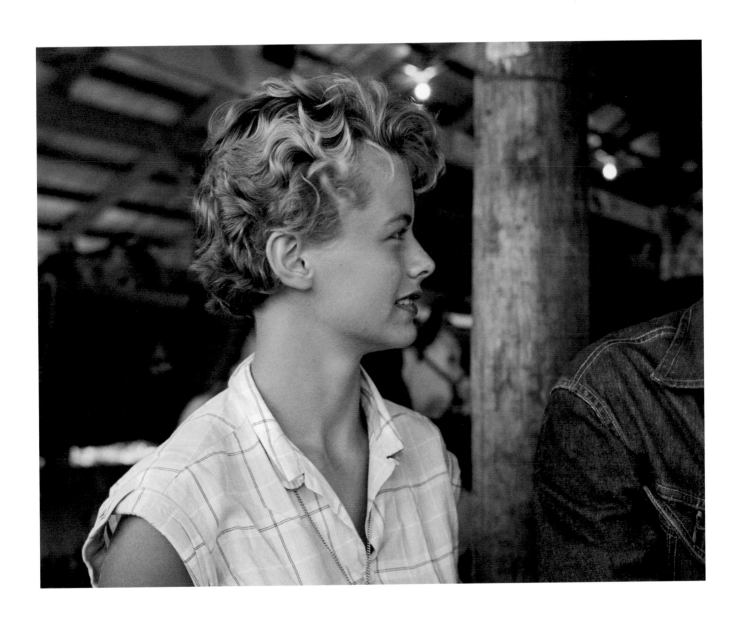

8 Goths and 22 Norwegians on exploration-journey from
Vinland over the West We had our camp by 2 skerries,
one days journey north from this stone we Were and fished
one day After we came home found 10 men red with
blood and dead Ave Maria Save us from Evil

KENSINGTON RUNESTONE

MINNESOTA'S FIRST CHURCH was a twenty-five-foot log cabin, built in 1841 by five volunteer workers named La Bissoniere, Gervais, Bottineau, Morin, and Geurin. It was called the Basilica of St. Paul, and its pastor said later that while it was smaller than the church of the same name in Rome, it served as well as a place to pray.

In 1866, a young Norwegian wrote home from Faribault: "In this small town there are seven churches belonging to seven different congregations. Indeed, religious sects and nationalities are blended here in the most variegated manner: deep and sincere religious feeling is found side by side with the most uncompromising kind of rationalism" (*Land of Their Choice,* THEODORE BLEGEN).

Among the Christian settlers, it seems that the Devil Himself was sometimes considered less of a threat than the rival sects. The various denominations competed for mission funds, for government favor, for effective voting blocs, and for the souls of the Indians. And within each sect there were national prejudices that loomed as large as theological differences. A St. Paul priest wrote in 1857 that there was still the hard business of making peace among the French-Canadians, the Irish, and the Germans. The Irish wanted an Irish priest, the Germans a German. The French, he said, found an Irish priest an especially heavy cross to bear. One magnificently adaptable priest of the early years was remembered in an Illinois parish as Father Matthew Kelly, and later, in St. Paul, as Father Mazzuchelli.

Within the various denominations there was division, and among them there was distrust and often prejudice. But considering the importance of the issues, the degree of distrust was perhaps less remarkable than the degree of tolerance and unity. In his first sermon to his St. Paul congregation, Dr. Edward D. Neill said: "If we . . . know nothing but Jesus Christ and Him crucified, we and the people should be blessed, but if we evince a disposition to say, 'I am of Calvin,' 'I am of Wesley,' 'I am a successor of Peter,' 'I am scripturally immersed,' there will be 'envying, strife and divisions'" (*With Various Voices,* THEODORE BLEGEN and PHILIP JORDAN).

And as the years passed, and there came times of Civil War, and grasshopper plagues, and other afflictions, many men came to hope that the other man's prayers, too, were being heard.

of Minnesota was widely publicized during the early years of settlement. There was said to be a special quality to the very air of the place, a higher concentration of ozone, or something, which made iron men from erstwhile weaklings, as long as they stayed out in the open air as much as possible. The claim about the climate's healthfulness was and is perfectly true; more important, it provided a fine, complicated excuse for men who wanted to spend all their free time out shooting prairie chicken or ducks or deer, or fishing for pike and trout, or skiing, or ice skating, or simply sky watching. And they have been doing these things ever since, in greater numbers each year. Here in Minnesota, the outdoors comes close to being a philosophy of life.

The outdoors has also become a very big business. Besides the Minnesotans, a few million other people come each year from less favored parts of the earth to refurbish their spirits in the cool blue Minnesota waters. Various research projects have aimed at determining just what this vacation industry means to the state. The researchers have asked the vacationers many questions, and tabulated many answers; they have found, for example, that in a single year out-of-state vacationers eat enough Minnesota eggs to make an omelet over half a mile wide. Another study found that the average visiting fisherman stays at a resort for 9½ days, spends $96.86, and catches walleyes (40 percent), northerns (41 percent), panfish (34 percent), or, on occasion, nothing (6 percent).

Such information is certainly as vital as it is interesting; nevertheless one wonders at the questions which apparently are never asked, such as:

1. Can you tell the difference now, at night, between the sound of a big bass jumping and the sound of a beaver diving?
2. What was the longest period during which you did not see a neon sign?
3. Did you see a loon, and hear it cry; and if so was it or was it not the saddest of all sounds that you have ever forgotten?
4. Why did you *really* come? What were you looking for?

Some would still say that they came to catch a mess of walleyed pike, and would really mean it; and for a very few (the ones who drop beer cans and candy bar wrappers on the portages) it really would be true. But most would know that this was not the real reason, and would try to explain, not without embarrassment. And perhaps one would write in at the bottom of the form: I did not hear a loon this year; but I went ashore to pick blueberries for my lunch, and walked over the soft, yielding grasses of a floating muskeg swamp, and for a moment I felt the heart of the earth beating beneath me.

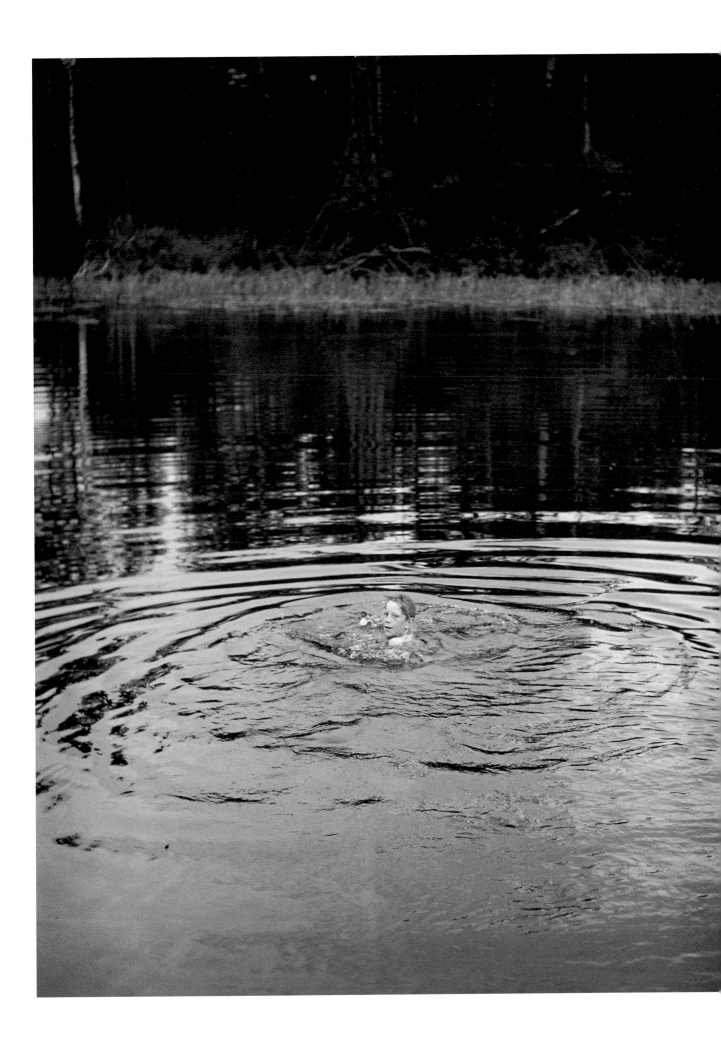

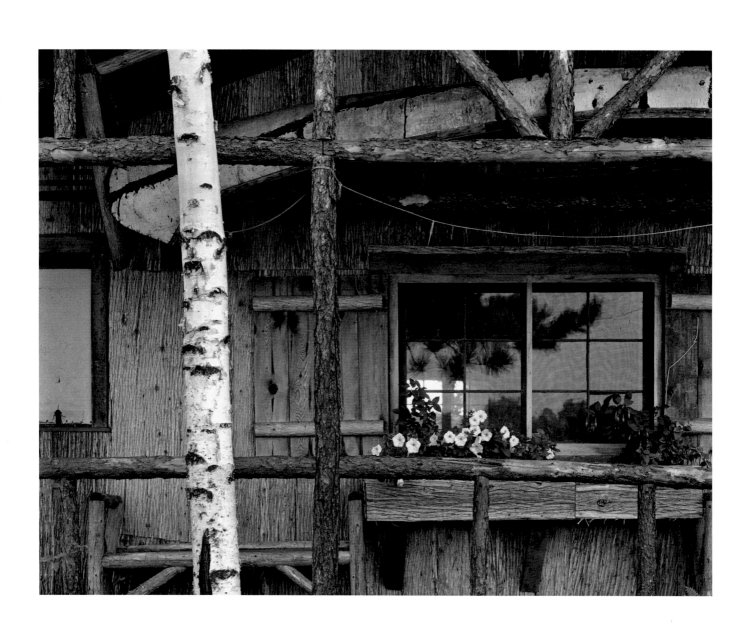

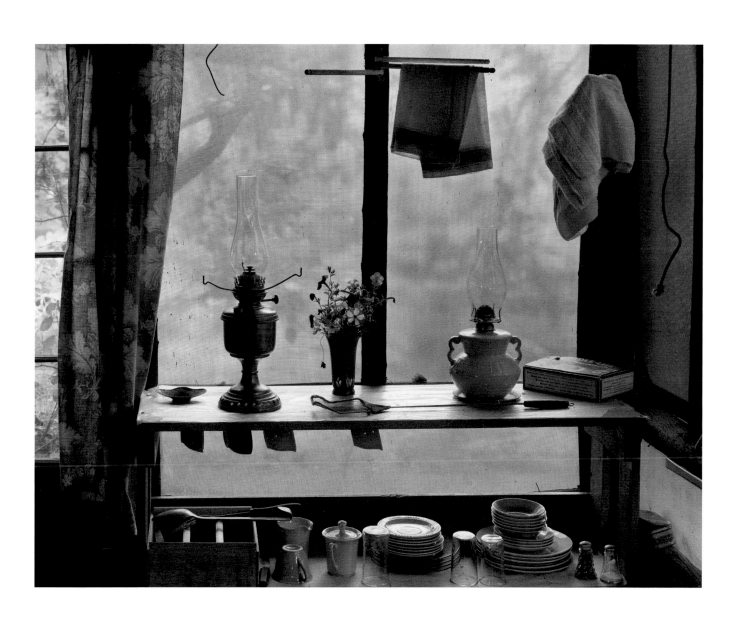

One day as I was walking
Close by the fountain fair
The beauty of the waters
Bade me to bathe me there . . .

These many years I have loved thee,
I can never forget thee, my fair.

<div align="right">FRENCH VOYAGEURS' CANOEING SONG</div>

I have got to have the sight of clean water and the sound of running water. I have got to get to places where the sky-shine of cities does not dim the stars, where you can smell land and foliage, grasses and marshes, forest duff and aromatic plants and hot underbrush turning cool. Most of all, I have to learn again what quiet is. I believe that our culture is more likely to perish from noise than from radioactive fallout . . .

And the population keeps on growing, the suburbs extend farther into the fields, a high-school boy has to be driven 140 miles to find some *fontinalis,* and the ordinary citizen must go always farther to find clean water and a natural silence. If we do not soon acquire a little business sense and some social intelligence, the nation will collapse from spiritual hemorrhage.

<div align="right">BERNARD DEVOTO</div>
<div align="right">"The Easy Chair—Hell's Half Acre, Mass.," Harper's, September 1955</div>

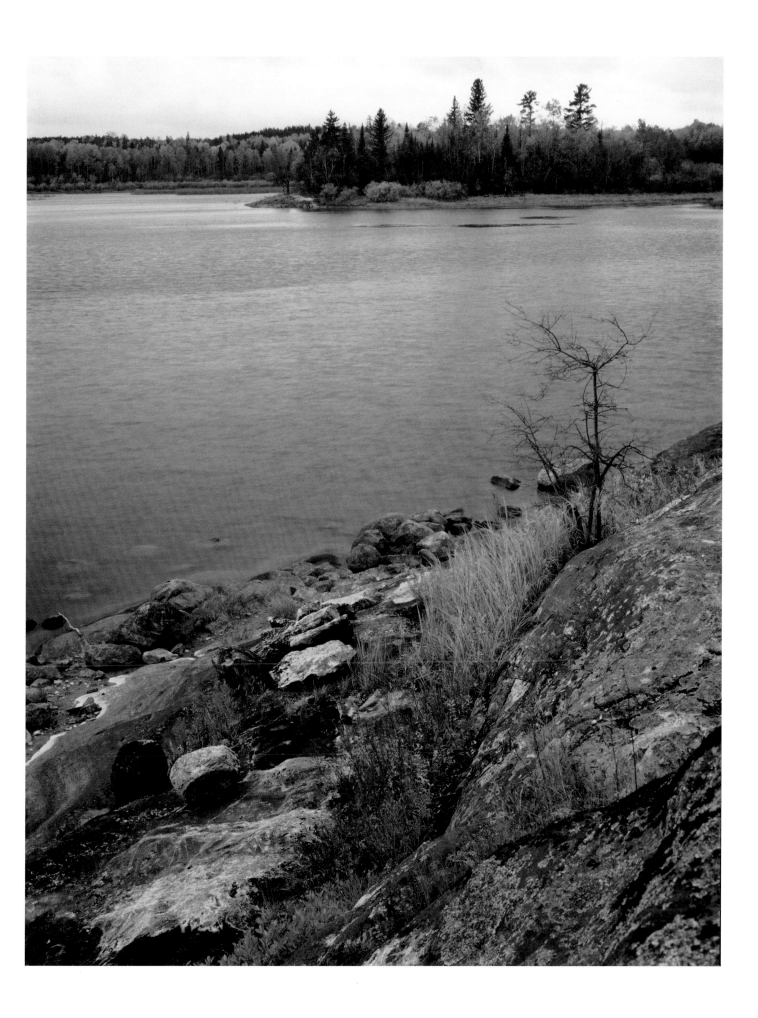

ON THE WALL of almost every northwoods tavern, on almost any rack of northwoods postcards, will be found the following message:

> Behold the fisherman:
> *He riseth early in the morning,*
> *Disturbing the whole household.*
> *Mighty are his preparations.*
> *He returneth when the day is spent,*
> *Smelling of strong drink.*
> *And the truth is not in him.*

Thus in his own country is the fisherman maligned. But in truth, the fisherman's lies are merely hedges against his neighbor's incredulity. He adds only as much to the size of his fish as he knows his listener will subtract. According to the unwritten rules of this convention, a two-pound walleye is universally described as "a little under three pounds."

Reports of the fisherman's drinking are likewise grossly exaggerated. It is in fact claimed by some that the term *Walleyed Piker* originated simply as the malapropism of an immigrant lumberjack, who intended it to carry no stigma.

But the fisherman has broad shoulders; he bears the laughter of his family and the jokes of the world with good grace. And though the line on his non-backlash reel may tangle like a bird's nest on every cast, though his shiny new motor may cough and die, though his hands may blister and his neck burn and his blood be diminished by the mosquito, he is happy. He is happy because he is fishing; and on the next cast . . . who knows?

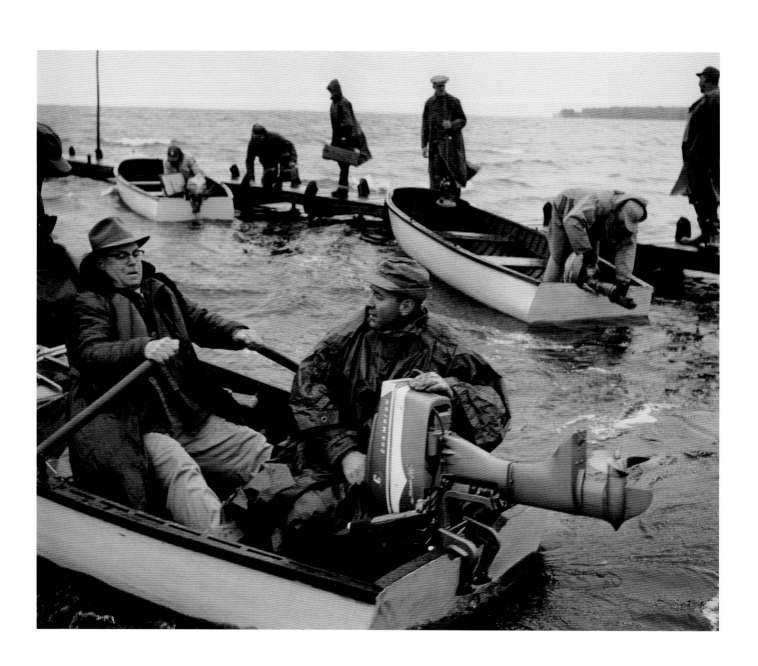

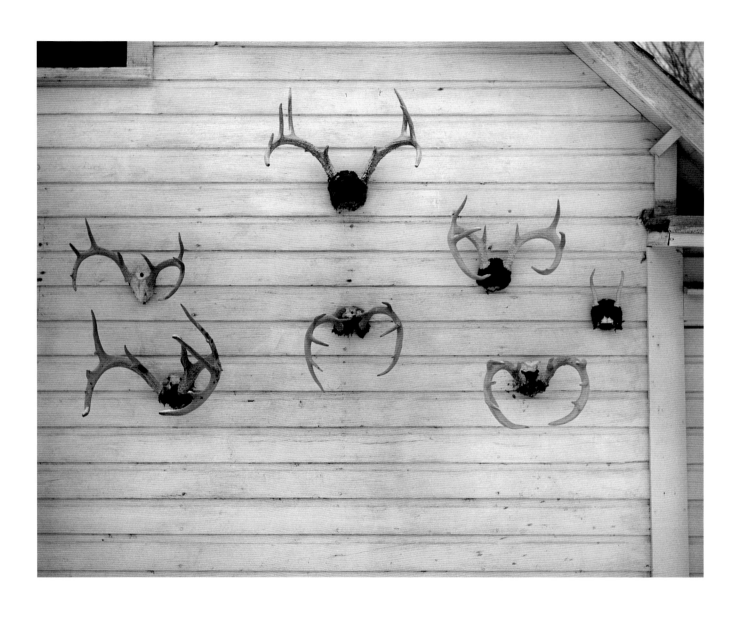

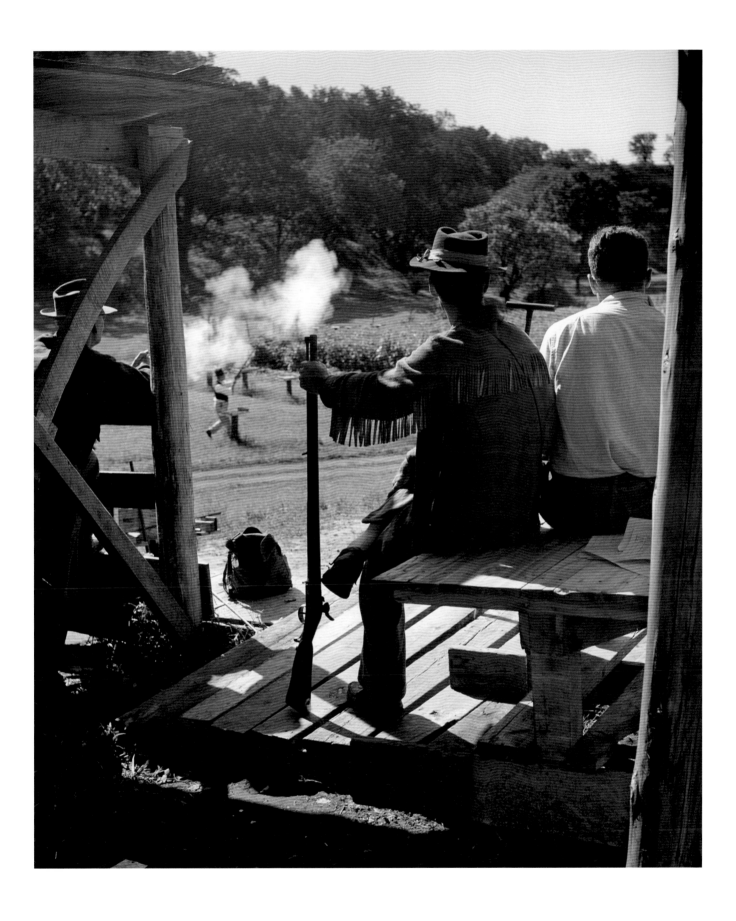

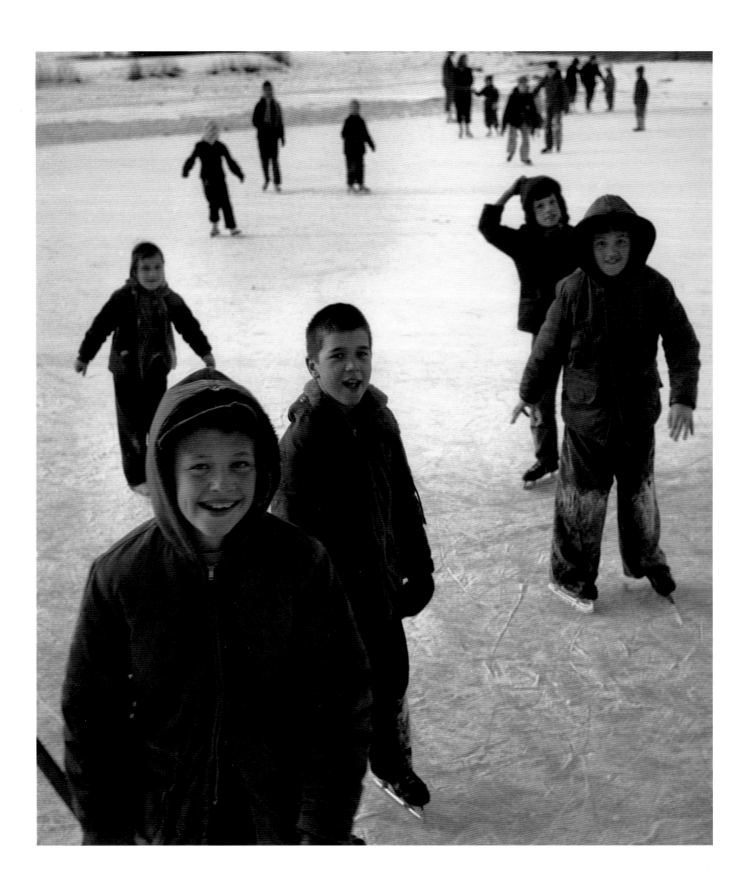

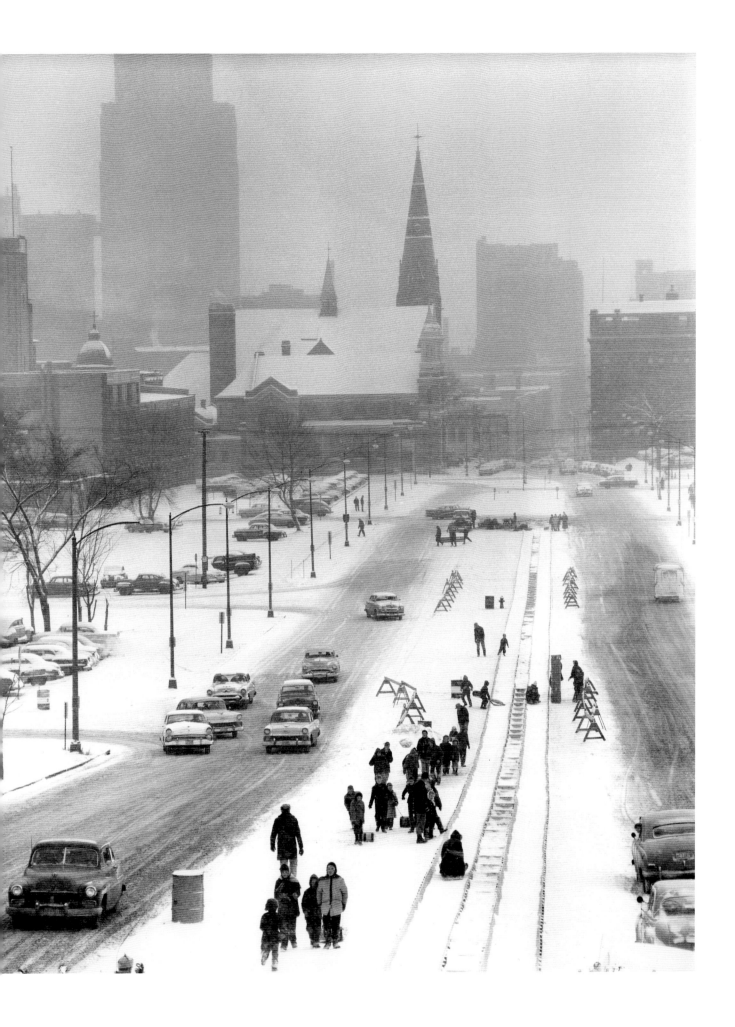

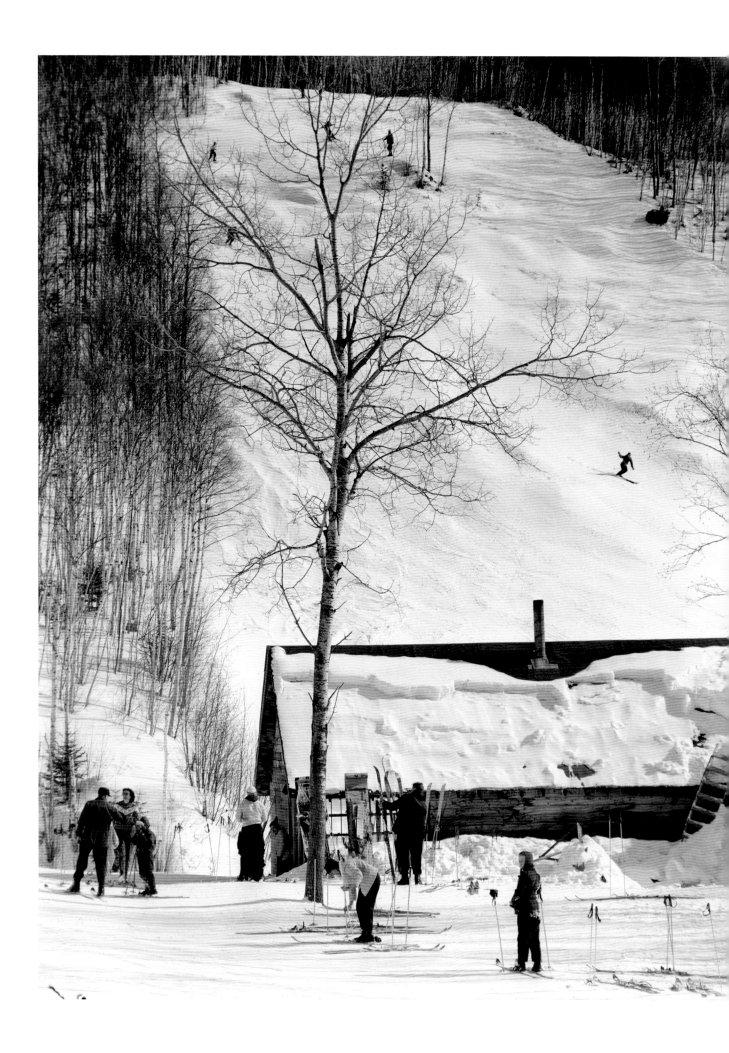

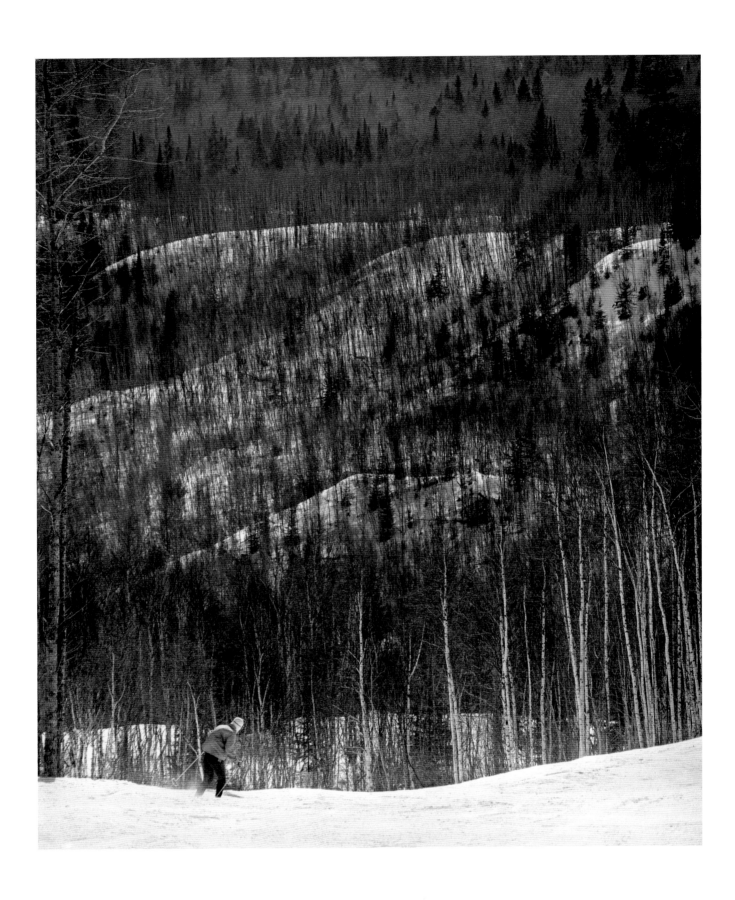

The Beginnings of a Group

WHEN THE STATE OF WISCONSIN was admitted to the Union in 1848, the triangle of land between the Mississippi and the St. Croix Rivers that had been a part of the Wisconsin Territory was left without any organized government. This was the area in which most of the people in the Minnesota country lived, and although the organized government they had previously enjoyed was more theoretical than real, they saw in their new predicament an excellent argument for the creation of a Minnesota (or Minasota or Itaska) Territory.

With characteristic frontier casualness, a handful of public-spirited citizens called a convention and chose Henry Hastings Sibley as their emissary to Congress, empowered to act on behalf of the proposed Minnesota Territory. At about this point one of the sophisticated thinkers in the group conceived the doctrine that the residue of the old Wisconsin Territory was now *the* Wisconsin Territory, and that its residents could elect a real territorial delegate instead of a mere minister-without-portfolio. People liked the idea, and elected Sibley.

Sibley was an excellent choice. He was intelligent, well educated, urbane in manner, and was thought to be able to whip anybody in the region with the possible exception of Bully Jim Wells. He had grave doubts that the Congressional Committee on Elections would honor his homemade credentials, but he went to Washington, argued his case well, and was seated. Actually, even if the territorial residue doctrine was correct, Sibley was not eligible for the office, since he lived in Mendota, on the west bank of the Mississippi, which had never been in the Wisconsin Territory. But he made a good impression on the members of Congress, and nobody brought up this technicality. Once seated, he worked toward the establishment of a Minnesota Territory, and early in 1849 this was achieved — after Senator Stephen A. Douglas stated his "impression" that there were between eight and ten thousand people in the area.

The new territory grew rapidly; by 1857 there were well over a hundred thousand people within its boundaries. Congress agreed that that was enough for a state, and

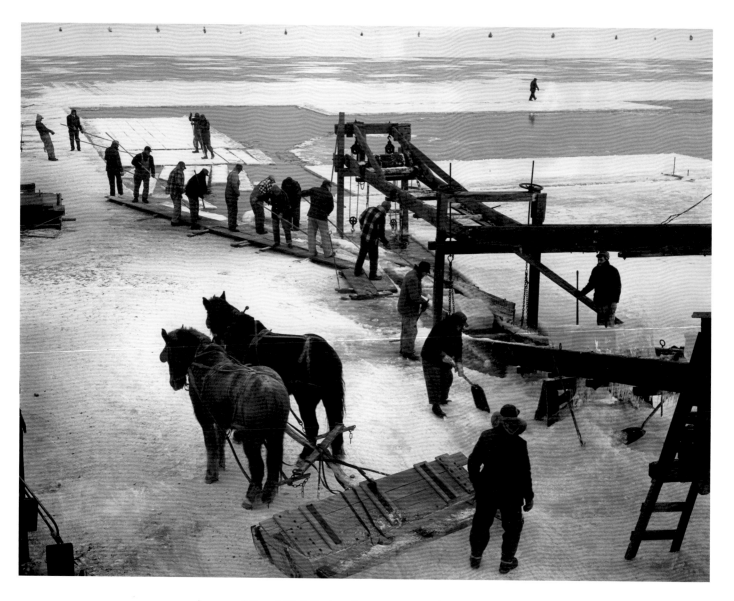

passed an enabling bill defining the new state's boundaries and permitting the people of the territory to draw up a constitution and elect officials. After a summer of comic-opera proceedings the constitutional convention produced a constitution; in the fall the people ratified it and elected a legislature and a governor, Henry Hastings Sibley.

The newly elected legislature met and began to pass laws, expecting that Congress would pass the Bill of Admission promptly. But Congress didn't. Since the early days of the Union, it had become accepted practice to admit slave states and free states alternately, in order to maintain the balance of power between the North and the South. The admission of California in 1850 had put the free states one up, and Southern congressmen were determined that the North should not gain further advantage. Congressman Anderson of Missouri said, "The whole of the Territories of this Union are rapidly filling up with foreigners. The great body of them are opposed to slavery.

Mark my word: if you [admit Minnesota] another slave State will never be formed out of the Territories of this Union. They are the enemies of the South and her institutions." But the new state was finally admitted in May 1858. Congressman Anderson's prediction was borne out. Two years later Abraham Lincoln was elected president with the votes from the new states of the Northwest.

As late as 1860 less than a tenth of the people lived in towns with populations of twenty-five hundred or more. But the towns, situated along the waterways that were still the key to their prosperity, had been growing. The Mississippi was the lifeline of the area. In the forties, the squatter village across from Fort Snelling, finding itself at the head of Mississippi navigation, rose to its destiny, changed its name from Pig's Eye to St. Paul, and waxed prosperous. The original settlement, a handful of houses clustered around the grog shop of Pierre (Pig's Eye) Parrant, was pushed unceremoniously down river to an island of uncertain political jurisdiction. Commenting on St. Paul's beginnings, Mark Twain said, "How solemn and beautiful is the thought that the earliest pioneer of civilization, the van leader, is never the steamboat, never the railroad, never the newspaper, never the Sabbath School, but always whisky! The missionary comes after the whisky—I mean he arrives after the whisky has arrived; next the trader, next the miscellaneous rush; next the gambler, the desperado, the highwayman, and all their kindred of sin of both sexes, and next the smart chap who has bought up an old grant that covers all the land, this brings up the lawyer tribe, the vigilante committees, and this brings the undertaker. All these interests bring the newspaper; the newspaper starts up politics and a railroad; all hands turn to and build a church and a jail and behold! Civilization is established forever in the land. Westward the jug of Empire takes its way!"

Eastward on the St. Croix was Stillwater, with a river to float pine down; downstream on the Mississippi was Winona, aiming to become both a riverboat and railroad center, above St. Paul was St. Anthony (later Minneapolis) which had the falls and their power potential. Up the Minnesota were the villages of the agricultural settlements, including St. Peter, which aimed to replace St. Paul as the capital city (and would have succeeded—but the Pembina fur trader and legislator Joe Rolette stole the bill before the governor had signed it, and hid himself and it until the session was over). Above St. Anthony smaller steamers were put into the river; they traveled to St. Cloud and above. Other steamers were dismantled and carried bolt by bolt all the way across the state to the Red River, from whence they served Pembina and the British settlement to the north.

As the spaces between settlements grew smaller, the settler's attitude began to change. Meridel Le Sueur said that he was as independent as a pig on ice; and he was, at first, but soon he saw that even on the frontier one couldn't be *wholly* one's own man; natural disasters, railroad monopolies, Indian wars, and claim jumpers convinced those who had thought they could be. One man couldn't protect his land claim, for example. Settlers often moved onto the land years before it was offered for

sale. To keep some outsider from outbidding the actual settler, when the auction was finally held, claim associations were formed. Each member had a legitimate claim and a club, and standing together at the auction they made an impressive picture.

In his analysis of the development of frontier culture, Mark Twain forgot to mention education. Generally, schools were built after the churches and before the jails. The first territorial legislature turned early to education; although they realized that practice would lag far behind theory, they designed a free common school system and a tax mechanism to support it. But it was some time before most communities could find the money, teachers, and public support which public education demanded. For parents who could afford it, private schools provided a solution. Besides offering a sound basic education, these schools, usually maintained by a particular religious group, helped to protect cherished traditions from the full brunt of frontier pragmatism.

The University was chartered in 1851, but did not begin offering college work until eighteen years later. In its early years it was confronted with repeated financial crises. But the persistent efforts of President Folwell and the financial influence of John S. Pillsbury gradually put the institution on a sound footing and prepared the way for its great growth of later years.

After the Civil War, the dream of universal prosperity for the industrious and brave began to lose some of its luster; even in years of bumper crops it was hard for the farmers to meet their obligations, for then as now good crops meant low prices. At first the farmer blamed most of his troubles on the railroads. Doubtless many other factors were involved; but the railroads were not an abstract economic principle, they were actual and present, and they were run by real men, who were rich. The railroads did hold despotic power over the farmer; at worst, they manipulated his interests with the same freedom that they manipulated their own stocks — but with less care. Gradually, in spite of his instinct for independence, the farmer began to organize. A Minnesotan named Oliver Kelley founded the National Grange in 1867, and in two years there were forty-nine chapters in the state. The Grange itself had little political potency, but it began the habit of organization out of which grew a long succession of radical agrarian political movements: the Anti-Monopoly party, the Greenback party, the Populist party, the Nonpartisan League, the Farmer-Labor party. The program of the earlier parties was broadened to oppose monopolies in general, and hard-money policies, and to demand government supervision of the entire marketing system. The most durable and perhaps the most talented of the movement's Minnesota leaders was Ignatius Donnelly, who allegedly spoke almost as well as his political kin William Jennings Bryan — and who lost almost as many elections.

Considering their influence, the nineteenth-century farmer parties were spectacularly unsuccessful at the polls; the reforms and often the philosophies that they expounded were adopted by their rivals as fast as such idea showed signs of being politically powerful. From 1860 to 1904 the Republican party won twenty-one out of

twenty-two gubernatorial elections. But the margin of victory was often small, and as a force which compelled the major parties to liberalize their thinking the farmer radicals had a profound and lasting influence on Minnesota's politics. In 1922 the Farmer-Labor party, heir to the Donnelly tradition, elected Henrik Shipstead to the United States Senate. After a half century of trying, the state's perpetual third party had become a dominant political force.

Ignatius Donnelly had known the territory when it was a land of free-lancing adventurers; he had watched the spaces fill and seen the forces of nature leashed, and had seen community life develop. For almost half a century he had fought the excesses of frontier individualism, had fought for a stronger voice for the social will. But in his own way, he was as much an individualist as Joe Rolette or Jim Hill. Donnelly lived to see the first day of the new century, and then died.

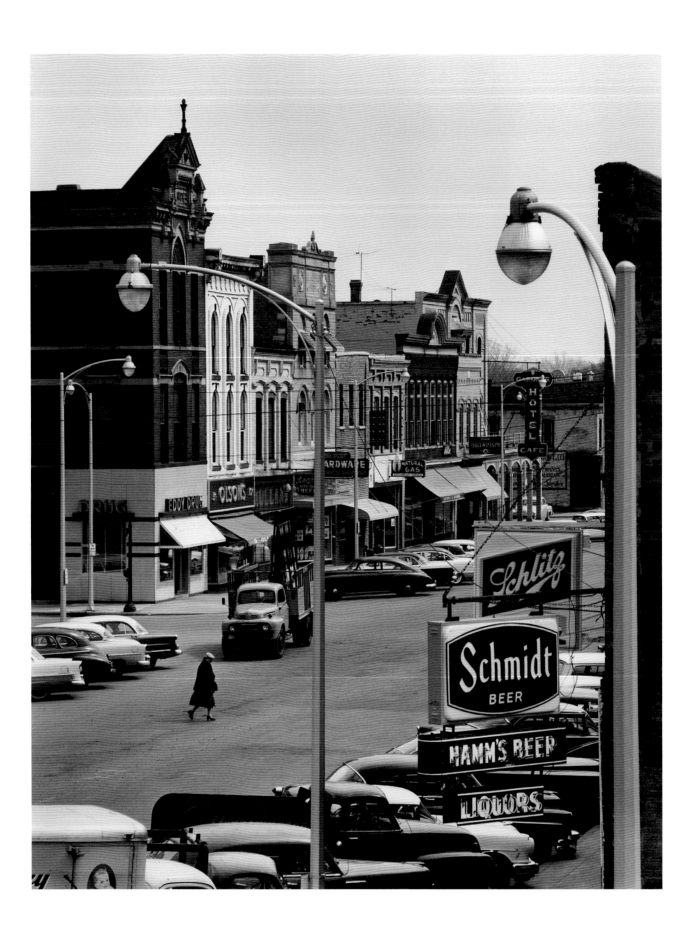

The towns and cities

of Minnesota are no longer so easy to generalize about as they used to be. A few years ago one could say that the towns were service stations for the farms, and the cities were service stations for the towns. One had to make exceptions of the mining towns, and Duluth, and a few other places, but the statement was as true as most such statements; it was at least a useful half-truth.

Certainly the great majority of Minnesota towns are still predominantly trading centers for the surrounding farm areas. And because this is rich farm country, a Minnesotan is twice as likely as other Americans to live in a small town. But as farming changes, the small town changes. Just as the smaller farms are absorbed by larger, more highly mechanized farms, so do the small towns lose population to the more highly mechanized city. As the number of farmers decreases, the villages diminish rapidly, the small town does little better than hold its own; only the metropolitan areas and the smaller cities gain consistently and impressively. One third of Minnesota's people now live within thirty miles of the bridge that connects Minneapolis and St. Paul.

But the towns have refused to die quietly. They recognize that in many cases their importance as trading centers will continue to lessen. They are aware also that to start a new life in middle age takes imagination and judgment and a great deal of effort; but the towns claim that they have these qualities. Most of them think that their future lies in manufacturing. For a significant number this future has already arrived; many others are now planning with confidence and conviction:

"Not long ago I was in Granite Falls. I told them what I thought was their opportunity to lift themselves by their own bootstraps. I said, 'Of course, I don't expect you to do it, but these are the things you must do if you expect to get an enterprise of some size, of industrial nature, established in your midst.' The result was that they made a canvass of their 857 homes in Granite Falls; 855 of them subscribed a minimum of fifty dollars apiece for the purpose of encouraging industrial location. . . ." (JAMES W. CLARK, Commissioner, Department of Business Development)

A hundred other towns are doing the same thing. They spend the money to secure good industrial sites; they protect these sites by zoning, and service them with highways, railway trackage, fuel supplies, and utilities. Then they go to a suitable industry and say, "Look what we've got." And more and more industrial leaders, wondering whether the size and complexity of metropolitan areas may have reached the point of diminishing returns, are looking very carefully indeed.

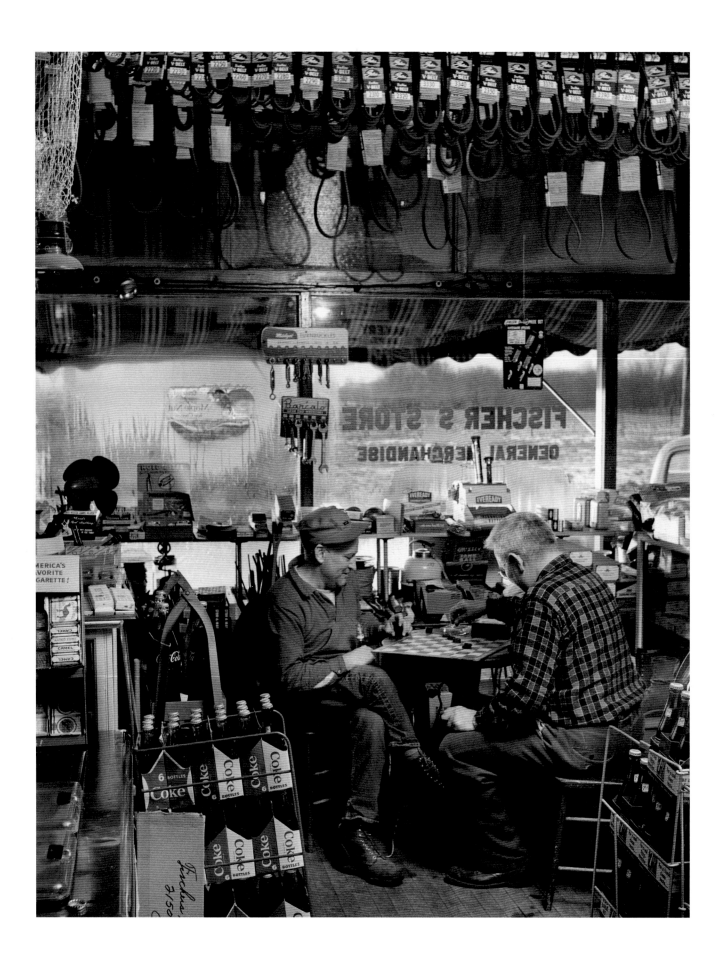

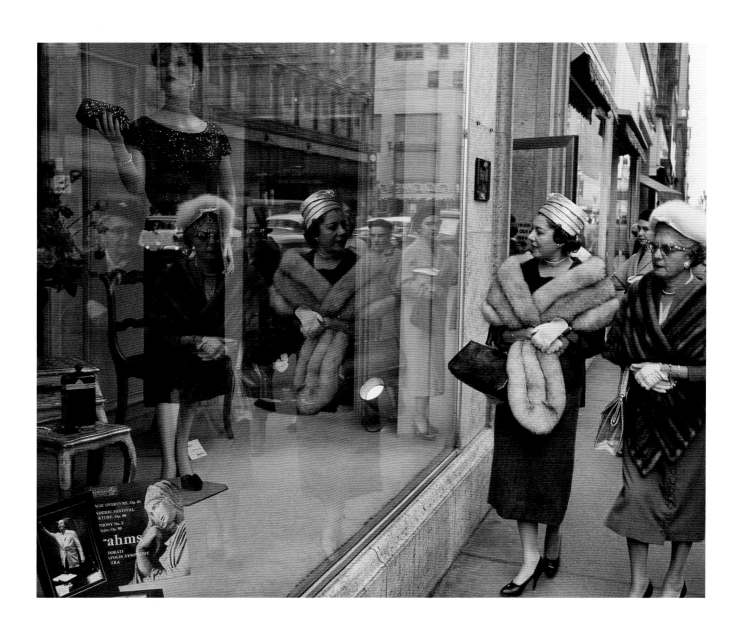

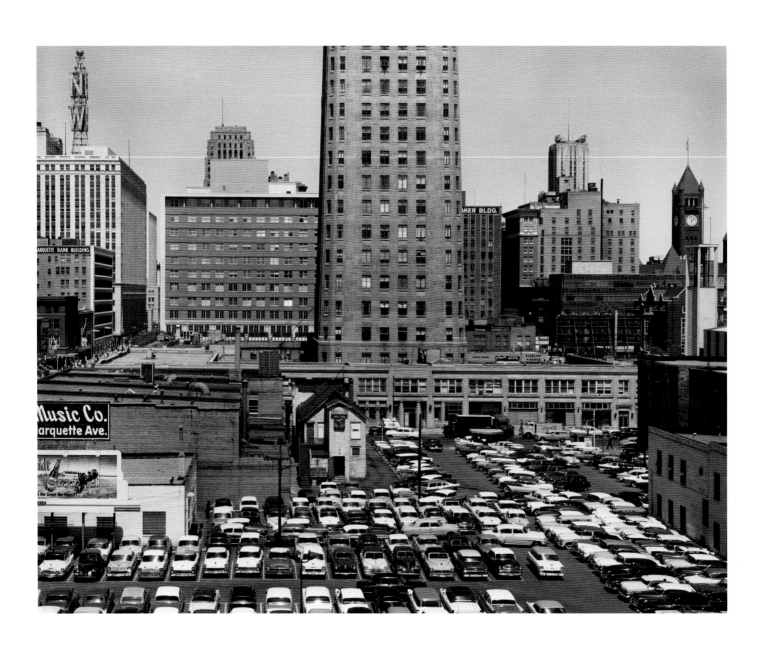

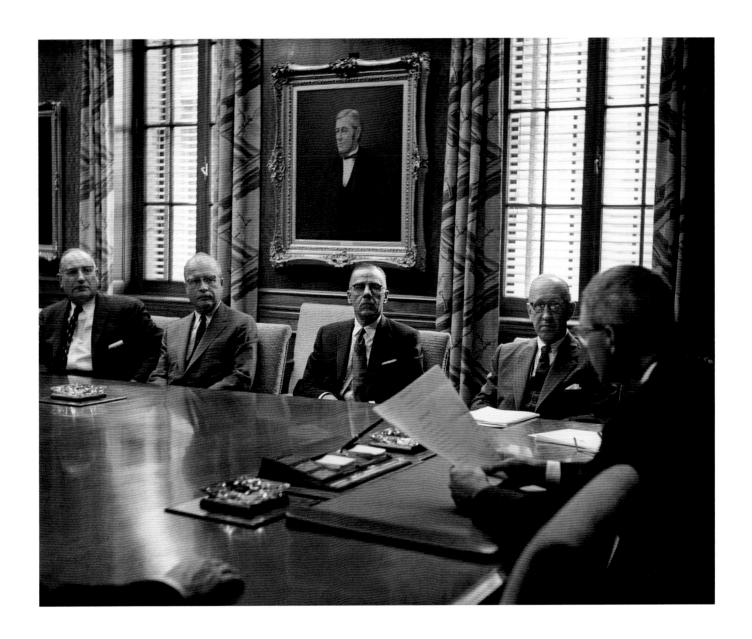

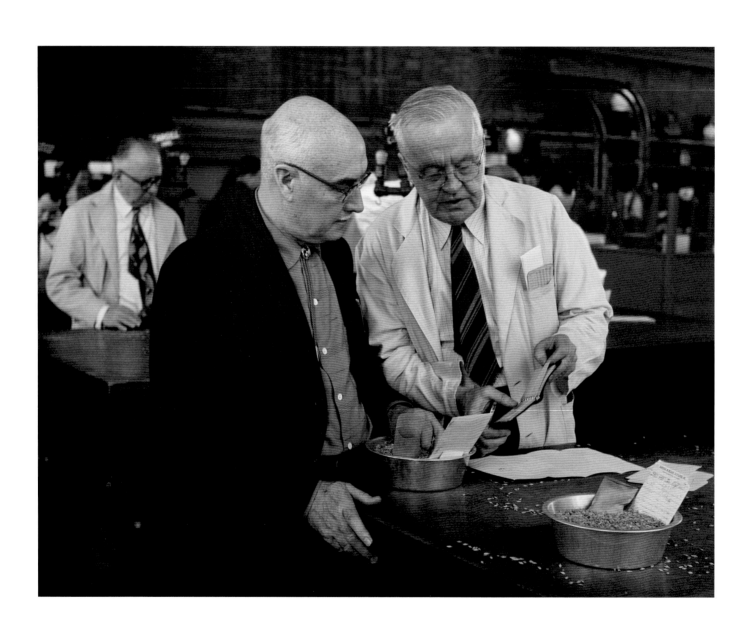

SELLING GRAIN is more complicated than selling automobiles, for example, because nobody really knows how much grain will be produced, or, consequently, how much a bushel of it will be worth a few months from now. This includes the farmer, who starts the chain of guessing by deciding whether to store his crop as collateral for a loan or to sell it for cash to the local elevator. The elevator in turn sells to the miller or brewer or feed manufacturer. More of this selling goes on at the Minneapolis Grain Exchange than anywhere else in the world. Here the agents of the elevator men, surrounded by sample pans of the grain they have for sale, find the buyers who will pay the best price. This is very straightforward: when the buyer contracts for grain he really wants it, he really pays for it, and it is really delivered to him.

The more mysterious functions of the Grain Exchange center around the Futures Pit, where millions of bushels are bought and sold and very seldom delivered. A futures contract is a promise to deliver or accept a given amount of grain at a given future date. The price of these contracts varies from day to day, depending upon anticipated supply and demand. Two kinds of men trade in futures contracts: speculators—who are trying to make money from the fluctuations in price, and hedgers—who are trying to keep the money they already have. The man who runs the country elevator, for example, is a hedger. When he buys wheat at two-fifty a bushel, he is in danger of having the price fall before *he* can sell it to the miller. To neutralize this risk he *sells* at that day's price a futures contract for a like amount of wheat. When he finally sells the farmer's wheat, he *buys* a similar future at *that* day's price. The two transactions neutralize each other, and no grain changes hands. If during this period the cash price has fallen, the elevator man loses on his cash transaction and gains on the futures transaction; if the price has risen, he gains on the cash sale and loses on the futures. The speculator, on the other hand, is gambling: if he expects prices to go up, he buys futures; if he expects prices to drop (no hailstorms in Kansas), he starts his cycle by selling futures. In this case, instead of buying grain he doesn't want he is selling grain he doesn't own.

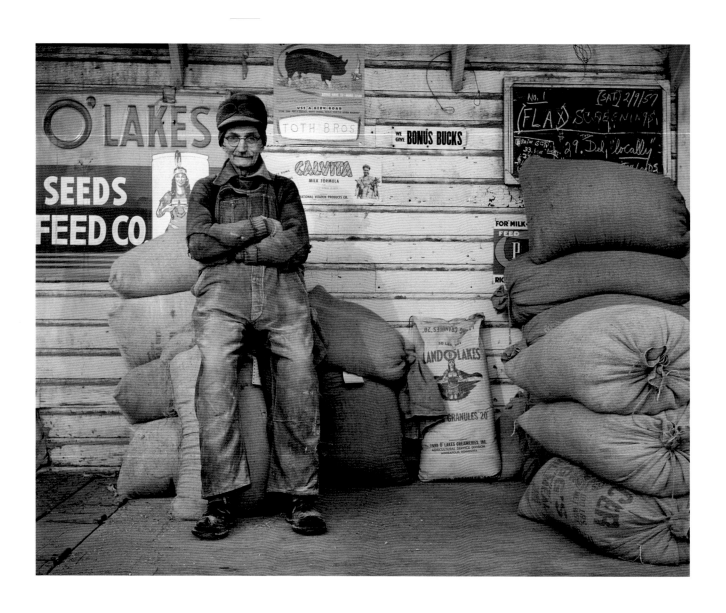

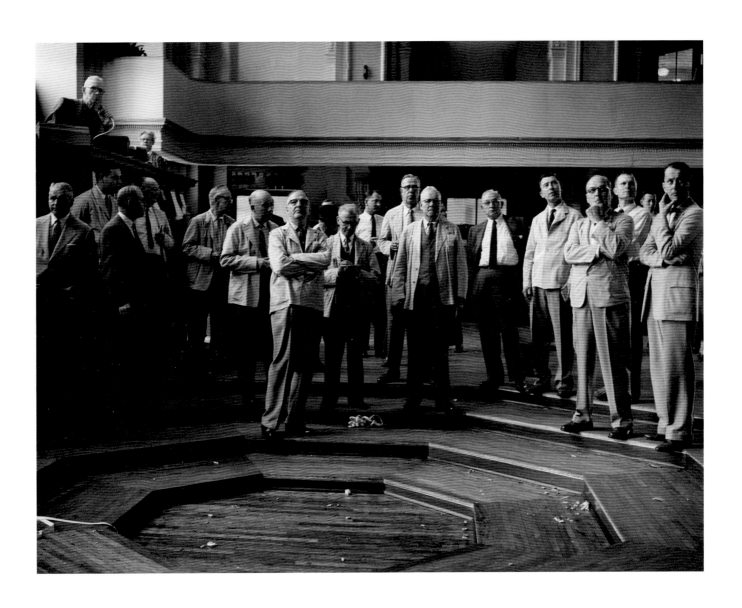

than any other state. This may be a matter of population patterns, or it may be because Minnesota people enjoy governing themselves and are unwilling to resign their prerogatives to the next-bigger political unit; at any rate, here it is a paltry village indeed which is satisfied to remain unincorporated.

There are close to two thousand townships in the state. The town meeting is held once a year, when the people of thirty-six square miles of countryside come together to say their piece and conduct their business — deciding such issues as whether the town should buy a new road grader or try to find a new blade for the old one.

But there are years when the peaceful, tedious details of government are overshadowed by issues of drama and principle — philosophic issues, where lines are tightly drawn and heroically defended. This will happen when a hundred-year-old farming community suddenly finds itself half suburban.

New resident:

All we are asking was that the meeting be postponed until Saturday, so that our husbands could be here to vote on the proposal for a planning board. We're property owners too, and we don't want gravel pits and truck depots moving into our laps. And also, something has got to be done about street lights over in the development area. But these old timers refuse to realize that this township is no longer in the middle of nowhere, that it can't continue to just grow like Topsy; and they also don't realize that a person has some rights even if their grandfather didn't settle here.

Old resident:

I can't see why it is so hard to explain that we can't make our own rules as we go along, like a bridge club. This is the day which was advertised as meeting day, and the law says all financial business must be transacted on that day. But aside from that, I don't see why we should pay a professional planner who-knows-how-much to tell people that they shouldn't build their houses between the main highway and the railroad spur. After all, these people moved out here to get rid of some of the complexities, and some of the taxes, of living in the city. Then they want dogcatchers, and concrete curbs, and a four-man police force, and a fire house on every corner, and pretty soon things are just like they were in the city, so they move out another twenty miles and start the whole thing again. Not that I blame the new people. I guess it's just that in the city they never really had any real experience with self-government.

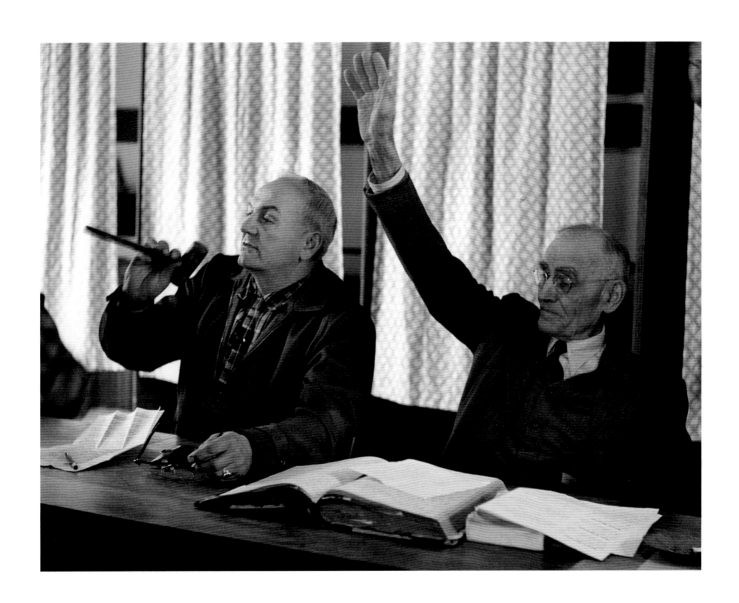

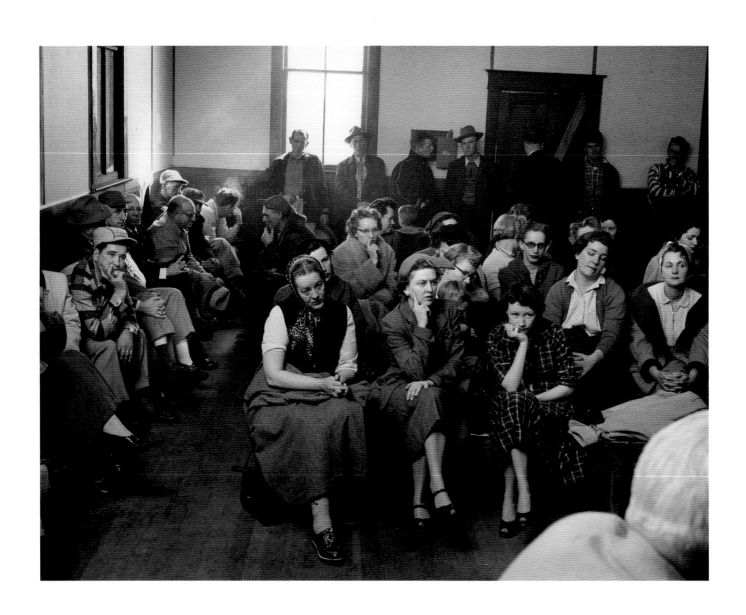

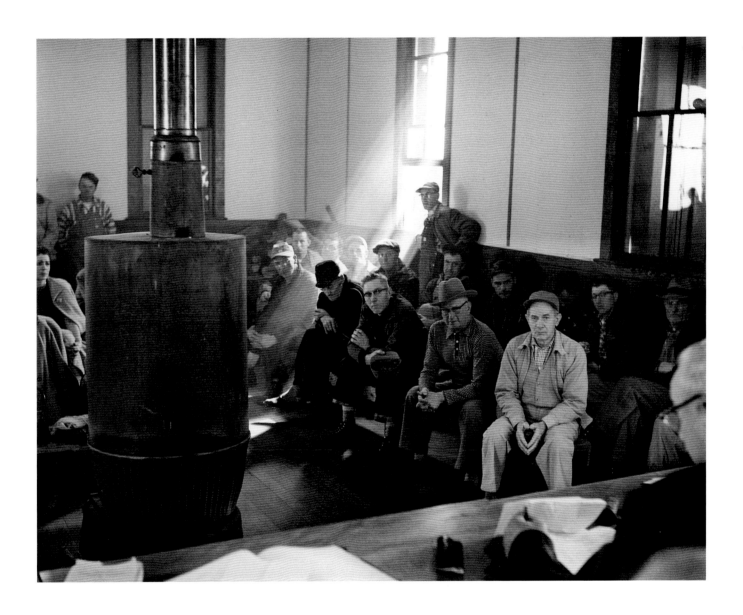

THE POLITICAL TRADITION of the Upper Midwest has been one glorious succession of philosophical contradictions. Alternately — even simultaneously — radical and rock-steady conservative, its intra-party schisms, third-party revolts, and willful independence have made the region a laboratory for testing political ideas and a rich fossil ground for the political scientist.

If we use this tradition as a standard, Minnesota is perhaps the most Midwestern state of all. From the days of Ignatius Donnelly and his agrarian crusade, through the eras of John A. Johnson and Charles A. Lindbergh, Sr., and Floyd B. Olson and Harold Stassen, down to the Kefauver revolt in the 1956 Democratic-Farmer-Labor primary, it has been axiomatic that a Minnesota politician would rather be unpredictable than president. If this will to splinter has lasted longer in Minnesota than in its neighbor states, the reason may lie in the unusually balanced diversity of both its people and its economy. With so many different axes in need of grinding, it has perhaps been even more difficult here than elsewhere to preserve a coalition that could trust to 51 percent of the vote. Two parties would not really be enough, unless they were free to realign on various basic issues; and so this is what they have often done. When electing the state legislature, it has even proved expedient to dispense with party labels altogether. This system (practiced elsewhere only in homogeneous Nebraska) has led to the charge of governmental irresponsibility. A reporter from *Time* magazine asked, "What are you people out there trying to do, imitate the French system? The theory of government in the rest of the country is that you elect a organized majority party, let them govern, and then hold them responsible for what goes wrong. In Minnesota the legislators can just say, 'Why look at me? I'm an independent.'" Actually, many Minnesota politicians don't like the system either. But the voters seem to think it's fine. The voters even distrust the parties which exist for organizational purposes on the floor of the legislature — the Liberals and the Conservatives — and think that the best possible arrangement is to have one group in control of the House and the other in control of the Senate. The logic behind this preference may be that such a situation makes it difficult for the legislators to do anything, including anything that the voters wouldn't like. Or possibly the voters simply feel that the system makes for entertaining politics, which it certainly does. Most likely of all, the voters are just experimenting. To the *Time* reporter, they might speak of their politics as a Chicagoan speaks of his town's weather: "If you don't like our political system," they might say, "just wait a minute."

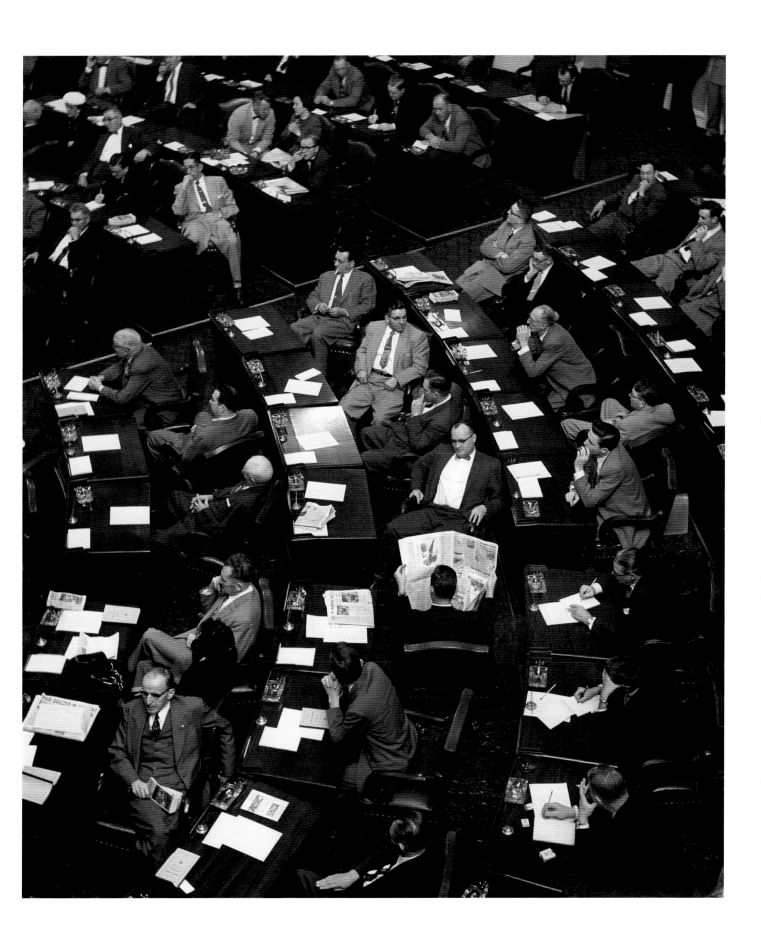

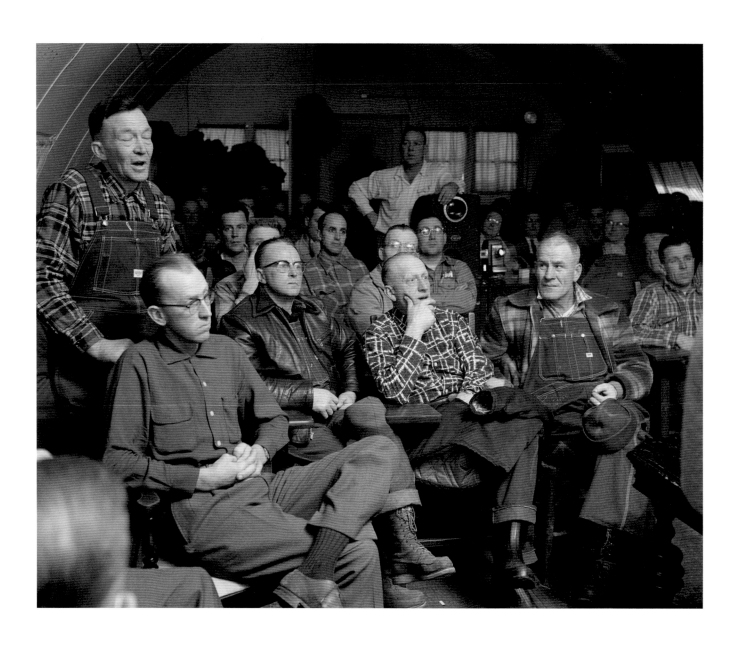

TOWN IS WHERE THE FARMER TRADES, and often where he votes; it is also where he gathers with his colleagues to pool information: it is the site of a continuing seminar on How to Farm. There is no specified meeting place or hour for this study; it goes on constantly in the coffee shop and at the feed store and on the sidewalks. But occasionally, to take care of a problem of special interest, the class will meet in formal session. The county agent may have supervised on local farms a series of tests of a new method of planting corn. When the final results are in, those who participated and those who are curious come together to report and ask questions. To an outsider these meetings are very impressive. There is an air about them of quiet professional competence, there is an easy precision in the standard technical vocabulary, there is an unspoken acceptance of the principle that no one has yet found the best possible way to do any farm job. These men are curious, studious, and alert.

At the meeting that discussed the new corn-planting technique, a dozen men stood to speak. One said:

"Well, I tried this new planting system, and not just because it requires less cultivating either, but because it is supposed to be a soil conservation measure. I've been trying these soil conservation measures for quite a few years now, and I think that by now I'm keeping more ground for myself than the river gets. Even so, the hardest place to grow a new crop is between the ears, as my father used to say, and it would be too much to ask that a man should get smart all at once. I started terracing in '37, but I figured that contour plowing looked too fancy to be necessary, and I kept watching the ground run downhill with every good rain until 1940. Then during the war . . ."

At this point a farmer who had evidently heard all this before interrupted, and said, "Now about this new planting system; is it true that you have to a more careful job of plowing?"

The old timer thought it over for a moment and then answered: "Well, yes. The system won't work well unless you've got good straight furrows. But this field of mine had to have a very careful plowing job anyhow. It lies rights next to the main highway."

The total expenditure for education

in Minnesota in relation to its wealth and income has been above the national average [for some time]. All evidence justifies the belief that the above-average willingness to support education in this State has been productive. One bit of recent comparative evidence stems from the official report of . . . the Armed Forces Qualification Test. . . . Against the national average of 16.4 per cent rejections, Minnesota heads the list with fewest rejections, amounting to only 1.3 per cent. . . .

Manufacturers place the education and trainability of Minnesota workers among the prime reasons for locating here. Until now Minnesota has been in a fortunate position in being able to produce the manpower that modern industry requires. But the supply of highly trained people is becoming limited. . . .

. . . It would be a serious mistake to over-emphasize the place of vocational training in higher education. Pressing as the need is for the specialists on which the economic life, the schools, and the health of the State depend . . . it is becoming evident that the youth of this State need as much general education as they can absorb to fit them for their increasing responsibilities as citizens. . . .

The educational program . . . is now restricted partly by inadequate buildings and facilities, but even more by the limited supply of qualified teachers. This shortage is probably the greatest manpower problem of the State at this time. . . .

Some of the most difficult educational problems are faced by the rural communities. . . . The rural youth who expects to remain on the farm will need more training that his father. . . . Many others, probably at least half, will have to leave the farms and enter other kinds of work. Because these young people offer one of the richest supplies of potential manpower . . . more opportunities are needed if they are to make wise decisions as to their work. . . .

Our changing society fills some with concern . . . and changes that affect the schools and colleges are particularly prone to resistance. Yet it is on the adequacy of the education of the young people of the State, judged by what they need for their own time, that the future of Minnesota . . . must be based. . . .

There is no question but that substantially greater financial effort will be required of the citizens of Minnesota. As a lay committee which is properly concerned about the mounting costs of State government, this conclusion has not been an easy one to accept. It does, however, conclude a fairly long period of extensive study and has been found to have no alternative.

Report of the Governor's Committee on Higher Education, 1956

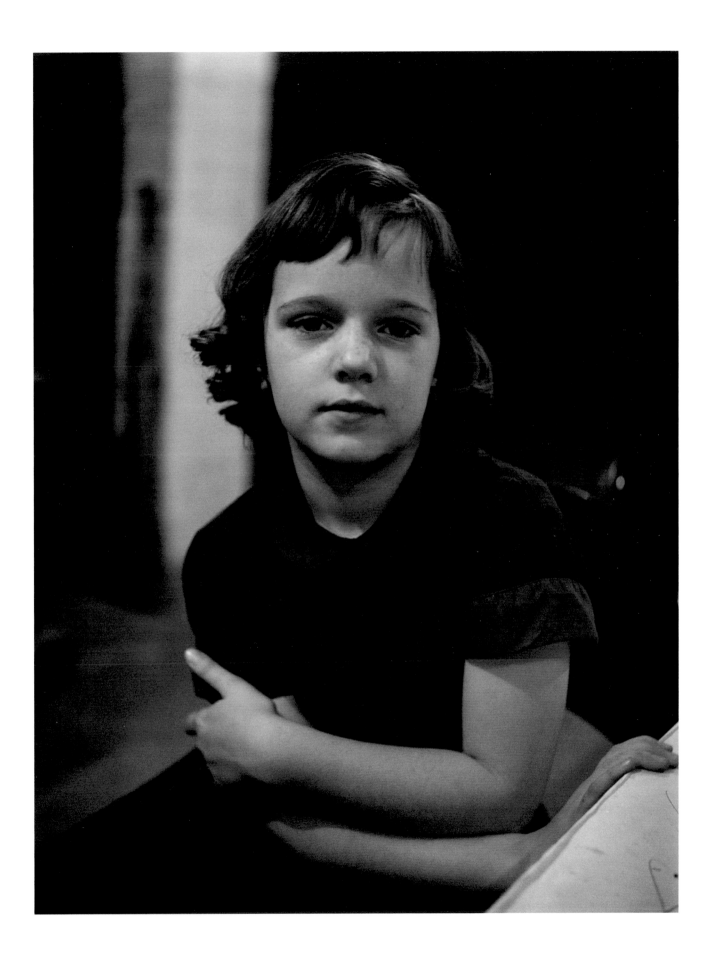

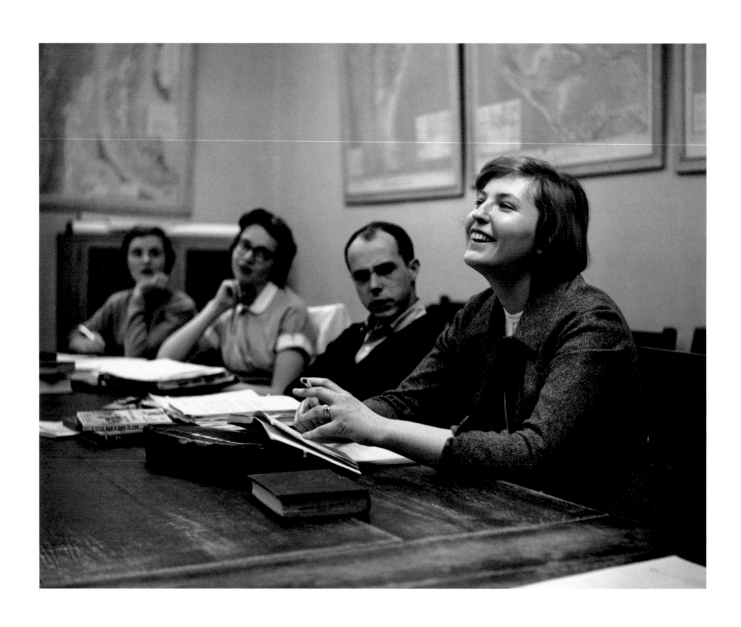

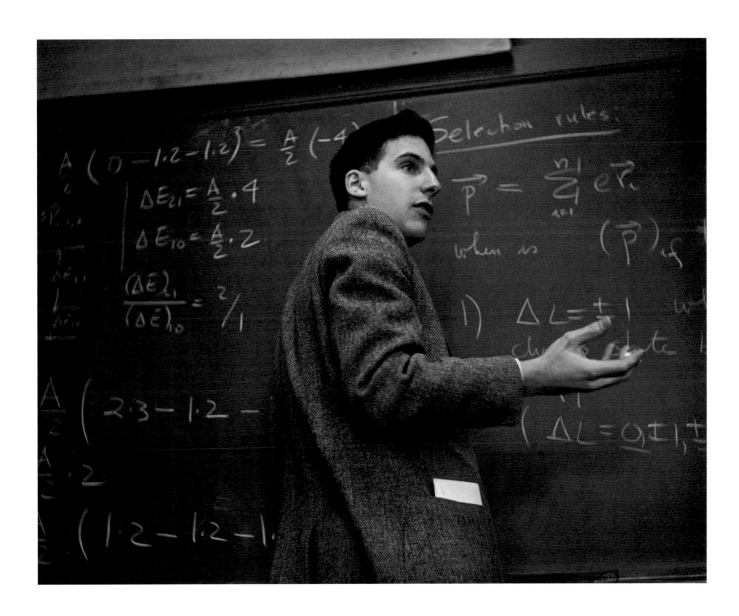

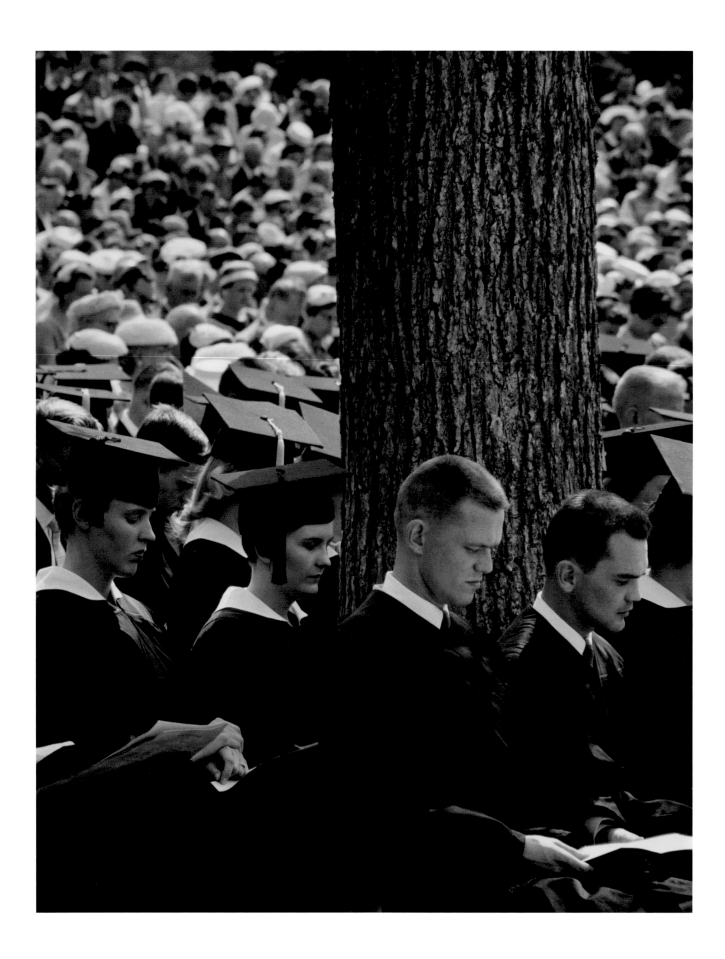

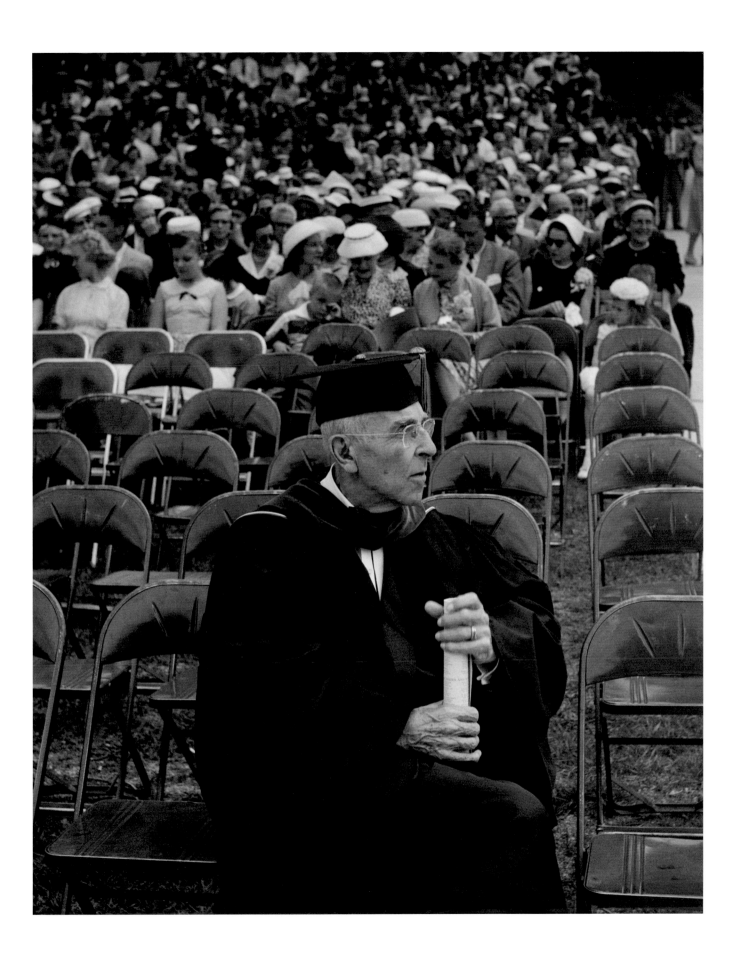

The summer of a Minnesota town

is filled with celebrations: church rallies and sauerkraut festivals, county fairs and water carnivals. No occasion—historical, present, or hoped for—is too obscure to be the inspiration for such a celebration. So it is not too important to know precisely what is meant by Willie Wired Hand Day, or Hook-'Em Cow Day, or Roaring Stoney Day; the main thing is that there is going to be a party. And whatever its uniqueness, the celebration will borrow much from an old-time Fourth of July. Whatever else happens, there will be a parade, picnic lunches, boat races, foot races, a softball game, and a band concert.

But there will be no speeches. The time once allotted to the fine, brave, ringing speeches is now given over to the Queen Contest. Next to fishing and baseball, selecting Queens is perhaps the Minnesotan's favorite sport. At present, the chances of a Minnesota girl's growing up to be Queen are roughly twenty thousand times better than the chances of a Minnesota boy's growing up to be President, and the possible titles have been by no means exhausted. Besides the Queens (of Lakes, Snows, Apples, Hearts, Bees, Tourists, Turkeys, etc.), there are the Princesses, the Dreamgirls, the Sweethearts, and the Misses: Miss Fixup, Miss North Side, Miss Soft Water, Miss Rural Electrification, and Miss Print (sic).

And hundreds of others. This may sound as though it would get pretty repetitious, but actually no two potential Queens are *exactly* alike, and nobody has yet suggested going back to the speeches.

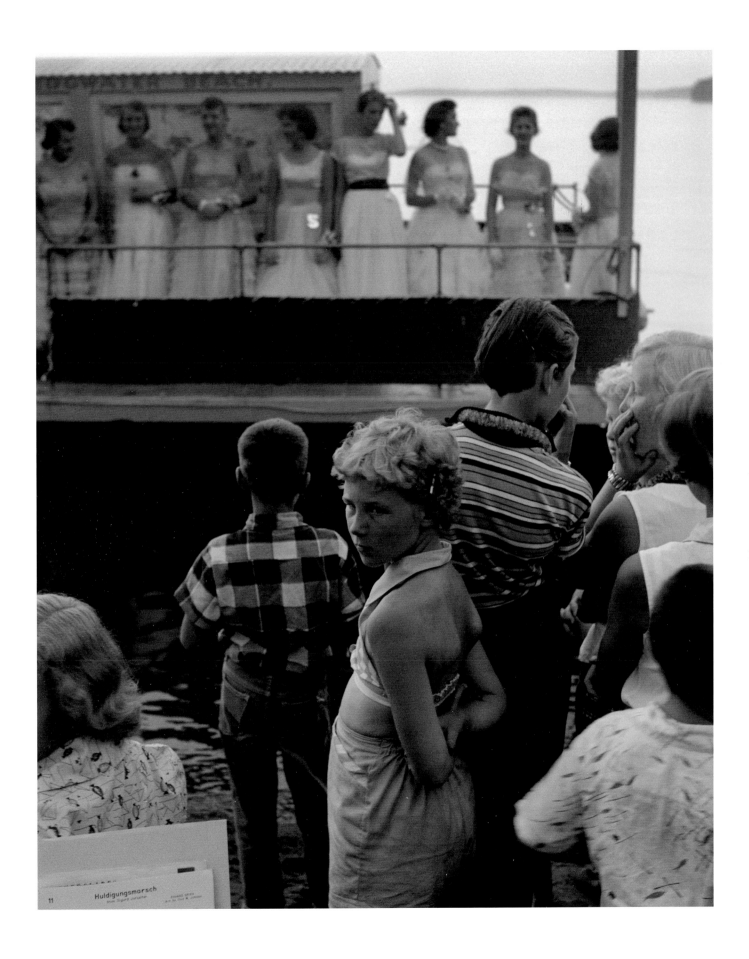

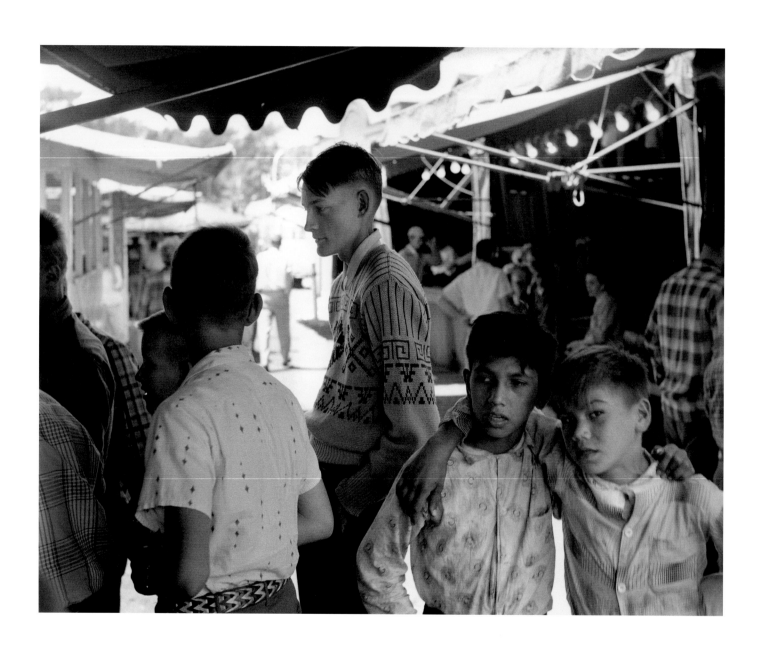

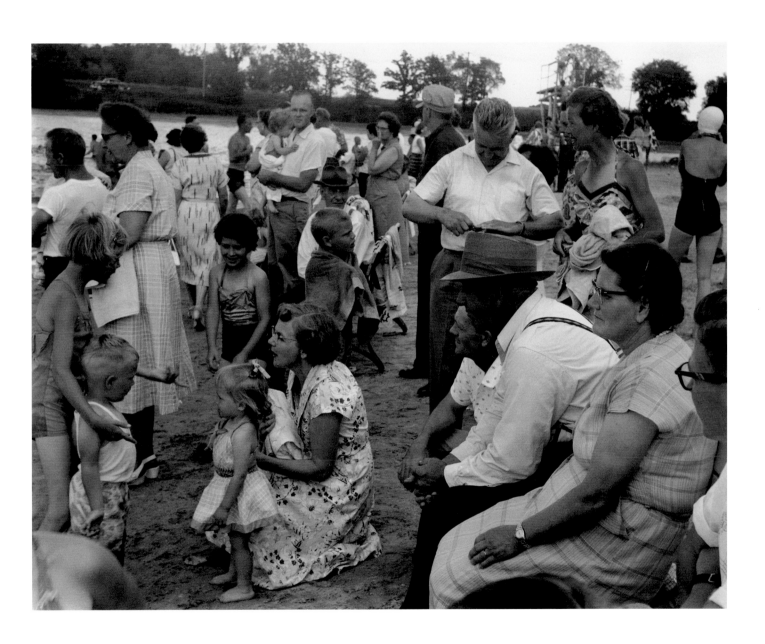

THE REAL IMPORTANCE and the greatest excitement of the county fair come not from the sideshows, or the midway rides, or the game where you win a doll by knocking the wooden bottles not just down but *off* their platform; the real meaning of the fair lies in the competitive exhibits, especially in the contests among the beautiful sleek farm animals.

The animals are brought to the judging areas in groups. The Guernsey heifers come in: sparkling clean, their bodies scrubbed, their hoofs and horns polished, and their coats curried — and brushed perhaps to disguise a back that is not quite straight. The judge wears a white straw hat and a look of inscrutable wisdom and heavy responsibility. He walks from animal to animal, viewing each from close and far, from sides and front and rear, measuring with his eyes, probing with his fingers, weighing virtue against virtue. When his decision is final he slaps the winner on the rump and passes out the ribbons: blue and red and white and light blue and pink. Whether the exhibitors are veterans of fifty fairs, or young members of 4-H and Future Farmer clubs, they are genuine professionals, and there are no extravagant expressions of joy or sorrow at the results. The judge says a few words of temperate praise: "Several good dairy types in this group. Our number one has a fine frame, she stands nice and high, and she's got good udder attachment. I might like to see her carrying just a bit less flesh. But she will made a good cow."

She is Champion. If she is judged a better animal than the Champion Guernsey cow, she becomes Grand Champion. If she goes to the State Fair she will compete against other Champions as beautiful as she is, or more so. The best animals there are *perfect*.

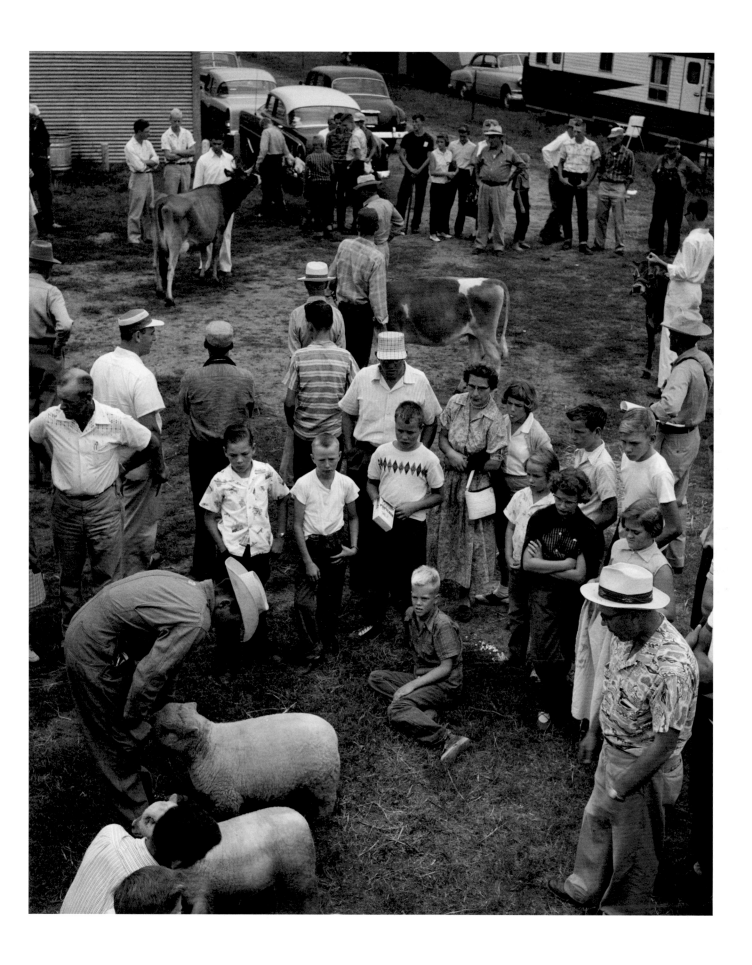

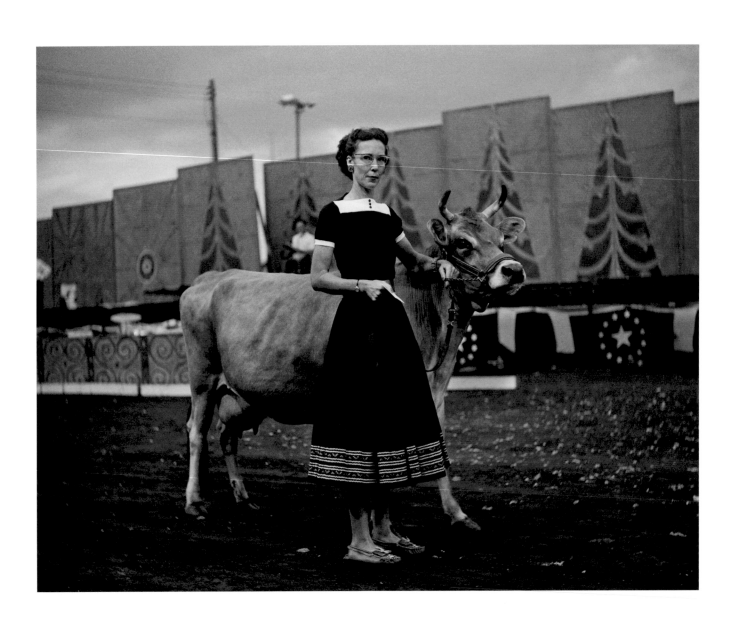

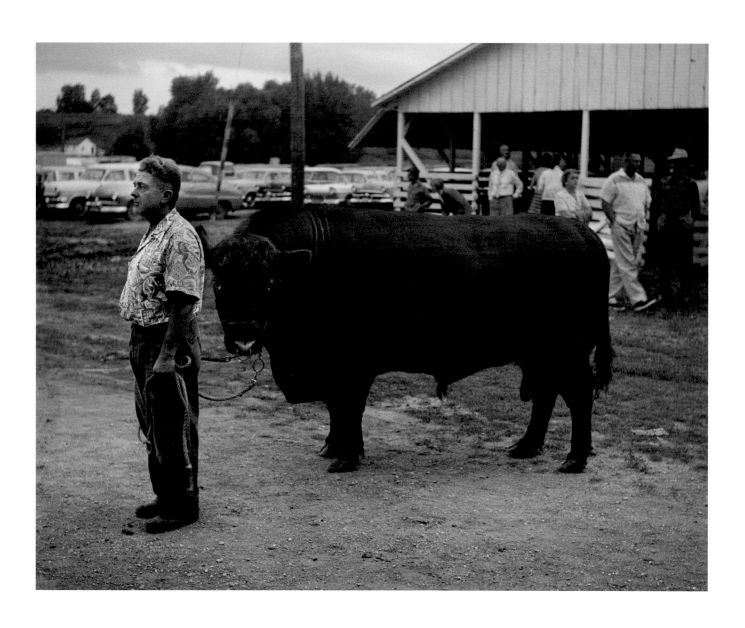

THE COUNTY FAIR is the climax of summer — a contest, a carnival, and a summer school for the boys who walk down the midway counting their remaining funds, weighing in their minds the relative attractions of the rocket ship ride, the baseball-throwing game, and show where the man wrestles with . . . what?

The barker: "I TOLD HIM NOT TO DO IT, I TOLD HIM NOT TO GO IN THERE. But he's going in there anyhow. I told him yesterday not to go in there, I pled with him not to do it, but he went in there, and it bit him, and he's going back in there today. He's ready right now to go back in there, and for just five nickels, for the fourth part of a dollar . . ."

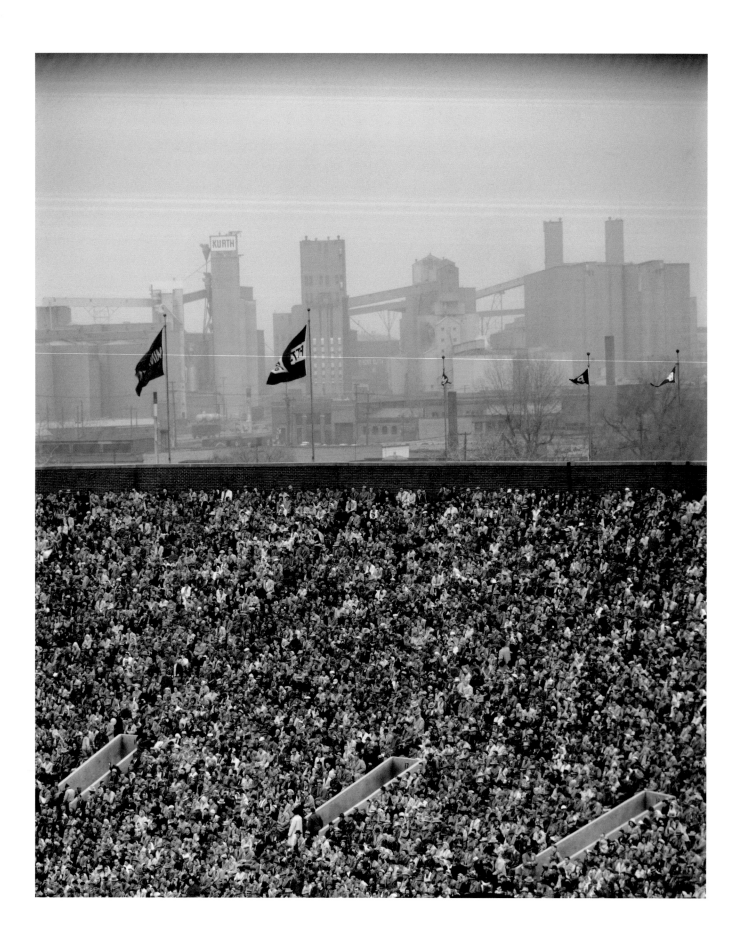

THE FIRST MINNESOTA TEAM SPORT was lacrosse, which the Indians played. The white men who had a chance to watch it said it was a great game with no rules to speak of, closer to field hockey than anything else, except that the field might be several miles long, including forests and rivers and all kinds of other natural hazards. Because of the size of the playing area, lacrosse was not too satisfactory as a spectator sport—it was a little like watching a sports car race over a thirty-mile course—but almost everyone who could run was a member of the team, so this was not a serious drawback.

After the lacrosse period, there were a few years during which the state was too thinly settled to make much progress in team sports, so people just hunted or fished or boated, or perhaps wrestled, which took only two. But with the development of towns and town rivalries, team sports became very popular. All sports were played in all circumstances, but gradually each sport developed its own most characteristic milieu. Baseball became the civic sport: the best teams were city teams, and their contests determined who had the best town. Football became the characteristic college game, and football games decided who had the best college. Basketball—a game of continual, unrelieved running and jumping—became, naturally enough, the classic high school game. The crowds at high school basketball games are perhaps the most rabid fans of all. To witness the entire spectrum of human emotion from semi-hysteria to hysteria, there is no place on earth like the Minnesota State Basketball Tournament.

In recent decades ice hockey has gradually filtered down from the Canadian border until it has become one of the most popular sports of the entire state. Hockey has some of the precision of baseball, as much speed and much more change of pace than basketball, and it is almost as uninhibited as lacrosse—which makes a combination very hard to beat. Also it is played on ice, and Minnesota has a good deal of ice.

Another very popular team sport is curling, a game a little like shuffleboard on ice, apparently. Curling is not a spectator sport, however, but a true game, like bridge; no one who doesn't play even knows the rules, or why the players run along sweeping the ice with their brooms.

The Minnesota Daily, 1903:

"Minnesota will have the best football team in her history this year. This is no vain boast, but it is a plain unvarnished fact, warranted by a casual look at the squad of young warriors that assembled on the campus last evening. . . .

"It will however take more than our gridiron heroes can do to put Minnesota where she belongs at the head of all Western football teams.

"It will take the undying loyalty of 4,000 students. Without this we can do nothing.

"The team cannot hope to win by its own strength alone, it must know that back of its efforts there stands the student body of a great University ready to sacrifice everything in order that the team may be victorious. . . .

"Everyone who does not give . . . the team his support, should be classed as a knocker of the basest sort. . . .

"WIN WE WILL,

WIN WE MUST,

MICHIGAN'S GOAL

WE CROSS OR BUST."

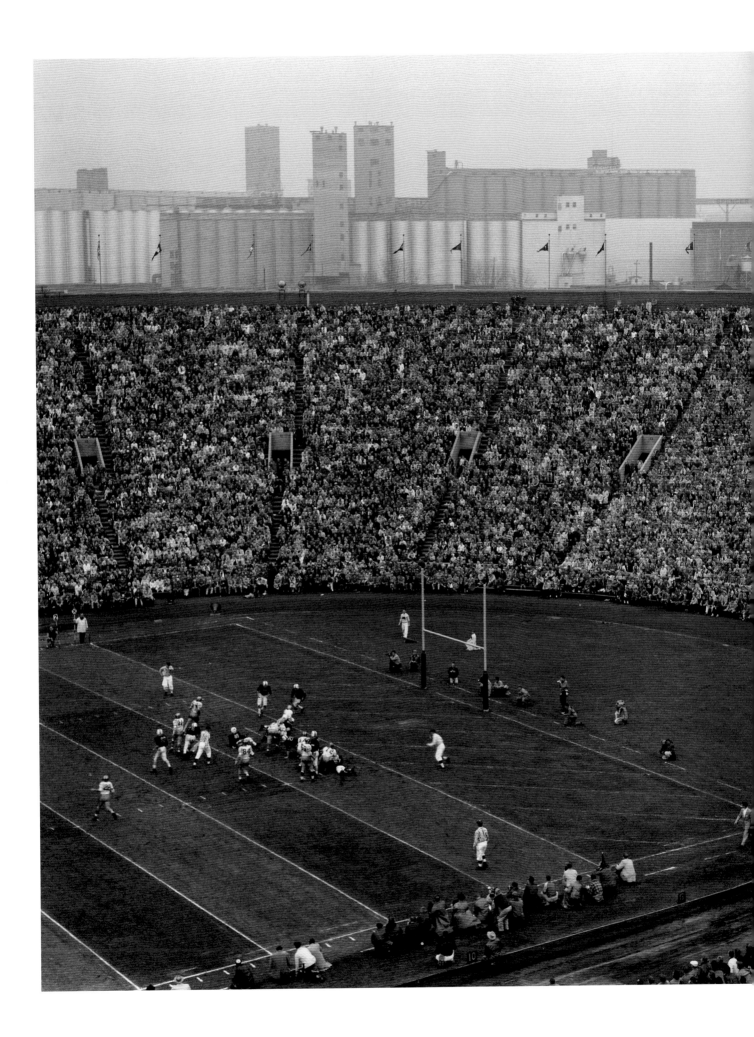

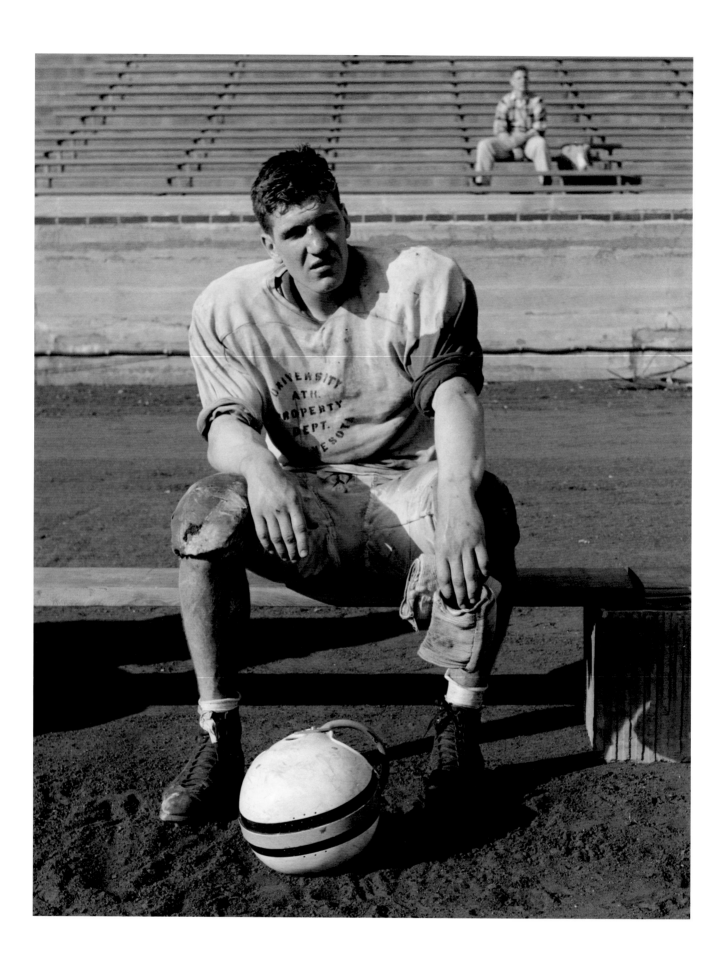

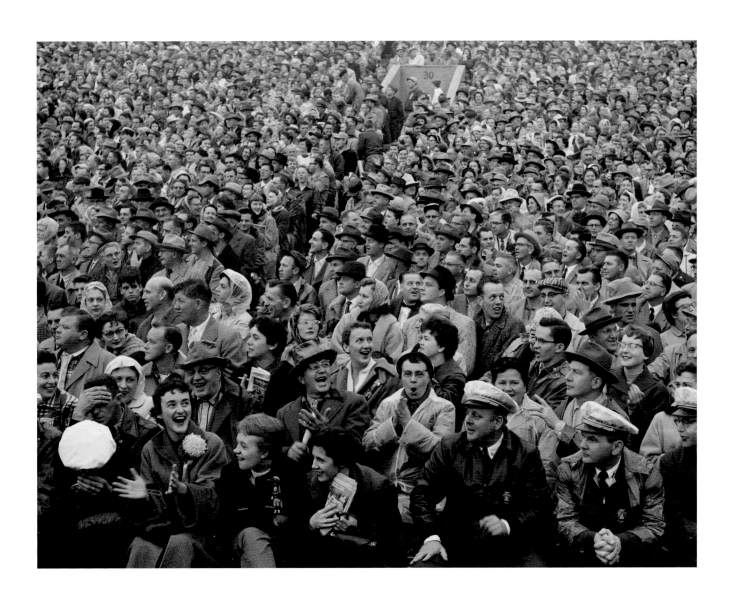

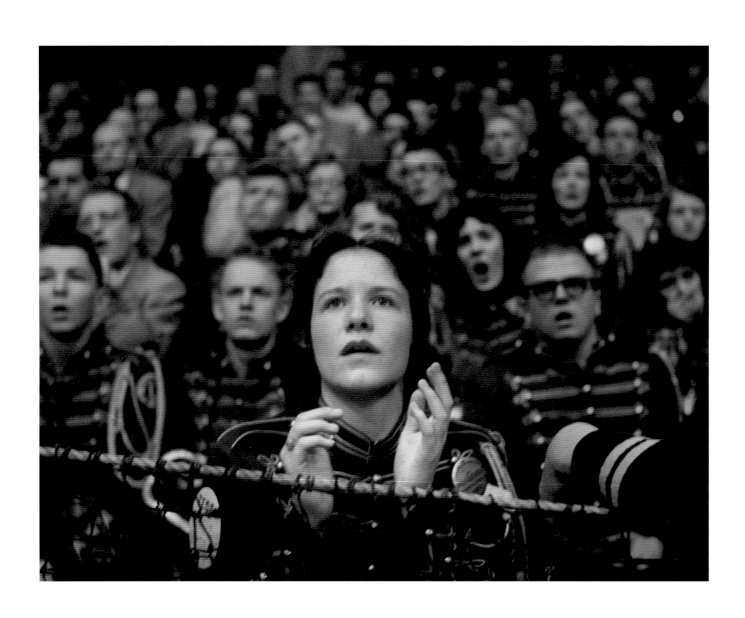

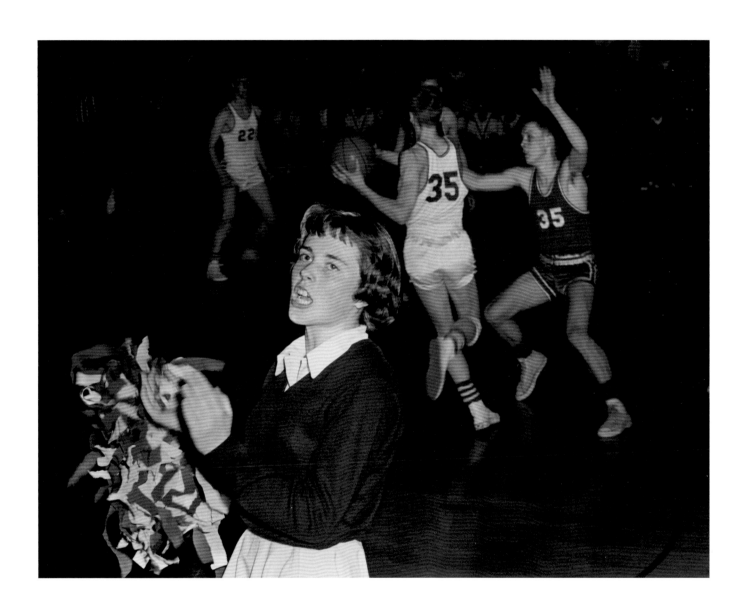

MINNESOTA PROBABLY PLAYS MORE BASEBALL per person than any other state in the Union. She plays it in fine new fancy stadiums, and in clearings carved out of the second-growth jack pine, where wild flowers grow up to the outfielders' knees, so that any ball not caught on the fly is likely to go for a lost-ball triple.

Mechanically, the best baseball is played in the Twin Cities, whose teams play in a league classified in the baseball hierarchy as Triple A, which means very good indeed, just an eyelash slower than major-league ball. Some claim, however, that the game is really most exciting in the villages, where it is played by gas station operators and schoolteachers and farmers, who play their entire careers in the same uniform, and are not continually being sent up to the Dodgers for a tryout, or down to Little Rock for More Seasoning. It is unquestionably true that the amateur teams play some epic contests, such as last year's game between Carlton and Mahtowa, called by mutual agreement after fifteen innings with the score tied one to one. The game had to called because players on both teams had cows that needed milking.

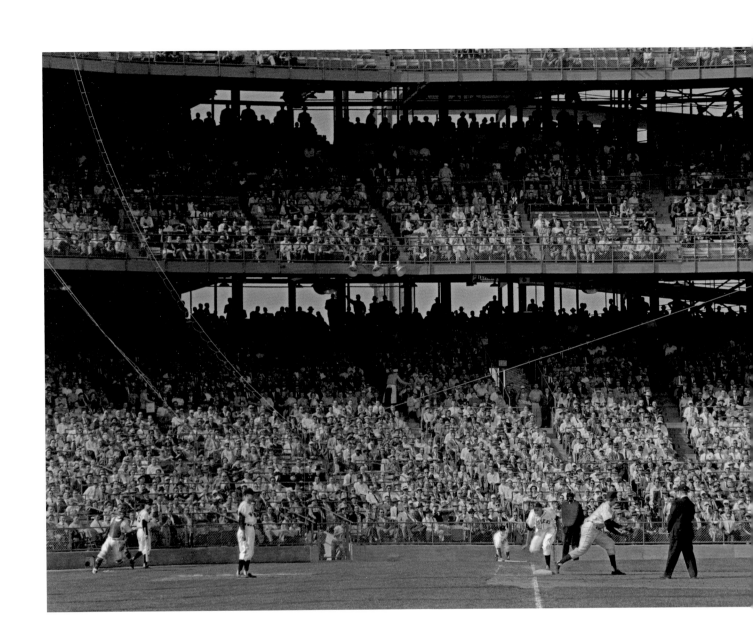

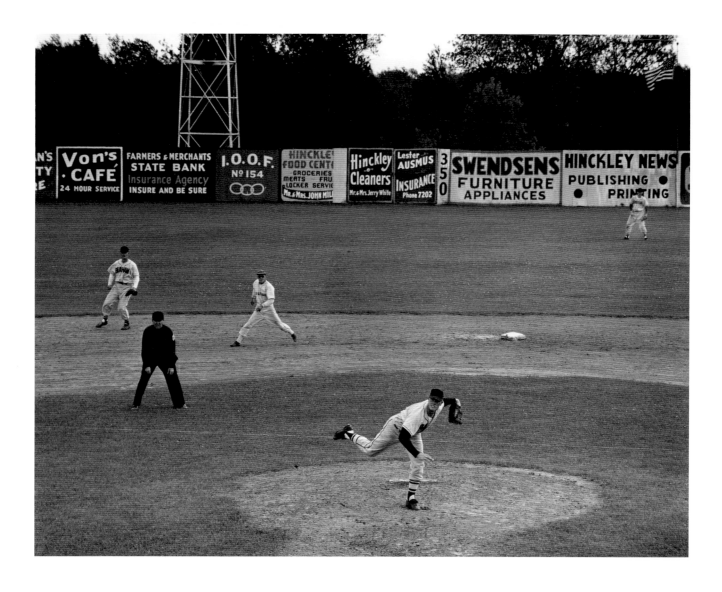

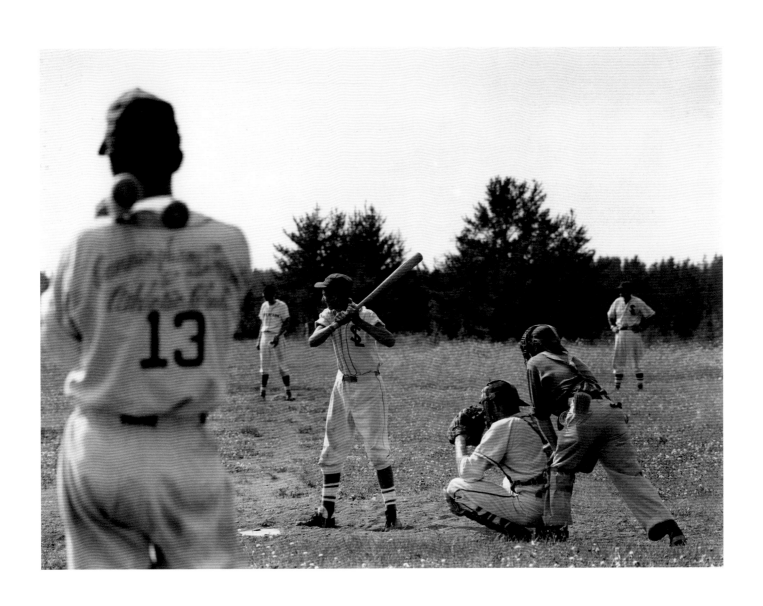

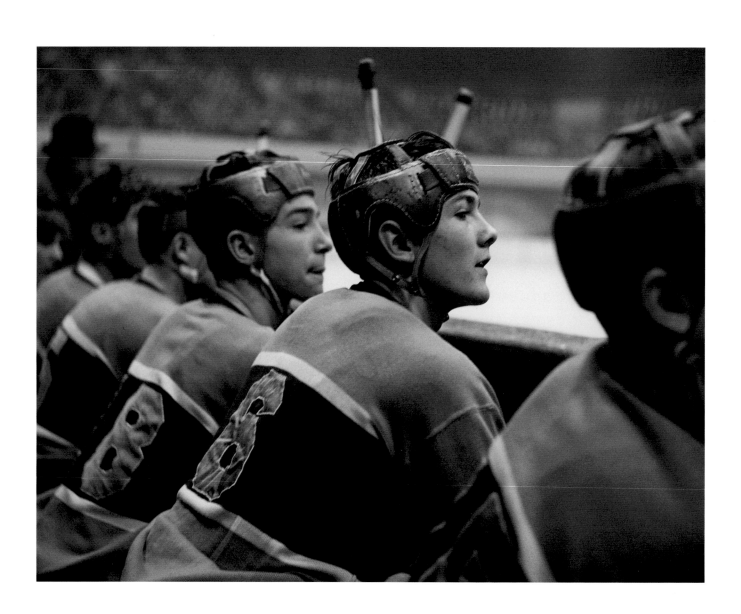

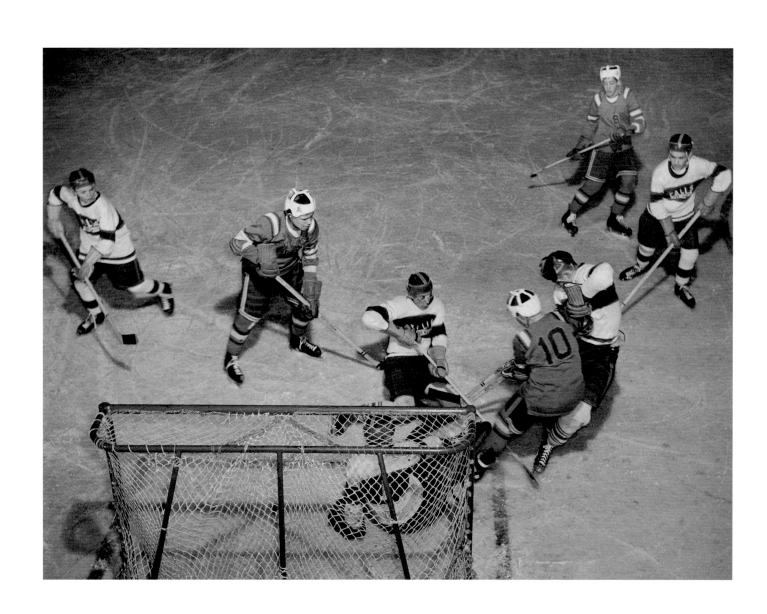

Of all the fine arts

music seems to have taken root in Minnesota most easily, probably because it was part of the tradition the settlers brought from their native lands, where it was a natural, unselfconscious, necessary mode of expression. And writing — particularly prose-writing — has been practiced and enjoyed here from the first. But the visual arts were another matter. People mistrusted painting and sculpture and even "Architecture." The tendency toward ornament smacked of decadent aristocracy, and the very idea of image-making seemed slightly pagan. True, an early newspaper editor bravely proclaimed that the new state should make not only its own hobnails but its own art; but it is not clear whether he really wanted homemade art or whether he was just damned sure he didn't want any *outsiders'* art. In any event, no indigenous art sprang full-blown from the prairies; what little art there was was mostly imported, just as most of the music and most of the language and most of the people — and for that matter most of the hobnails — were imported. The only surprising thing about this was the fact that for many years it seemed to disturb people: they felt that the citizens of a new country or even a new region should be able to create a new fine arts tradition as they stepped across the border.

When the visual arts finally began to be a matter of concern to Minnesotans, they were regarded more as a symbol of cultural progress than as something intrinsically pleasurable or helpful. It was admitted that art might sometimes taste a little odd, but it was — somehow — *good* for you. It is in fact only during the last twenty years or so that the visitors to Minneapolis art museums could be honestly referred to as crowds, and it is more recently than that that they stopped walking on tiptoe. But lately there has been a fundamental change. Outside of New York, there is perhaps no American city with two museums as lively or as serious or as well used as those of Minneapolis. Minnesota art schools are not only respected, they are attended. The commercial Kilbride-Bradley gallery sells more good modern paintings on time payments than it does for cash. The people in general seem determined to make up for the years when they didn't know what they were missing. And almost no one any longer expects a painting by a Minnesota painter to look, somehow, like a Minnesota painting.

Carl Bennett, a banker, was deeply concerned with art — concerned as few amateurs have been, in any time or place. When his family decided to build a new bank building, he saw a priceless opportunity. He did not say, "I'm all for art, but after all a man has to be practical." He said instead, "It was determined to make a search for an architect whose aim it was to express the thought or use underlying a building . . . like a virtuoso shaping his materials into new forms of use and beauty." He recognized the virtuoso when he saw him, and the virtuoso built a masterpiece.

A half century later the bank's business had expanded and changed; there were new problems of space and arrangement and mechanics which would no longer fit into the old scheme. The new banker — not unaware of his responsibility — studied, asked advice, considered carefully, and called in architects to plan an interior remodeling that would better serve his needs.

When the remodeling plans were announced, a corporal's squad of Minnesota architects, historians, and museum people decided that a valuable thing was about to be spoiled; they had seen good things ruined before, sometimes by callousness, more often by a crushing weight of good intentions. Through the State Art Society, they got in touch with the country's leading architectural critics and explained the situation. The critics answered, with varying degrees of heat, that there were few buildings in the country so well worth saving. They understood the rights of property and the obligation of business to conduct itself efficiently, but they said that a creative idea also had some rights and imposed some obligations. They spoke strongly and promptly, to their credit.

To *his* credit, the banker did not say that after all, it was the company's bank. Nor did he say that the letter writers knew nothing of the banking business, nor ask why this sudden concern with his bank, when other Louis Sullivan buildings from St. Louis to New York had been ruined with impunity. He said instead that perhaps he had not understood the problem as thoroughly as he had thought, and that he would be happy to meet with a committee and listen to their suggestions.

At the meeting, no one suggested that anyone else was impractical, mercenary, unrealistic, unimaginative, sentimental, or insensitive. The committee, mostly architects, suggested an architect named Harwell Hamilton Harris, from far away, who they felt could help solve the banker's problems and salve the committee's conscience. The banker said he would like to meet the architect. He did; the architect drew new plans, the banker and the committee studied them. They both thought the new solution was fine.

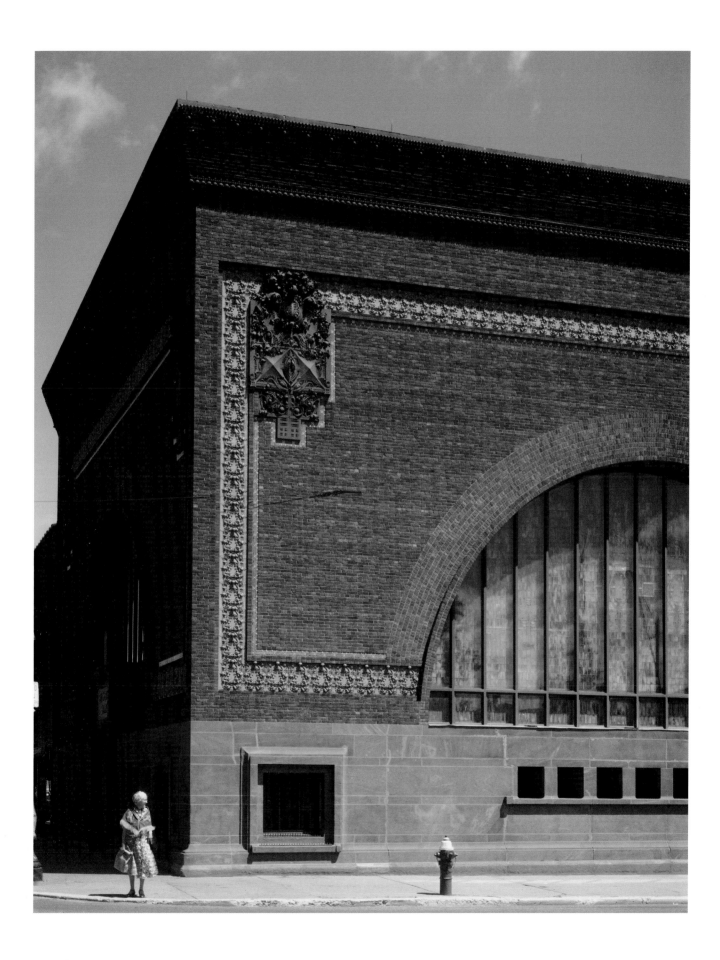

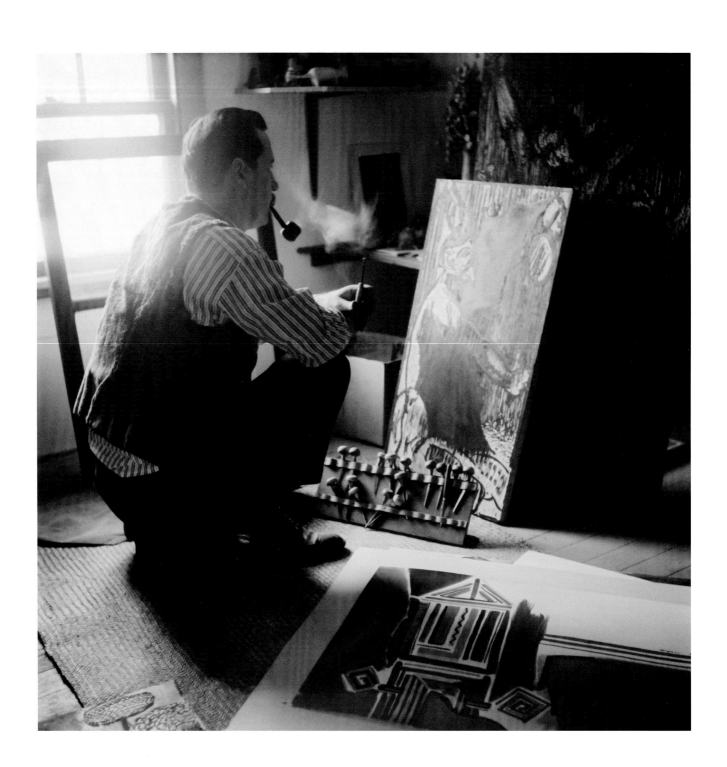

Cameron Booth:

I like to think of painting in its own inherent qualities having a unique beauty brought about mainly through its own laws of order and unity.

Painting is a paradox in which narration becomes poetic fantasy, description gives way to suggestion, concrete objects become evocative configurations, never obvious, never over-stated, and yet an emphatic intensification of experience and thought.

John Anderson:

I would like very much to use oxyacetylene welding equipment to weld and braze three dimensional drawings. I want to put rods and sheets together to see what the things I am painting now really look like in space and volume. . . . I want very much to learn all there is about the use of transparent and translucent plastics. I want to make large paintings with them that can be viewed from either side. I want to go where there are stained glass windows. . . . and at last I want to put this transparency and translucency into my painting.

Warren and Alixandra MacKenzie:

We learned to produce in a natural and easy manner, a way of working which now permits us to make from 50 to 200 pots a day. This level of production is generally rejected by American potters who hold that . . . that amount of work will automatically lead to "dead pots." But our experience has been that . . . with the relaxation and ease of making comes a fluidity of expression which permits the pots to come closer to being "born, not made."

Attributed to Byron Bradley in the K-B Potboiler:

When the last quarter moon in June is over and classes are finished in Minneapolis, I like to shed my phony, pretentious, egg-stained Ivy League clothes in a hurry and run all the way to Grand Marais and get back to nature. All I wear all summer is an old stocking cap and my money belt. I have to wear the money belt because I'm treasurer of Artists' Equity.

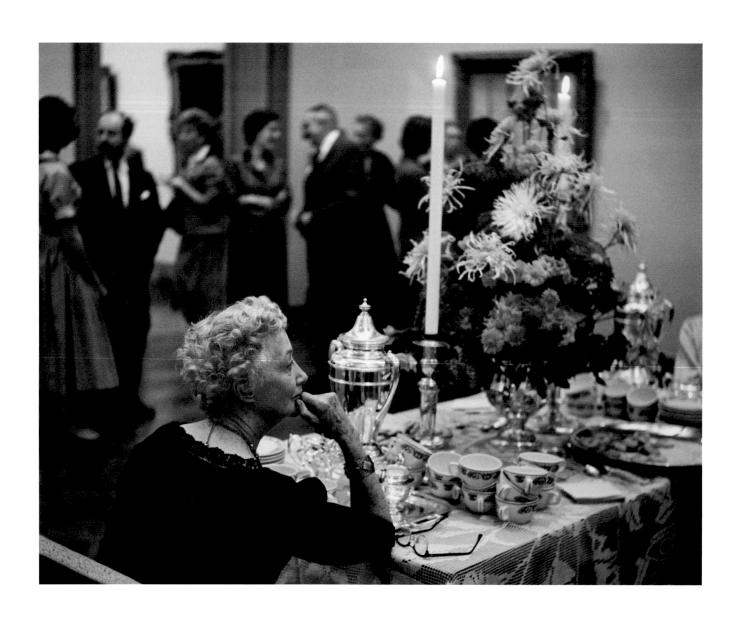

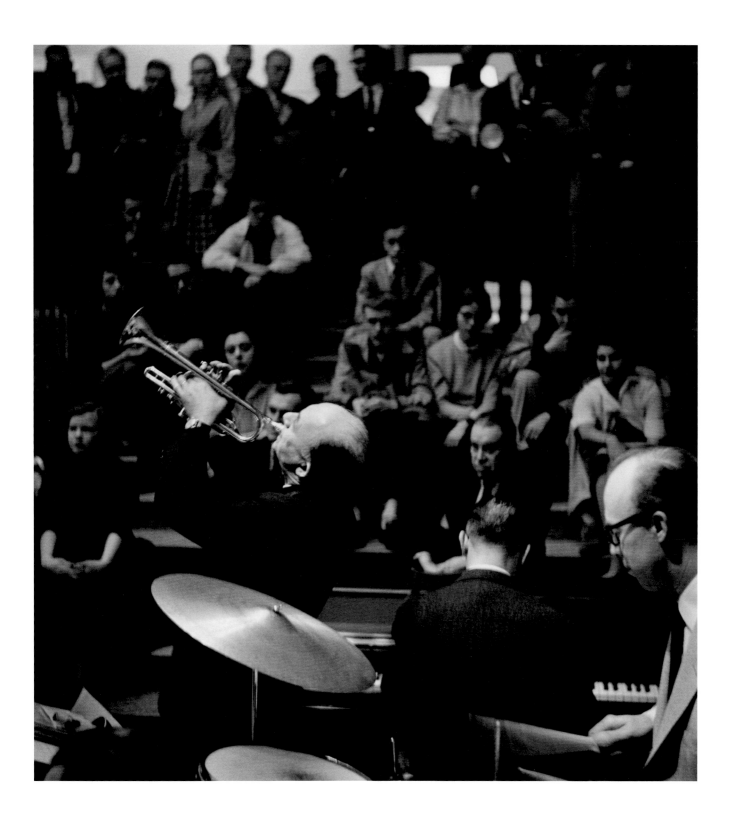

THE MINNEAPOLIS SYMPHONY is famous, and so is the St. Olaf Choir; but there are scores of serious musical groups in Minnesota that almost no one outside the state has heard of—semi-pro symphonies, choirs, chamber music groups, and opera societies. Perhaps these are as important as the great groups.

In 1863, only a few months after the terror of the Sioux Uprising, two hundred St. Paul citizens formed a musical society ambitious enough to include a Haydn symphony in its concerts. During the seventies and eighties, singing groups, most of them Scandinavian, sprang up in profusion. The Minneapolis Symphony was founded in 1903, but the seeds from which it grew had been scattered during the false springs of many earlier years. Modest instrumental organizations had led brief flickering lives during the preceding half century, and in 1872 an eighteen-piece Minneapolis orchestra played at least three concerts, including music by Beethoven, Strauss, and Rossini, before their money or their repertoire was exhausted.

It is not remarkable that most of these early groups were shortlived; it *is* remarkable that they were formed, and that when one failed another would appear to take its place. Apparently the people of Minnesota—quite a few of them—really wanted music. And they still do. They want it two ways: they want to hear it played and sung at its inspiring best, and they want the adventure of playing and singing it themselves, whether the result is inspiring to anybody else or not. This desire for music—the great desire of a few and the modest desire of very many—is the good soil from which Minnesota's musical tradition has grown.

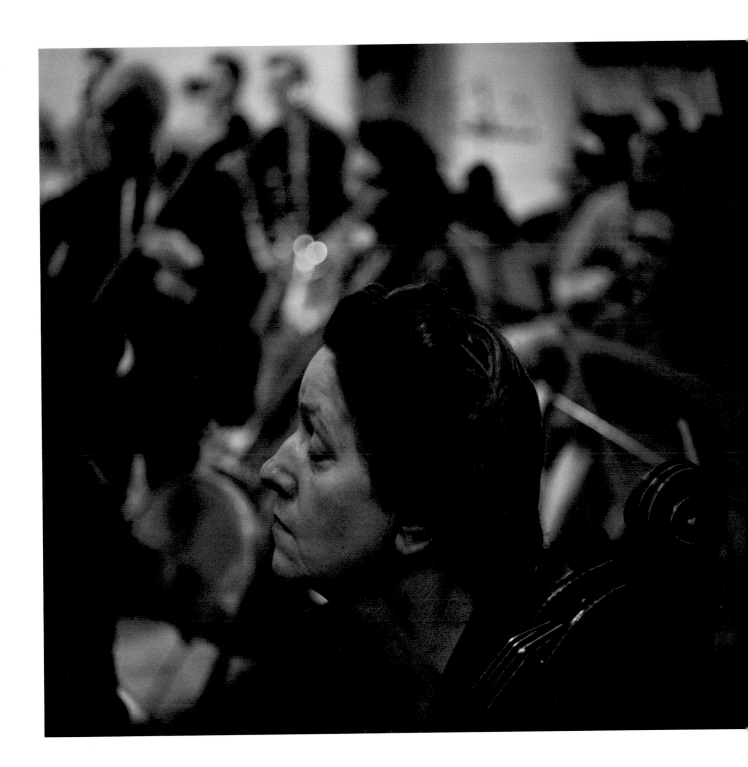

I am a violinist with the Minneapolis Symphony Orchestra. I have just returned to my hotel after participating in the first concert of the orchestra's Mid-Eastern tour. It has been the most thrilling experience of my musical life.

I have been a member of the orchestra for twenty years, and have played concerts up and down and across the United States . . . but nowhere have we had the reception given us tonight in Athens, Greece.

. . . I let my imagination go. I looked back across the centuries and could see five thousand or more Athenians and Romans witnessing, on this same stage where we were now playing, the hair raising tragedies of Euripides, or chuckling at the comedies of Aristophanes. . . .

Often, when I had a few measures of rest in my music, I would glance out at the audience. . . . Those faces were fixed in rapt attention, sober when the music was weighty, lively when the music was gay or spirited. Those people were living every moment of the concert. . . .

When the last frenzied climax of the Ravel number had been achieved, the audience rose in a body and shouted in appreciation. More than five thousand people acclaimed our Minneapolis Symphony with enthusiastic cries. . . . Far up at the top of the steep amphitheatre, men took off their shirts and waved them frantically in applause. . . .

Finally we played a fourth encore, and that is a circumstance I never before have experienced in all my years with the orchestra. . . .

Mr. Dorati and the orchestra remained standing, acknowledging the still thunderous applause. The people passed close by the stage, holding up their hands as they clapped them, often to many of us individually, and their faces beamed at us in appreciation. I shall never forget it.

In these countries where we are going to play, the people will be saying to us, "We know what you Americans have in your pocketbooks; now we want to know what you have in your minds and in your hearts."

I feel that we gave a good account of ourselves here tonight, in Athens.

<div style="text-align: right">

IRVING L. WINSLOW
Minneapolis *Star*, September 14, 1957

</div>

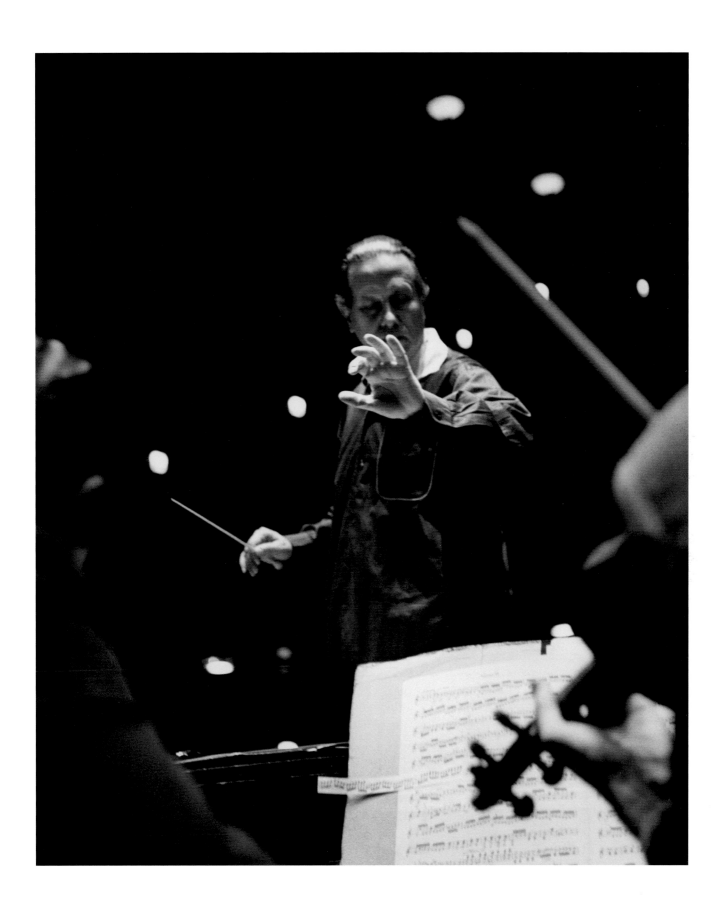

Every man has some inspiration for good in his life. With my brother and I it came from our father. He taught us that any man who has physical strength, intellectual capacity, or unusual opportunity holds such endowments in trust to do with them for others in proportion to his gifts.

<div align="right">DR. WILLIAM J. MAYO</div>

For half a century the Mayo Clinic of Rochester has been a world capital of the modern crusade against preventable death, and a symbol of hope to the hopelessly sick.

More recently the University of Minnesota Medical School has also become a medical center of the first rank. One of its many areas of constant research and experiment is in the diseases and disorders of the heart. One of the most stubborn of surgical frontiers was crossed there in the spring of 1954, when a team of University surgeons closed a hole in one of the interior partitions of a child's heart. The heart's interior, free of blood for thirteen and a half minutes, was repaired under the direct vision of the surgeons. During this time the patient's blood was pumped through the circulatory system of another human being, whose heart purified and oxygenated their common blood supply.

The surgeons of the team were Drs. Lillehei, Varco, Warden, and Cohen, but the achievement belonged to many men — surgeons, diagnosticians, scientists, technicians — who had worked for six years in the laboratory, developing the concept and techniques of the operation. During these years over two hundred laboratory dogs were experimented upon. In the years since 1954 experiment has continued, and the techniques of the operation have undergone continual refinement. The living donor has now been replaced by a simple oxygenator, which performs the function of renewing the venous blood.

Somewhere between ten thousand and fifty thousand children with congenital heart defects are born each year in the United States alone. Until now, the prospect for most of them has been a short life of precarious invalidism.

Dr. William J. Mayo said that it was the duty of the medical profession to provide continuity of knowledge and effort, so that the sickness and pain of no man would be wasted, but would be his contribution to the health of future generations.

228

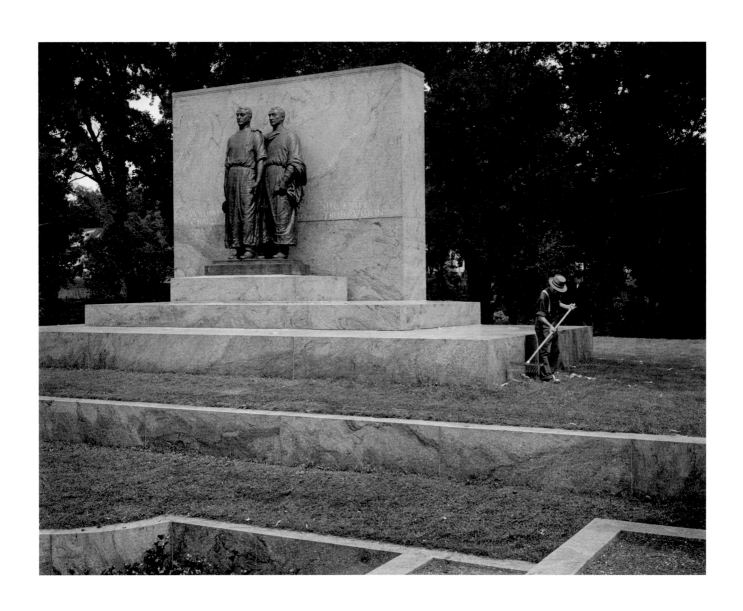

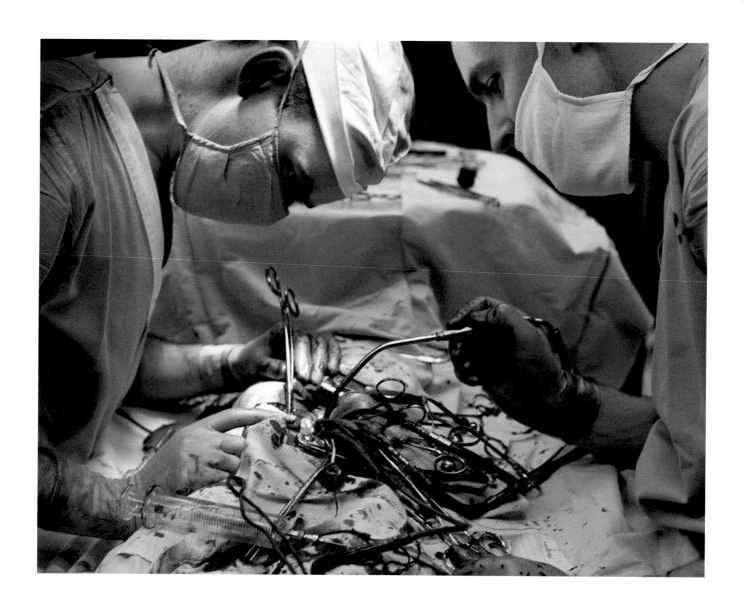

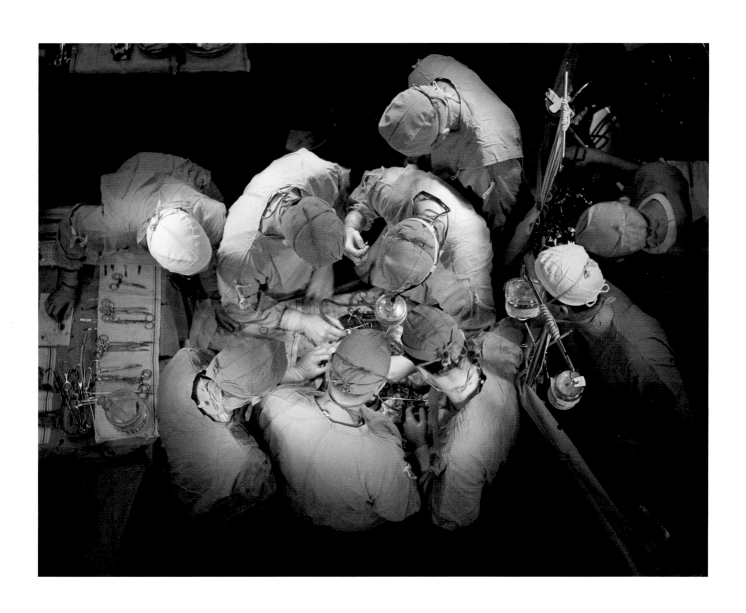

The Techniques of Survival

THE 1860s BEGAN A PERIOD of prodigious change in American agriculture. The Civil War stimulated demand at the same time that its armies took farmers from the fields; the resulting labor shortage gave tremendous impetus to the new mechanization, and during the war years a quarter million reaping machines were sold in the country. In Minnesota, the Indian treaties and the Homestead Act of 1862 released seemingly unlimited tracts of virgin farm land for settlement. In a few years the railroads would span the state, making commercial farming practicable throughout the new lands. The decade after 1860 saw Minnesota's wheat production increase tenfold; by 1875 two thirds of the state's farm land was planted to wheat.

The power of St. Anthony Falls had attracted flour mills even before the war, when most of the wheat had to be imported from down river. By 1872, Minneapolis was already being called the Mill City. The wheat, the transportation facilities, the power, the capital, and the demand were all present. But before Minneapolis could become the world's milling center, one more thing was needed: an improvement in milling techniques which would overcome the disadvantages of Minnesota's hard spring wheat. The very hard bran jacket of the spring wheat kernel would pulverize between the grinding stones and mix inextricably with the flour. The solution came from a family of French immigrant millers named La Croix, who had developed a separating system based on series of vibrating screens and air blowers. When his own mill at Faribault burned down, Edmund La Croix brought his system to Minneapolis, and finally found a big miller—George H. Christian—who did not think that he was crazy. With La Croix's middlings purifier, plus the use of steel rollers which cracked rather than crushed the wheat kernel, Minneapolis millers were soon making flour of the highest quality. The price of their product soared, and with it the price of northern wheat.

The single-crop economy did not last long in Minnesota agriculture. Perhaps one of the most convincing arguments against complete dependence on wheat was offered

233

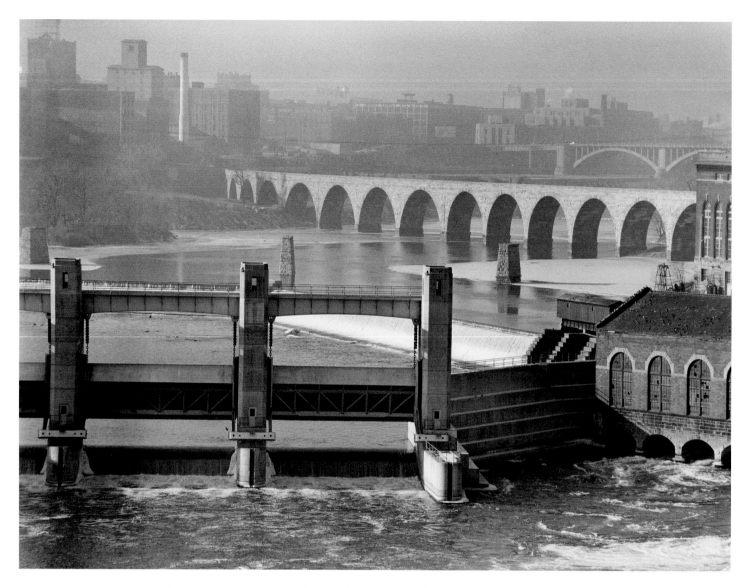

by the grasshoppers — the Rocky Mountain locusts — which descended upon the Minnesota prairies in the summer of 1873. It was said that the sound of their coming was like the roar of a prairie fire, that the juice of the crushed locusts would run in a stream from under the wheels of a moving wagon, that bare legs would bleed from the insects hopping against them. The farmers devised a dozen methods of combating the bugs, and sometimes managed to grow enough crop for the next year's seed. County boards paid bounties for dead hoppers — at first three cents a bushel; later the state offered as much as a dollar a bushel, or fifty cents a gallon for eggs. These

bounties helped the settlers survive – those who had not fled from the terror. In the fifth summer the insects rose and flew away.

Less frightening that the grasshoppers, but more damaging in the long run, was the fact that the repeated planting of wheat rapidly depleted the fertility of the soil. As yields became smaller those farmers who were determined to stick with wheat moved westward into the Dakotas. Those who stayed began to experiment. One such was a German immigrant named Wendelin Grimm, who brought with him to Carver County a pumpkin-sized bag of alfalfa seed. He planted the seed his first spring, and the next winter almost all of it died from the cold. What little lived bore seed, and Grimm gathered it and planted again. And again, each year. Some say that Grimm was not being scientific, only stubborn, but the result was the same: he developed a strain of alfalfa which is now one of the state's most valuable crops.

Another experimenter was a Yankee named Oren Gregg. Gregg was a practical farmer and a pioneer educator, who by 1886 was conducting Farmers' Institutes throughout the state, telling the farmers that they should stop farming by habit, that they should breed their cows in spring and milk them in the winter, and that they should not all compete in raising the same things, but seek out and supply the neglected wants. Another man who pushed diversification was James J. Hill. He distributed eight hundred thoroughbred bulls in the area, and many fine imported breeding hogs. He was deeply discouraged and apparently surprised that in a bad year some farmers would slaughter their breed stock for food.

What Grimm did for alfalfa, Peter Gideon did for apples. He came to Minnesota from Ohio, laden with seeds and seedlings. A dozen years later all of his carefully nurtured stock had died except three trees. But from one of those hardy survivors, with infinite patience, he developed the Wealthy apple.

During the sixties and seventies, all the good things of civilization were symbolized in the coming of the railroads, and towns competed for them as they now compete for manufacturing plants. And the inducements of the towns were trifles compared with the largess of the state and federal governments. In 1857, Congress subsidized the Minnesota railroads with the gift of six square miles of public lands for each mile of track laid. But before the railroad companies could collect the first install-ment of their grant, they had to survey and locate twenty miles of road, and when the panic of 1857 struck they could not raise a dollar among them. A direct loan from the state (which was not yet really a state) was prohibited by the new constitution; but it was not difficult to pass a constitutional amendment which allowed what was a loan in fact if not in theory: the state would issue and deliver to the companies its special bonds, backed by the state's credit. The companies were to pay the principal and interest when due. As security, the companies offered their own first mortgage bonds (which were worthless) plus part of the lands which they would presumably soon own. This arrangement, it was argued, was only queer in theory, for it was obvi-ous that once the companies had a little operating capital, affairs would boom, to the

profit of all concerned. Two years later the companies went bankrupt before laying a mile of track. The state foreclosed what properties the railroads had acquired, then changed its mind and restored them to the companies.

By 1872 actual track had been laid spanning the state from the Twin Cities to Iowa, to Dakota, and to Lake Superior, and from Duluth to the state's western border. The next year another depression—the panic of 1873—again exploded the railroad bubble. James J. Hill had been keeping his once extremely perceptive eye on the railroad situation for years, and he recognized his chance. He later said, "After long and close study of the situation, the slender beginnings were made on which we risked our all. Failure would be immediate and final disaster." By the time of the *next* depression—the one of '93—Hill had pushed his Great Northern road westward to the ocean. The new panic bankrupted the Northern Pacific, and by the time Hill had finished administering aid, he controlled that road also. The main railroads of Minnesota had been largely completed a decade earlier; of the major rail services, only those from the iron ranges to Lake Superior were still to be laid.

The Ojibwa called the region of the ancient, worn-down mountains *mesabi,* meaning giant in the hills. It is a mystery how the Ojibwa knew; perhaps they were referring to a different giant, now forgotten, or still undiscovered. Timber cruisers and prospectors had traveled through the region for years, appraising the stands of pine or on their way to hunt gold, or later, on their way to find the familiar form of iron ore, sandwiched in veins between the slanting rocks of the Vermilion Range. But on the Mesabi the traditional signs of iron were missing, and mining experts and prospectors alike ignored the area. All except seven brothers named Merritt, timber cruisers, whose father had told them that iron was there. It took twenty-five years to find it. On a fall day in 1890 a wooden wheel of one of the Merritts' wagons broke through the surface crust and come out powdered with an unfamiliar henna-colored dirt. The dirt was tested; it was two thirds pure iron, part of the richest iron deposit in the country. The highly talented Merritt family began to develop their claim, and to borrow heavily. In three years their company was controlled by John D. Rockefeller, who was both talented and experienced.

The effect of the iron-mining industry on northeastern Minnesota was tremendous. An area of thousands of square miles of forest and swamp, almost empty of human life, was suddenly invaded by a new wave of immigration. In the thirty years after 1890, the population of St. Louis County increased forty times. Today's leading Range cities—Virginia, Hibbing, Eveleth, Chisholm—had not even been founded before the discovery of ore. The village of Duluth quickly became the state's third city and the nation's second port.

Nineteenth-century Minnesota earned its living in two ways: by farming and by gathering raw materials. Manufacturing grew up in direct service to these activities and, except in the case of milling, was relatively unimportant. With the center of the nation's population a thousand miles or more to the east, the state was at a

disadvantage in producing finished goods for export. But to a degree, this sword cut both ways; Minnesota was also a long way from the finished goods of the Lower Lakes, and what it could produce at home would not have to be imported. Thus from the beginning Minnesota's manufactures, while not the backbone of its economy, were of exceptional diversity.

The farms and pineries and mills and mines created wealth; as wealth grew, a smaller portion of the people's income went for foods and raw materials, a larger portion for finished goods and services. By 1880, Minnesota manufacturers employed twenty thousand workers; seventy-five years later the number was over ten times as great, and the dollar value created by Minnesota manufactures had passed that produced by Minnesota farms.

No one can say with certainty how Minnesota will earn her keep in the years beyond tomorrow. Each year of her history, the techniques of survival have become more complicated. Assuming escape from the simplicity of final destruction, it is likely that the future will be not simpler, but still more complex. But if the future's specific problems and methods are unknown, much is known about the way that the problems must be met. The Twin Cities' park planner, Horace Cleveland, spoke of the way when he remembered opportunities passed and lost forever: "What we might have done had we taken time by the forelock!" (*The Land Lies Open*, THEODORE BLEGEN).

Another man remembered without remorse the moment when it was not too late, when he sat in his overloaded airplane on a wet runway, calculating his chances: "Wind, weather, power, load—how many times have I balanced these elements in my mind, barnstorming from some farmer's cow pasture in the Middle West! . . . Gradually these elements stop churning in my mind. It's less a decision of logic than a feeling, the kind of feeling that comes when you gauge the distance to be jumped between two stones across a brook. . . . Sitting in the cockpit, in seconds, minutes long, the conviction surges through me that the wheels *will* leave the ground, that the wings *will* rise above the wires, that it *is* time to begin the flight" (*The Spirit of St. Louis*, CHARLES A. LINDBERGH, JR.).

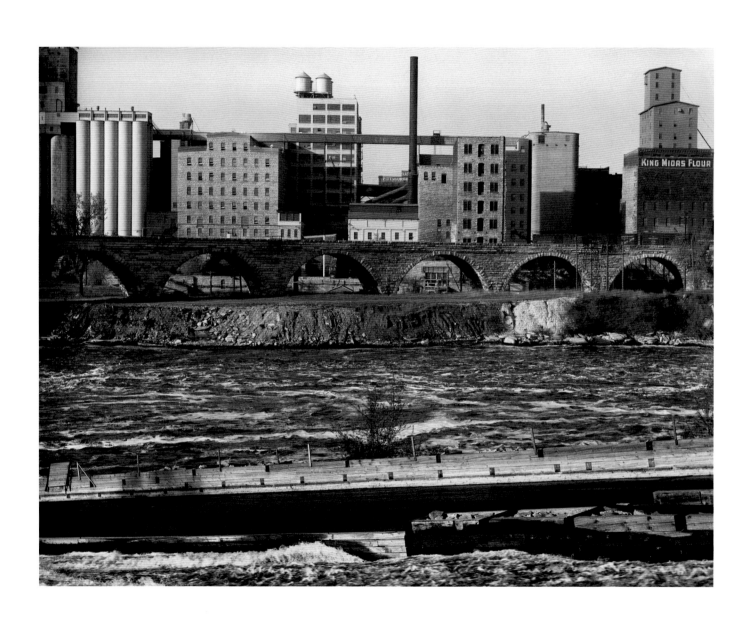

Since the Milwaukee baseball team

in an orgy of high-mindedness abandoned its old and honored designation of Brewers, the Minneapolis team now has the most appropriate nickname in the country. They are called the Millers.

This was the industry that built the city. The coopers alone, who came to build the millions of barrels needed, would have formed a goodly town. But during the nineteen thirties, the city's supremacy in flour-making was lost to Buffalo. This was owing mainly to the fact that American railroads run east and west, not north and south, and the center of flour wheat production had shifted southward into Kansas. The farms of the Upper Midwest were growing more durum wheat, which is better for macaroni than for flour. But as Minneapolis's flour production fell, the milling companies developed other products to replace it.

One man equipped an experimental laboratory — a bowl, a spoon, and an electric hotplate — and tried to produce foods by dropping bits of wheat mush onto the heated plate. He thought the result tasted fine (covered, presumably, with milk or cream and plenty of his favorite fruit), but when it was packaged it crumbled badly and became a half package of powder. So the man gave it up and went back to eating wheat mush. Others had become interested, however, and the company gradually solved the problem of making the new food crispy and crunchy the whole way through — and later, the problem of selling it.

That was only the beginning of diversification. Today, while Minneapolis milling companies still produce prodigious quantities of flour, they also make packaged mixes, breakfast cereals, chemical synthetics, polyethylene balloons for ascent into the stratosphere, and electronic devices.

239

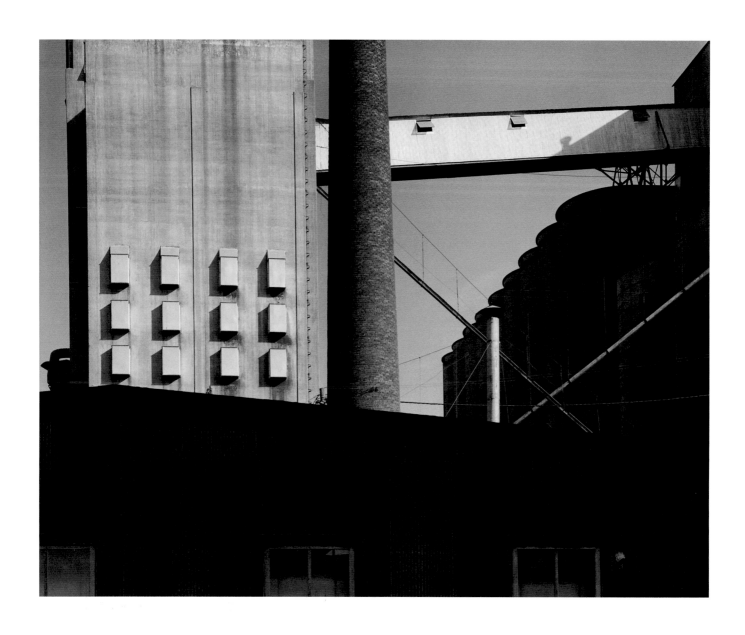

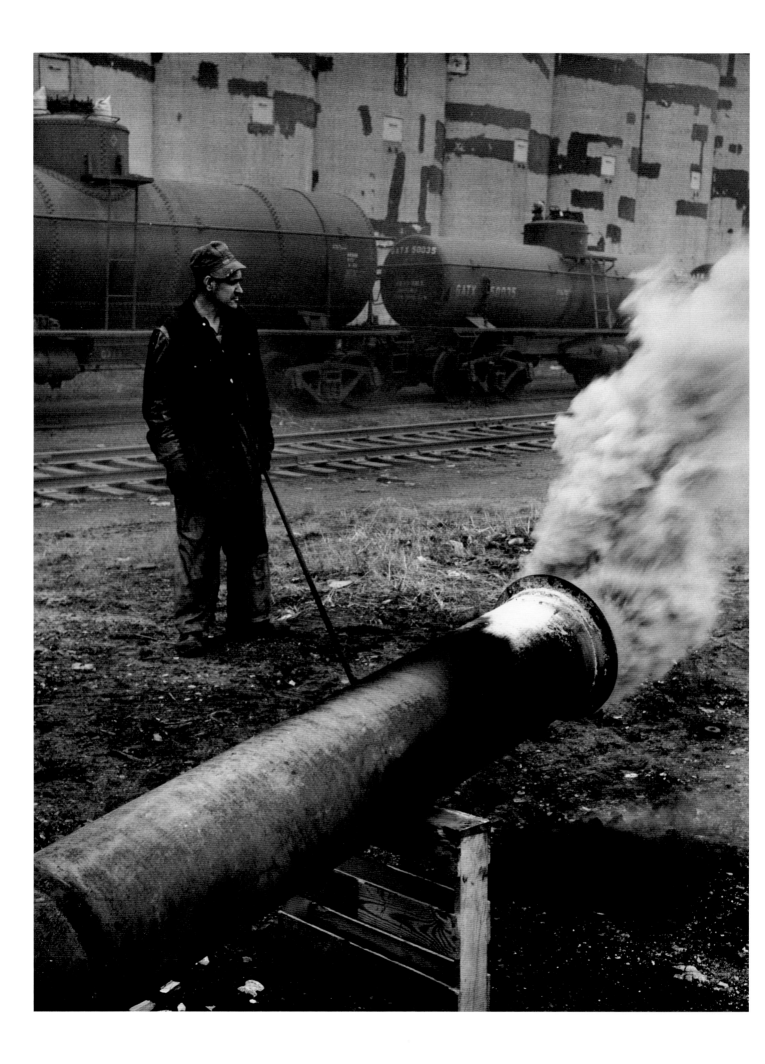

The clean geometric shapes of grain elevators punctuate Minnesota's horizons from Duluth to the western border and southward to Iowa. At the cross-roads towns are small country elevators with pointed roofs, and in the cities are long banks of concrete cylinders which store millions of bushels. The French architect Le Corbusier said that these were perhaps the most beautiful architecture that America had invented—precise, economical, ordered. On some nights, when the air is moist and still, the gentle, warm smell of grain reaches out from the elevators into the town. It is a fertile smell, half like the earth and half like fresh bread.

But the grain inside the elevators is for many things besides bread. It is for cereals and spaghetti and beer and animal feeds; the flax is for linseed oil, and the soybeans are for every conceivable thing under the sun, by the midwifery of the industrial chemist. And these things are all manufactured in Minnesota. Minnesota farmers and millers and haulers and sellers of grain once stood or fell with the year's wheat crop and the demand for flour; but now the great bins are filled with a dozen grains destined for a hundred uses.

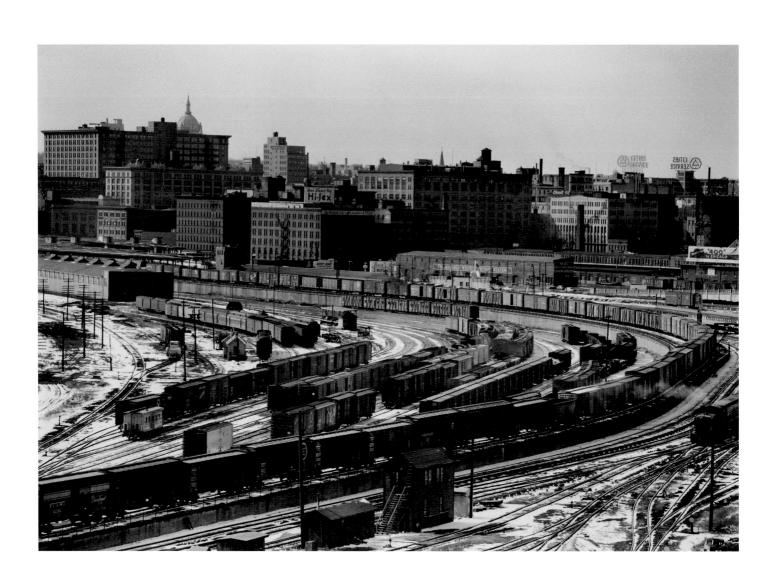

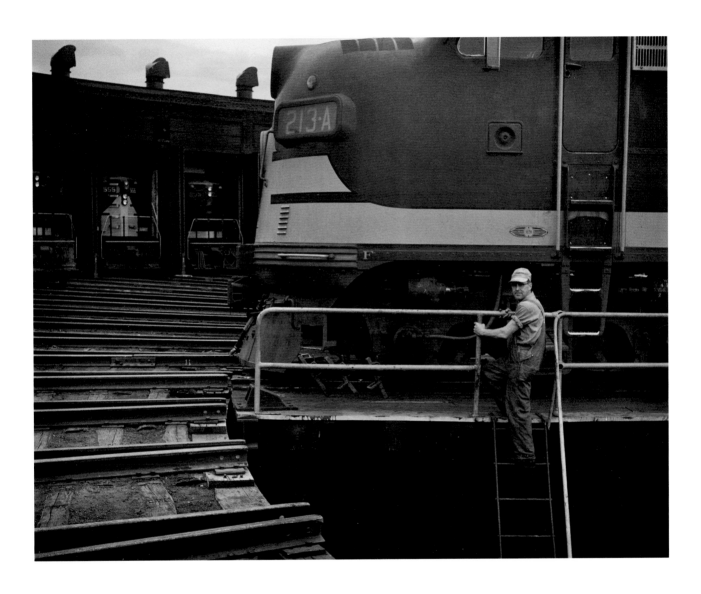

The railroads

were not necessary to get the people out onto the land. To acquire the kind of land that was available west of the Mississippi, people would have walked. In fact many did walk, rather than ride in the lumbering, springless Red River oxcarts. But once the people were out there, had built their temporary sod houses, and survived the first winter, the railroads *were* necessary. They were necessary to take the settlers' wheat to its markets — to make the prairie a part of the country commercially as well as politically. Many men built the railroads that Minnesota needed, but the giant among them was Jim Hill, who was perhaps the most praised, most insulted, most sung-about and joked-about man in Minnesota history. Many of these folk tales and songs outlasted Hill himself by a generation or more. For example:

> *I know Jim Hill*
> *He's a good friend of mine.*
> *That's why I'm walking*
> *Down Jim Hill's main line.*

CHORUS: *Hallelujah, I'm a bum,* etc.

All of the jokes and other apocrypha meant only that even if the people couldn't decide whether or not they approved of him, they were sure that he was a very big man, and had done something very important: he had filled western Minnesota and the Dakotas and Manitoba with settlers, and then sweet-talked and bullied them into producing fantastically big harvests for his road to carry eastward.

He also built one of America's most beautiful bridges, the great masonry span at St. Anthony Falls. This gave him great satisfaction, as other things must have too, for toward the end of his career he said, "Most men who have really lived have had, in some shape, their great adventure. This railroad has been mine."

The railroads have not changed much since James J. Hill died, though the steam engines have been replaced with Diesels, which are less beautiful and which have relatively puny whistles. In spite of the automotive revolution and the growth of a great trucking industry, it is still the railroads that tie the prairies to the cities and carry the abundance of the land to market.

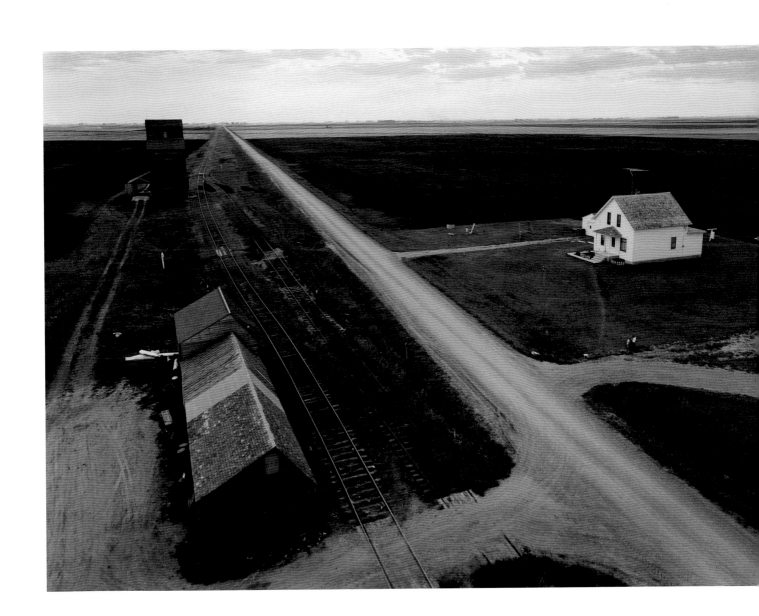

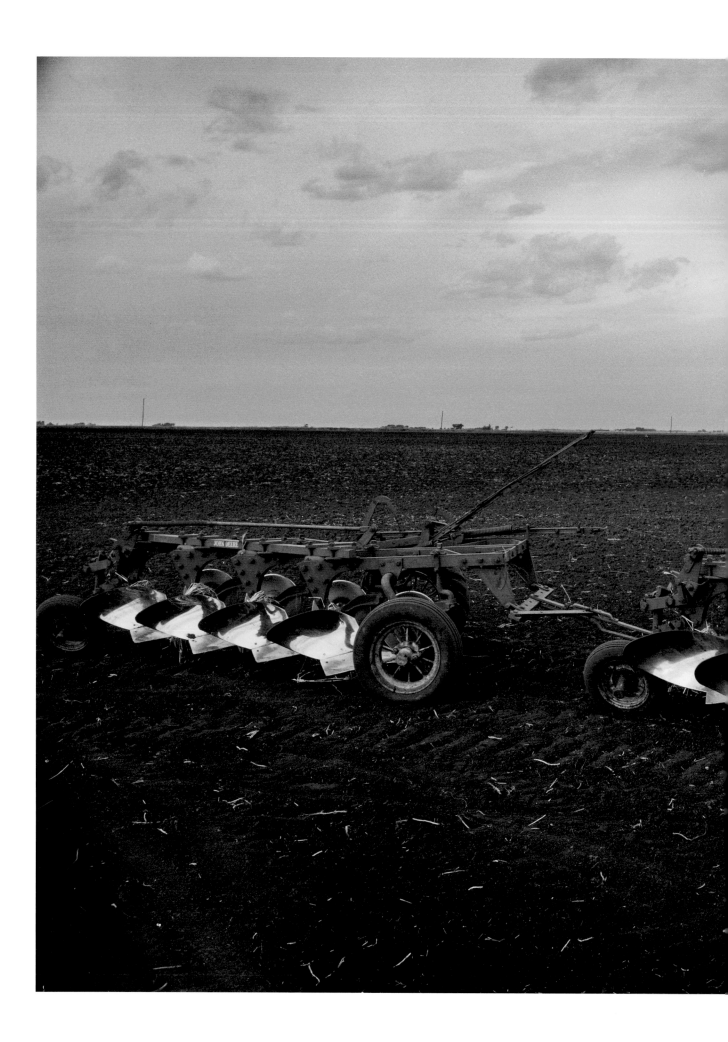

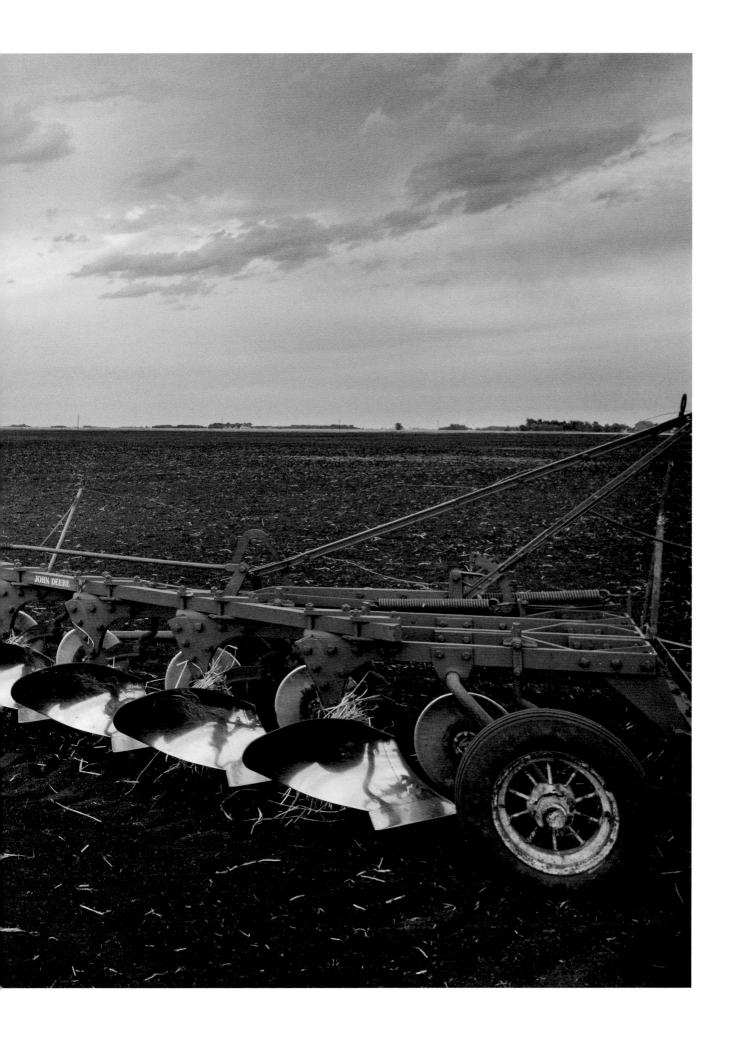

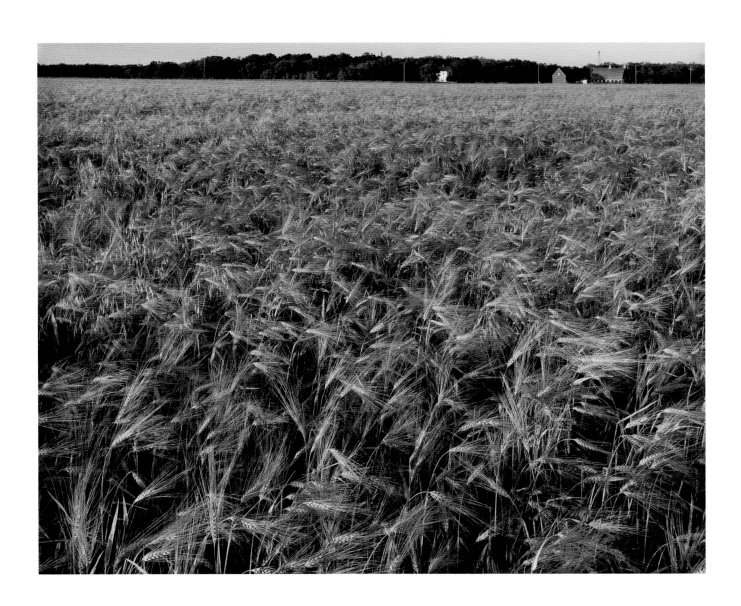

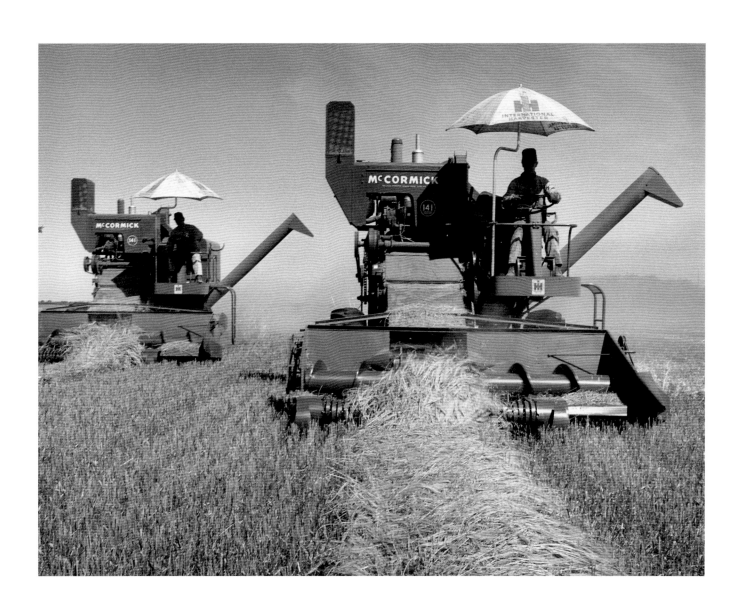

IN EARLIER TIMES, Minnesota farmers grew huge quantities of wheat, and their wives grew garden stuff for the table. Now Minnesota grows relatively little wheat and a great deal of many other crops. But while the produce of the state as a whole has become diversified, the individual farmer is perhaps as specialized as ever. The capital investment required to grow small grains competitively won't help a farmer to raise hogs or corn or apples or turkeys, so a man takes his pick, according to his land and his markets, and puts his energies and his money into a restricted group of crops. The logical choice, and consequently the pattern of land use, varies tremendously from one part of the state to another. In the south the farmers grow corn, and feed hogs and cattle. The more broken landscape of the east and central sections is chiefly dairy country. Northwest in the Red River valley they grow small grains and flax and potatoes and sugar beets. The comparatively marginal lands of the northeast are also dairy country, more or less by the process of elimination. These patterns are of course indefinite and continually changing—new hybrid corns have pushed the corn belt northward into shorter growing seasons; soybeans have become increasingly important in much of the state. In transitional areas crops compete for available acreage on the basis of what paid best the preceding year.

Perhaps the outstanding historical characteristic of Minnesota agriculture has been its adaptability. Minnesota farmers have repeatedly changed their thinking as economic conditions and farm technology have changed. At the same time, land use has become increasingly intensive. The enormously increased yields of today's crop lands have not been without cost, either in terms of immediate production costs or in terms of the money which must be plowed back into the hard-worked soil. For if corn is a soil-depleting crop, then high-yield corn is highly depleting. The complexities of soil chemistry become better understood each year, but to preserve the fertility of Minnesota's soil, more than knowledge will be necessary: farming is a business; a sound business must invest part of its profits in its own future; to do this, there must be profits.

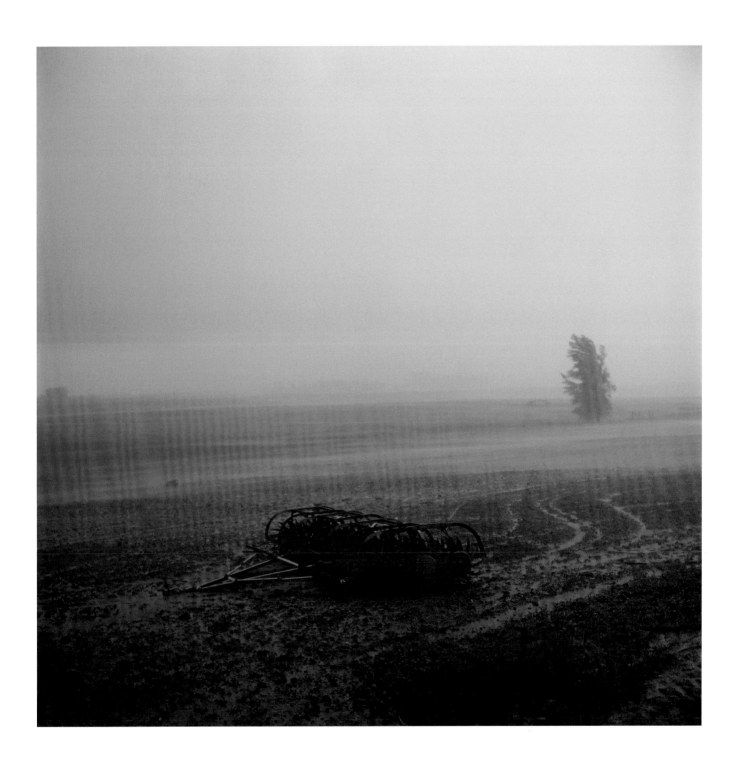

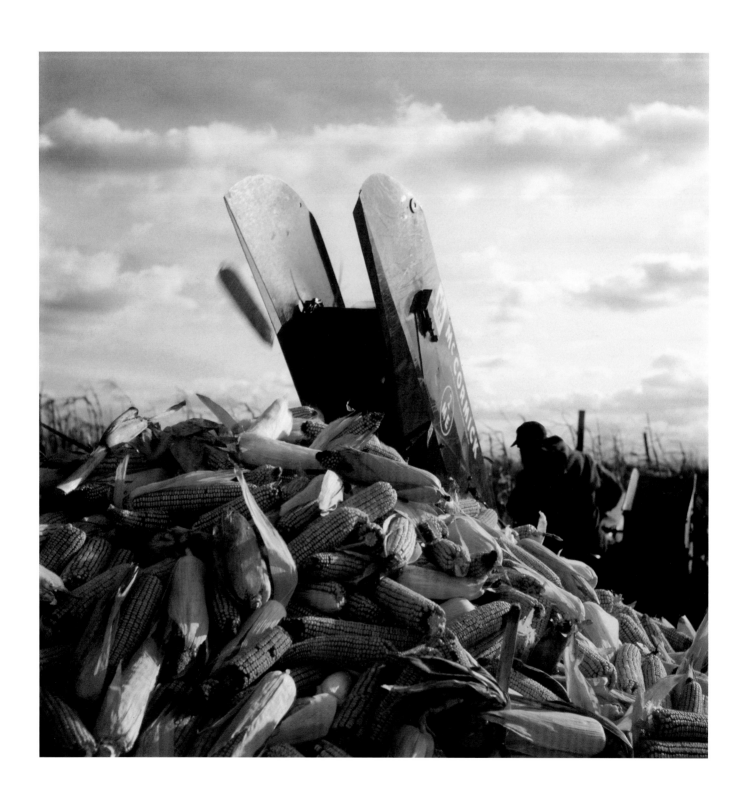

In one of Minnesota's less prosperous farming counties, a farmer said:

I have almost paid off my mortgage now; I am pretty nearly even with the board. I'm very nicely set up to keep milking my twenty-five cows.

The trouble is that to make a living I should now be milking thirty-five cows. Which means I need ten cows, a bigger barn, a bigger silo, more crop land, more pasture, a bigger tractor, and so on right down the line. If I borrow money to do these things, it won't be half paid back before I'll probably need *fifty* cows to keep up.

I haven't decided what I'll do. Sometimes I think that if my wife and I were each paid fifty cents an hour for the time we spent working this farm, we would come out ahead. But I'm not trained for anything but farming, and I'm not interested in anything but farming. Undoubtedly I'll continue farming.

In the corn belt, another farmer said:

We grow crops here that they wouldn't have believed possible twenty-five years ago, and we grow them with less risk and with less hired help. Of course you need money to farm profitably; it's a big business. It also takes more money to build an automobile factory than it did to build a carriage shop; that's just the way things are. But agriculture is perfectly sound — at least around here it is. I'm buying land. I say that this land is worth whatever you have to pay to get it.

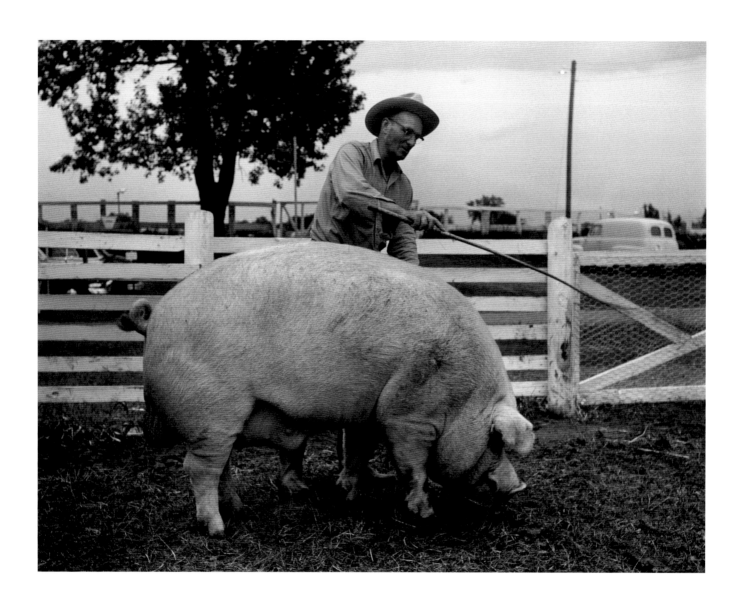

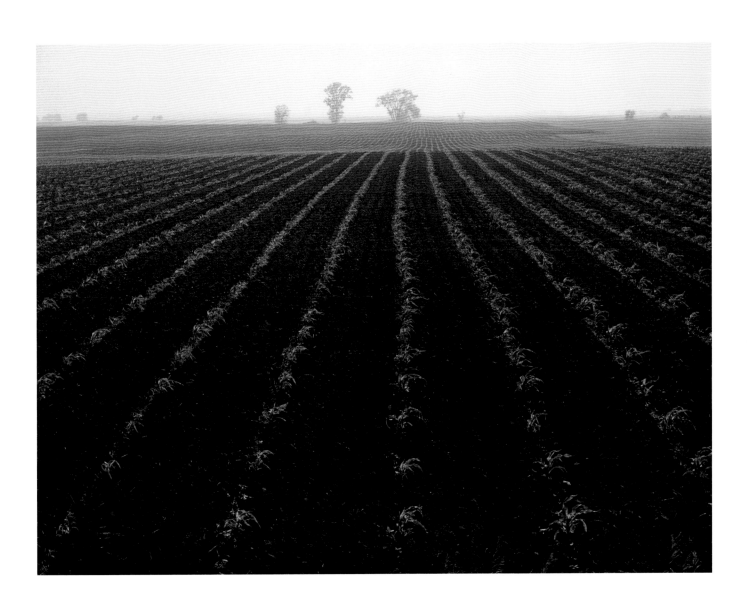

And why is any cow, red, black or white, always in just the right place for a picture in any landscape? Like a cypress tree in Italy, she is never wrongly placed. Her outlines quiet down so well into whatever contours surround her. A group of her in the landscape is enchantment.

Has anyone sung the song of the calf-bearing, milk-flowing, cud-chewing, tail-switching cow, slow-moving, with the fragrant breath and beautiful eyes, the well-behaved, necessary cow, who always seems to occupy the choicest ground anywhere around?

She is the dairy farm, the wealth of states, the health of nations.

How many trusties and lusties besides her lawful calf have pulled away at her teats these thousands of years, until the stream flowing from them would float fleets of battleships, drown all the armies the world has ever seen.

Oceans and oceans. All consumed by man and his beasts.

How the cow has multiplied the man!

And yet, so battened upon, she is calm, faithful and fruitful.

As companion, she endures all — even indifference — contented. . . .

And the dung that goes from her to the fields by way of sweating youths and men saturated and struggling in the heavy odor and texture of her leavings! This indispensable wealth that goes to enrich and bring back the jaded soil to a greenness of the hills and fertility to life itself — for man!

Yes, where her tribe flourishes, there is the earth, green, and the fields fertile. Man in well-being and abundance.

She is Hosanna to the Lord! For where she is, "at destruction and famine man laughs," as he salts her, fodders her, beds her, milks her and breeds her. And thus tended she contentedly eats her way from calfhood clear through to the digestive tract of humanity — her destiny. Her humble last farewell to man — the shoes upon his feet!

FRANK LLOYD WRIGHT, *An Autobiography* (1932)

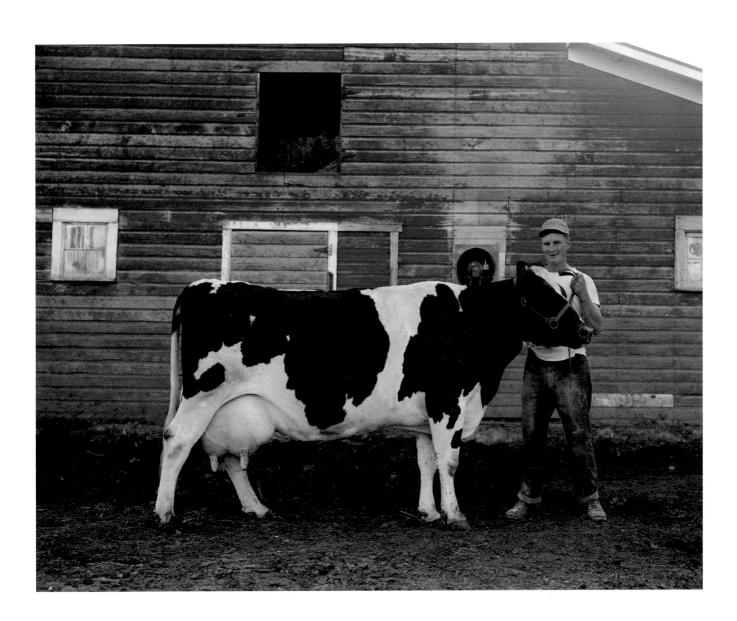

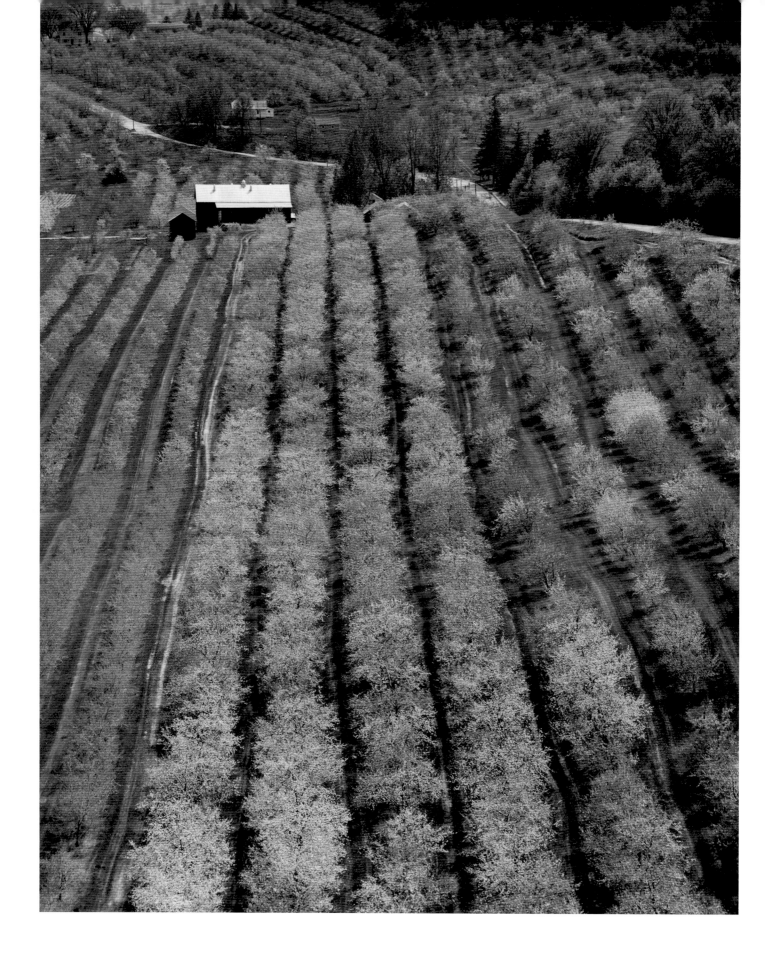

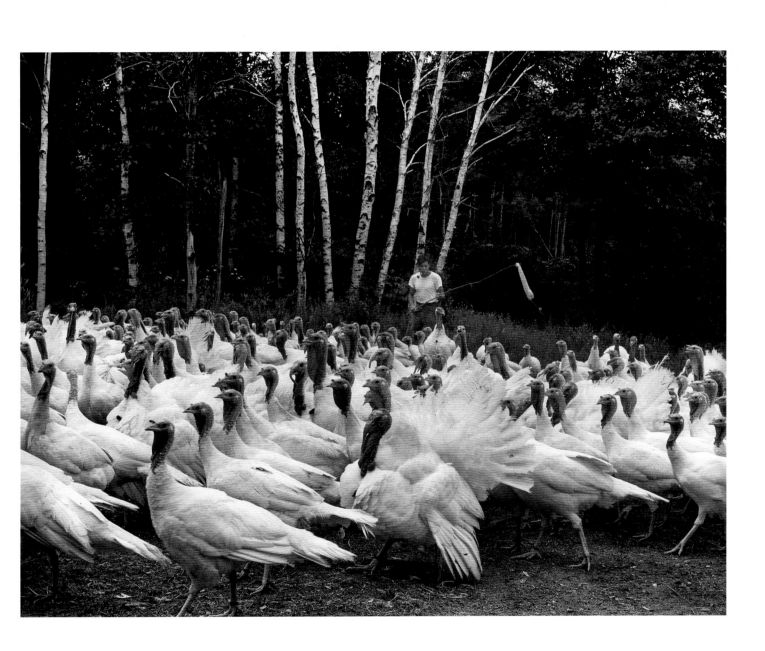

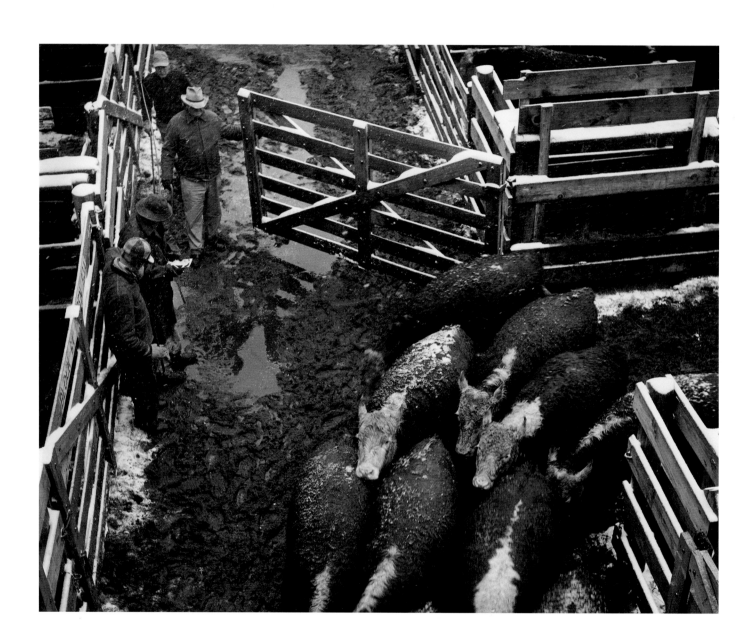

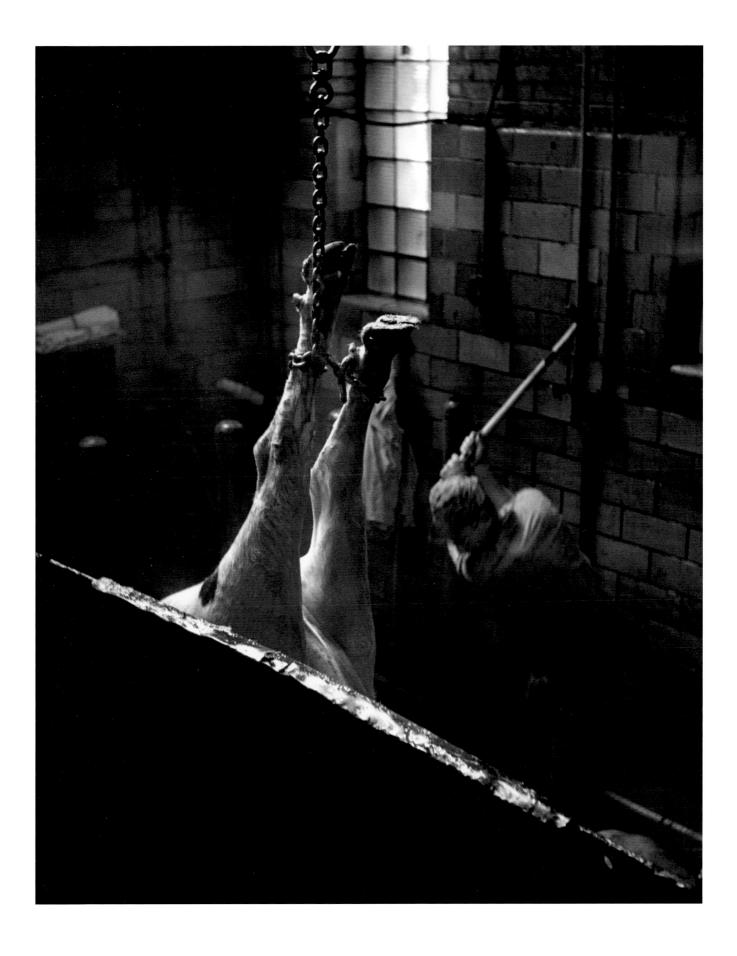

were the richest in the country. For over sixty years the easily mined ores of the Mesabi and Cuyuna and Vermilion ranges have provided the lion's share of America's steel. Now these desirable ores are almost gone. Postwar industry's voracious appetite has wolfed a hundred thousand tons of ore a year, a rate that would exhaust Minnesota's high-grade reserves in less than a decade. In 1956 the last rich untapped lode, the Stephens mine, was opened. In the same year several mines closed, and others continued at greatly reduced rates of production. Mountains of poor ores, stockpiled over the years, were restudied, concentrated, and shipped east to the steel cities.

None of this surprised those who know mining. Before the Mesabi Range was middle-aged, the thoughtful began to predict when the payments would stop. Some went further and suggested solutions. A few — one man in particular — did something.

Forty years ago Professor Edward Wilson Davis began telling anyone who would listen — and many who didn't want to — that the Mesabi Range was like a huge raisin cake, and that only the raisins were being appreciated. He said the whole cake was good. People said well, perhaps, eventually. The cake was an iron-bearing shale, taconite, one of the hardest substances there is. Working this rock, the scoop shovel's huge steel teeth wore blunt in seven hours.

By 1915 the professor had developed a method of magnetic separation which pulled the one quarter of iron from the three quarters of finely crushed rock. A plant was erected to try the idea; it failed. The process was imperfect and expensive. The crushed ore was fine as dust, hard to ship, and hard to work at the blast furnaces. Further experiment showed that the dust could be rolled into little balls, then baked hard. Gradually the process was perfected, but it was still expensive. And to the steel companies that made it hopeless; for under Minnesota tax laws, they claimed, only a quick stripping of the richest ores was economical. So E. W. Davis, already a laboratory researcher and industrial engineer, became an educator. At engineers' conventions and service club luncheons and city council meetings, he explained what was wrong: "The mining companies are taking our best ore and, when this is gone, will move elsewhere and leave us nothing but an enormous tonnage of low-grade material that may or may not be used in the distant future. This is apparently what the State of Minnesota wants them to do, as the taxation methods are entirely in that direction. It would seem much wiser for the State to do everything possible to encourage the mining companies to utilize the enormous tonnages of low-grade ore before the high-grade ore is gone."

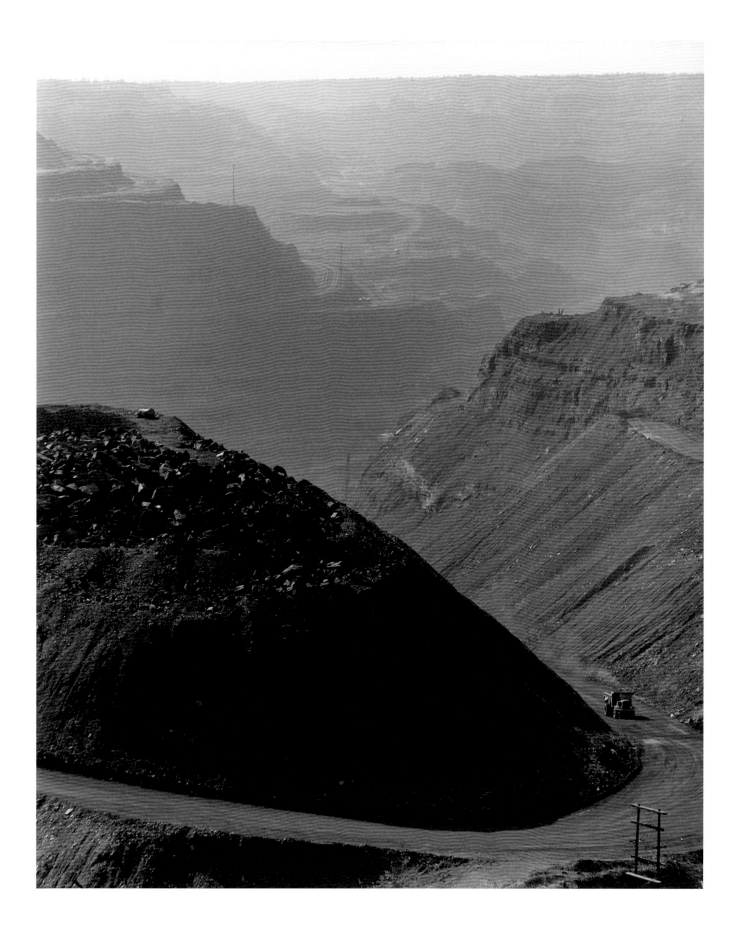

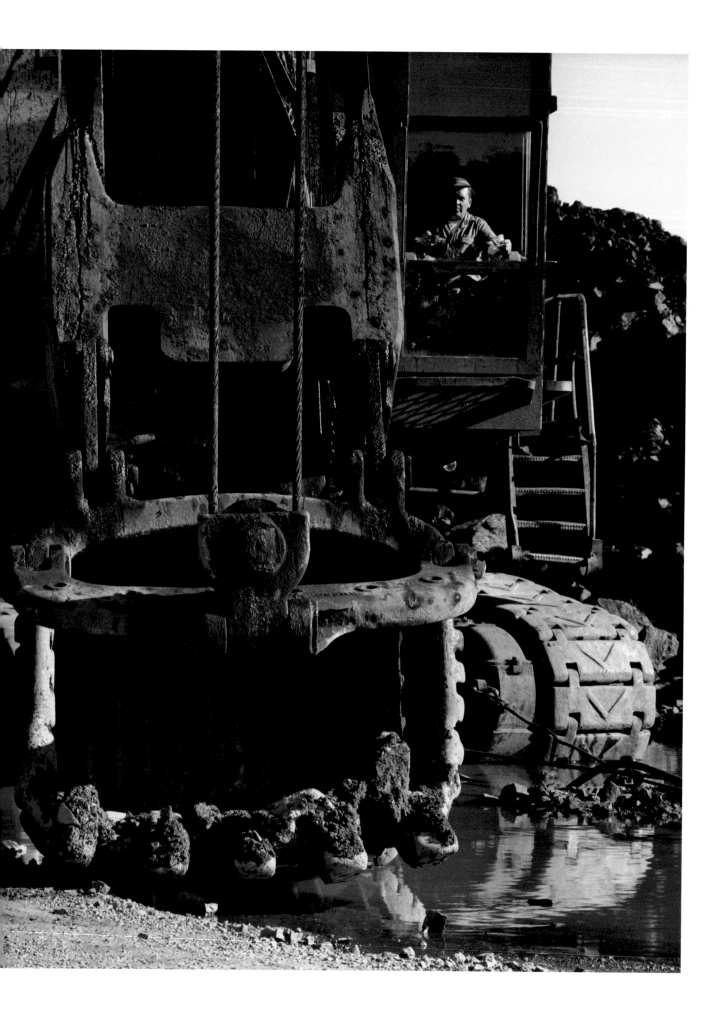

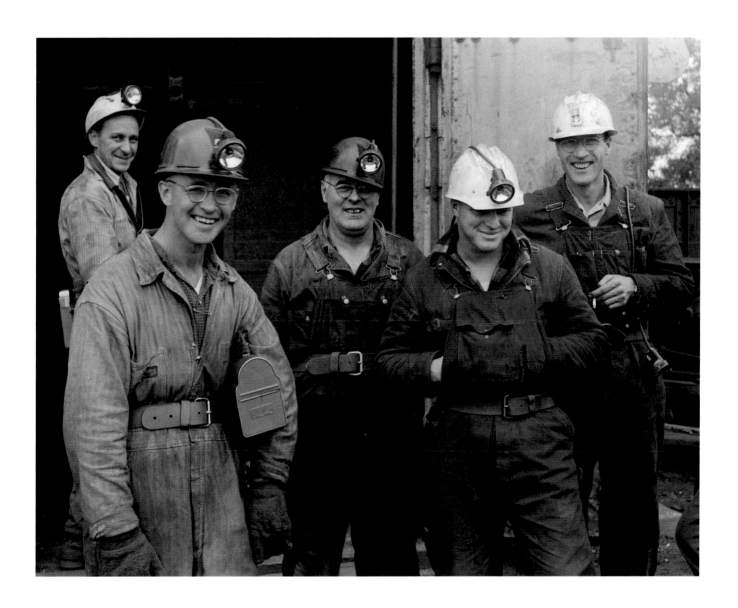

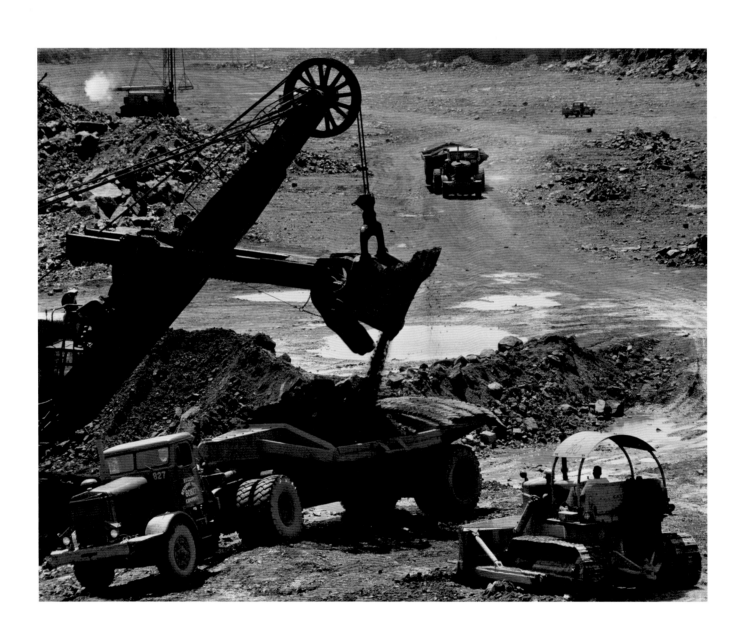

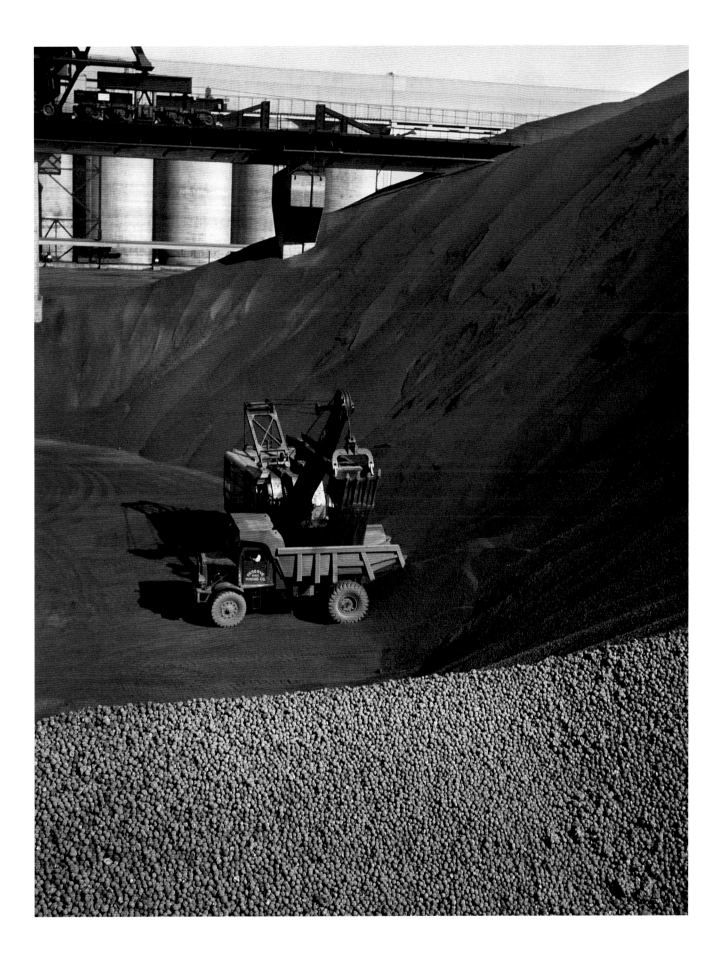

IN EXPLAINING THE FUTURE of iron mining in Minnesota, Davis also said: "Remember that when the ore is gone, there is nothing left to tax. . . . When the ore is gone, we will have spent all but about six per cent of the money received from it, and this is about all we will have to show for the wonderful ore deposits which the state contained."

In all this talk of taxes, Davis was on dangerous ground. The bulk of these taxes did not go to the state, but stayed in the locality where the ore was mined. It stayed with the people who had done the digging, and to them this seemed no more than just. With the money they had built the richest school systems in the state. It was expensive to run a town on the Range; as the pits got bigger the town might have to move back, and build new streets and a new city hall. After one of Davis's early speeches, a headline in the Ely *Pioneer* ran:

ANOTHER GRAB AIMED AT RANGES
Prof. Davis Has Brilliant Scheme to Rob Range Communities
of Balance of Tax Funds Not Now Confiscated by State!

That was in 1924. Gradually over the years the relationship improved. By the mid-thirties the Range newspapers thought that tax reform was perhaps not objectionable in theory, but only in practice — not so much vicious as visionary. By the end of the decade, as thoughtful citizens became increasingly concerned about the area's future, some active support appeared. After one of his speeches Davis was approached by a newspaperman, a lawyer, and a school administrator (W. A. Fisher, Howard Siegel, and John A. Blatnik). They were ready to help. Two years later the Junior Chambers of Commerce of the Range towns petitioned the state legislature to amend the law to make it possible for taconite development to proceed free of taxation on ores in the ground and on capital investments.

Within a year much of the state's best taconite land had been proved and claimed. Before the war ended, steel companies were at work translating the Davis experiments into full production scale. By 1948 the first mass-produced taconite pellets reached the blast furnaces. Taconite would work, and with full production it would be economically feasible.

Today three companies are processing taconite in northeastern Minnesota. Tremendous industrial compounds, and modern towns to serve them, have grown up in the wilderness north of Lake Superior. Existing plants can satisfy a significant part of the nation's steel needs. And the ore will last for centuries.

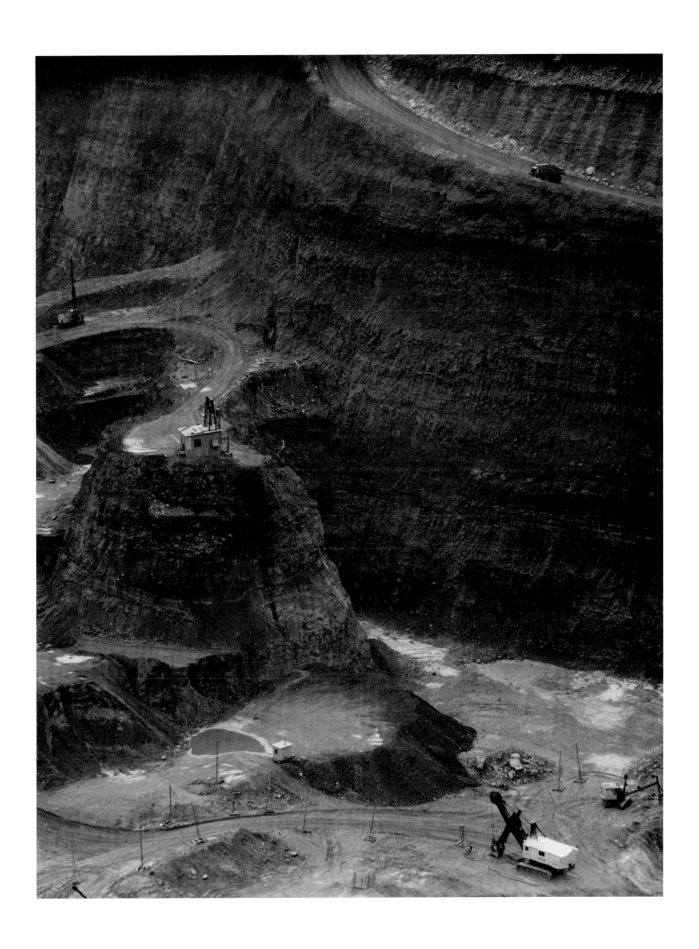

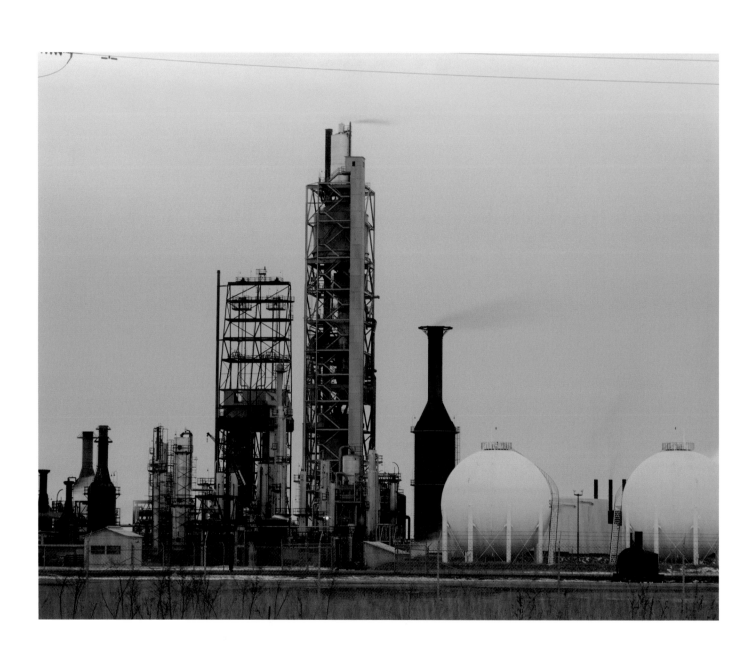

Minnesota lived off its capital

for most of its first hundred years. It prospered largely because it exported its raw materials — its furs, its forests, and its iron ore. The fur coats and paper and steel, and the wealth that they created, were manufactured elsewhere.

From a national perspective, there were two good reasons for this: the state's trading area was not a populous one and Minnesota was far from the country's main mass markets; second, the area was short of major sources of easily developed power. Thus Minnesota shared little in the phenomenal nineteenth-century growth of American heavy industry. Some heavy manufactures — farm machinery, for example — could be profitably produced because of the closeness of special markets; but for the most part Minnesota manufacturing was best able to compete when it concentrated on the skill industries, whose products were of high value in relation to shipping costs, which demanded little imported power and material and much skilled workmanship, managerial ability, and imagination.

In recent years Minnesota's position in regard to both power sources and markets has improved. The availability of oil and natural gas, and the development of hydro-electric power on the Missouri River, have supplemented coal as important energy sources. The time for economical development of the Dakotas' large deposits of low-grade coal is thought to be close at hand. Solar and atomic energy will in time further expand the power supply in areas like Minnesota which have in the past been power-poor.

Where industrial development has long existed, it tends to be self-perpetuating. Similarly, where it has once gained a foothold, it is self-generating. One industry helps produce the services, the capital, the labor pool, and the markets which are needed by others. Between 1940 and 1953 the value added by Minnesota manufacturing increased over four times — a greater increase than that of the nation as a whole. This firmly established industrial base can be expected to contribute to the further rapid growth of manufacturing in Minnesota.

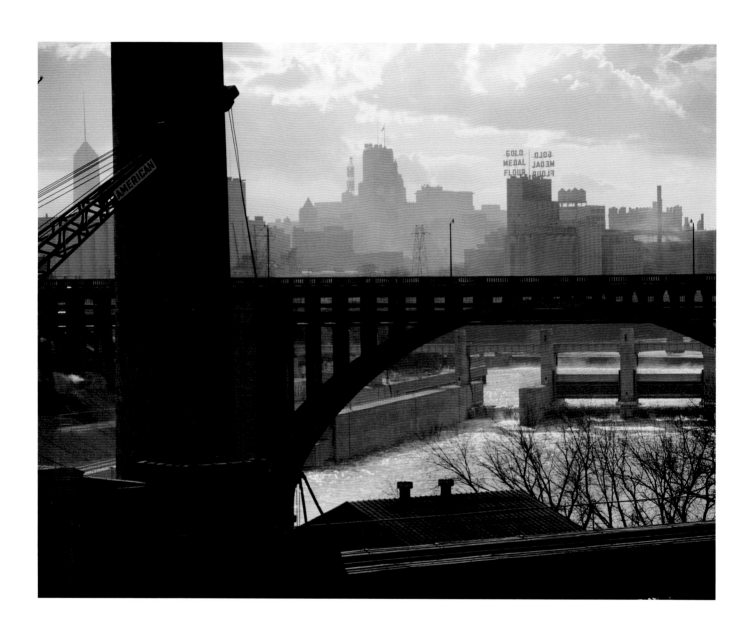

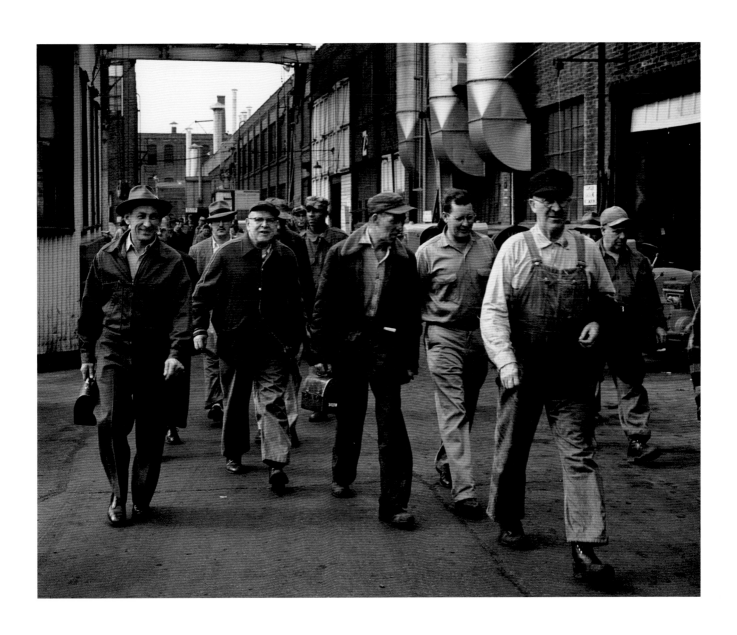

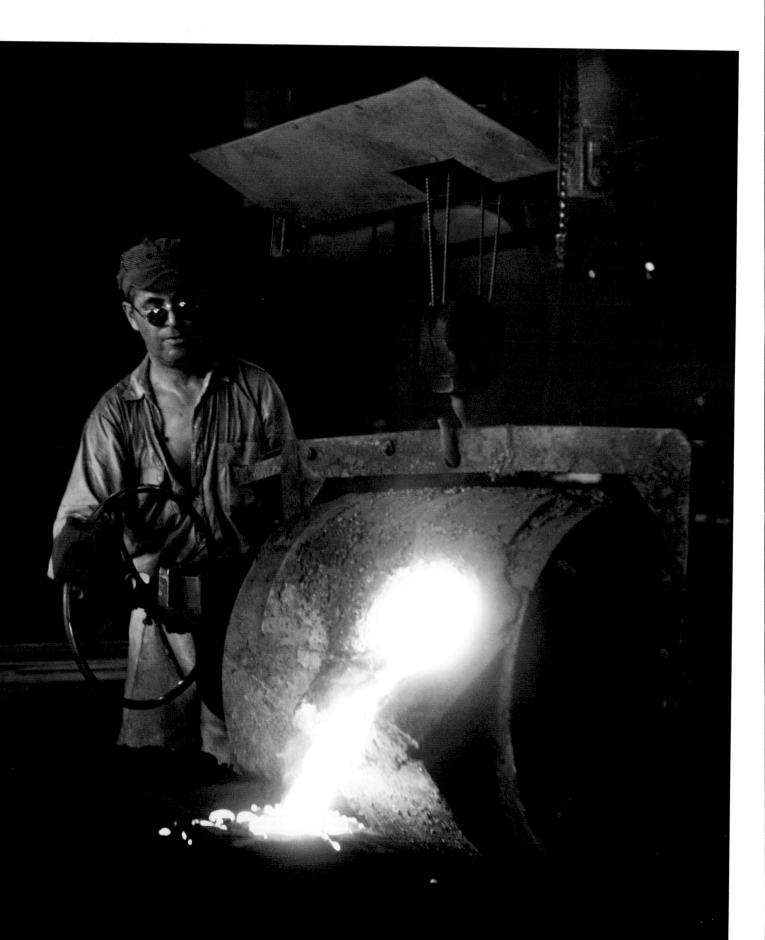

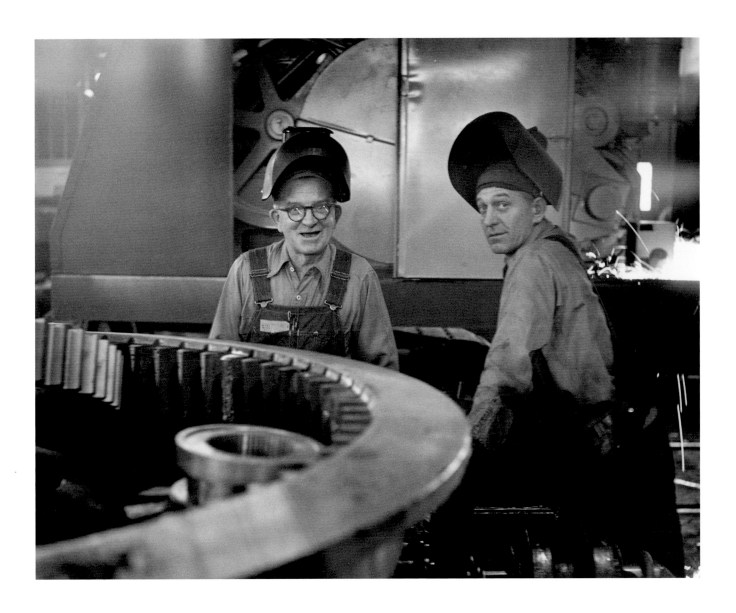

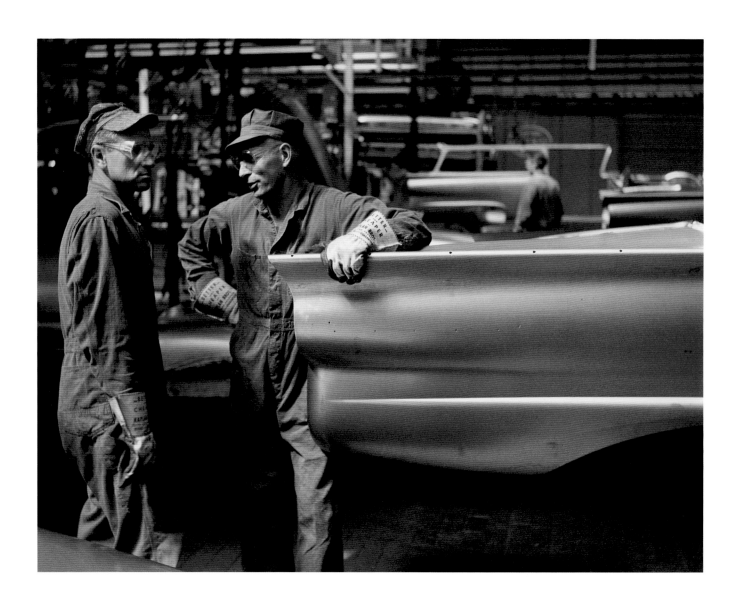

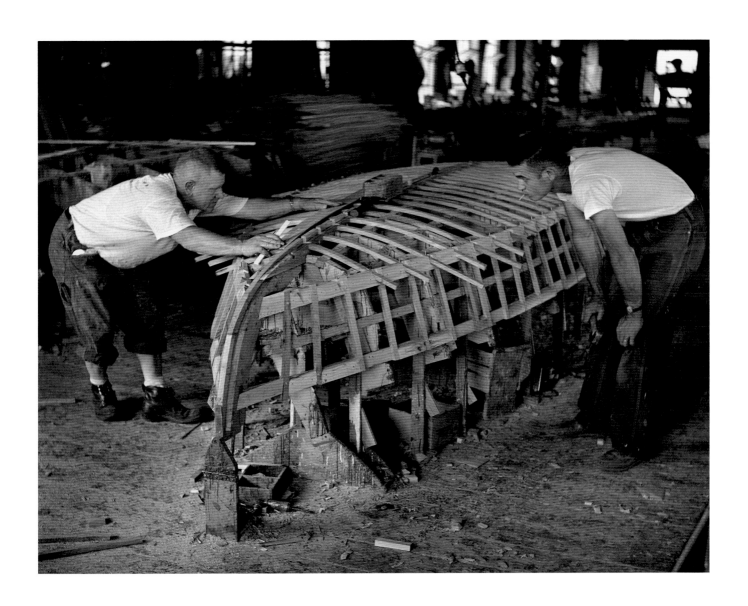

IF THERE IS A PATTERN to be found in the extreme diversity of the state's manufactures, perhaps it is this: without the advantages of strategic location, populous markets, and cheap power sources, Minnesota manufacturers have learned to depend upon wit and skill.

Manufacturing has depended upon an especially skilled labor force, as is the case, for example, in the Twin cities printing industry. Minnesota produces very large quantities of law books, religious books, medical publications, and agricultural publications; and it manufactures more calendars and desk memo pads than anybody else. There are also many printers who do not print the most of anything, but who are precise and sensitive workers, with a craftsman's sense of responsibility.

Manufacturing has been tied to invention. One company — Minneapolis Honeywell — started life seventy-odd years ago after a tinkerer named Al Butz, tired of walking to the basement to open or shut the draft on his coal furnace, invented a primitive thermostatically controlled damper-flapper. Today their automatic heating control systems compensate for temperature changes before they occur, and Honeywell produces electronic systems which will guide a missile or fuse its warhead or indicate, record, tabulate, or process almost any information.

Many of Minnesota's most successful manufacturing industries were born at the moment when simple material-gathering failed. Minnesota Mining and Manufacturing Company was formed to mine and ship bulk anorthosite, an abrasive found on Lake Superior's north shore. But the material proved inadequate, and the mine was closed. The company began manufacturing sandpaper from imported materials, and struggled along in a precarious competitive situation until one of its men invented a sandpaper which would work as well wet as dry. This was the first of a famous series of product inventions (including the transparent tape that would mend anything) which were created from ordinary base materials and extraordinary imagination.

When the virgin pine was gone, a few imaginative men took a closer look at the remaining trees, which for half a century had been scorned as weeds. With the help of research and experimental groundwork done in the universities of several deforested states, firms like Wood Conversion Company found economical ways to *manufacture* lumber from these plentiful species. For many uses, the new synthesized lumbers were better than sawed boards; the men who made them were not merely using value, they were creating it.

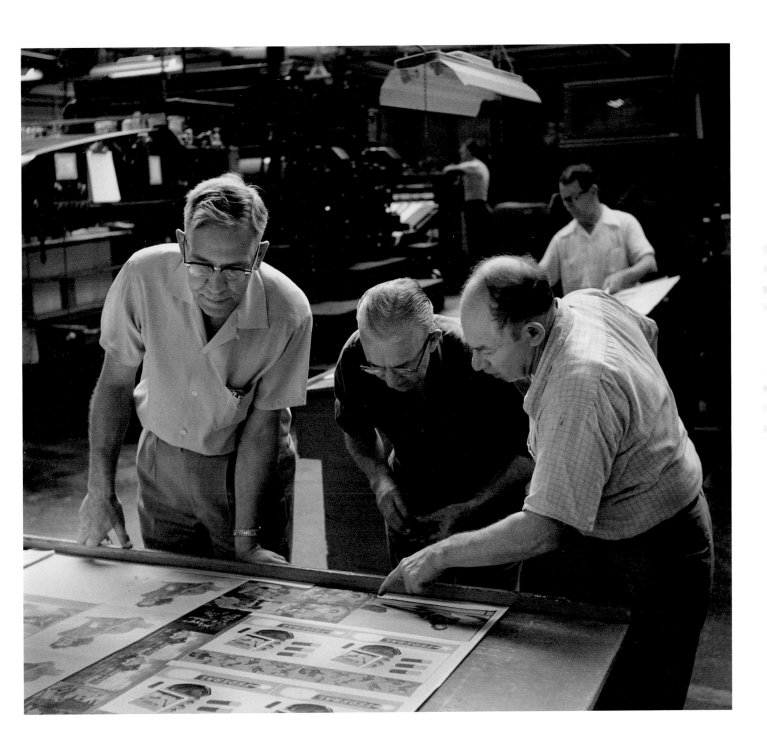

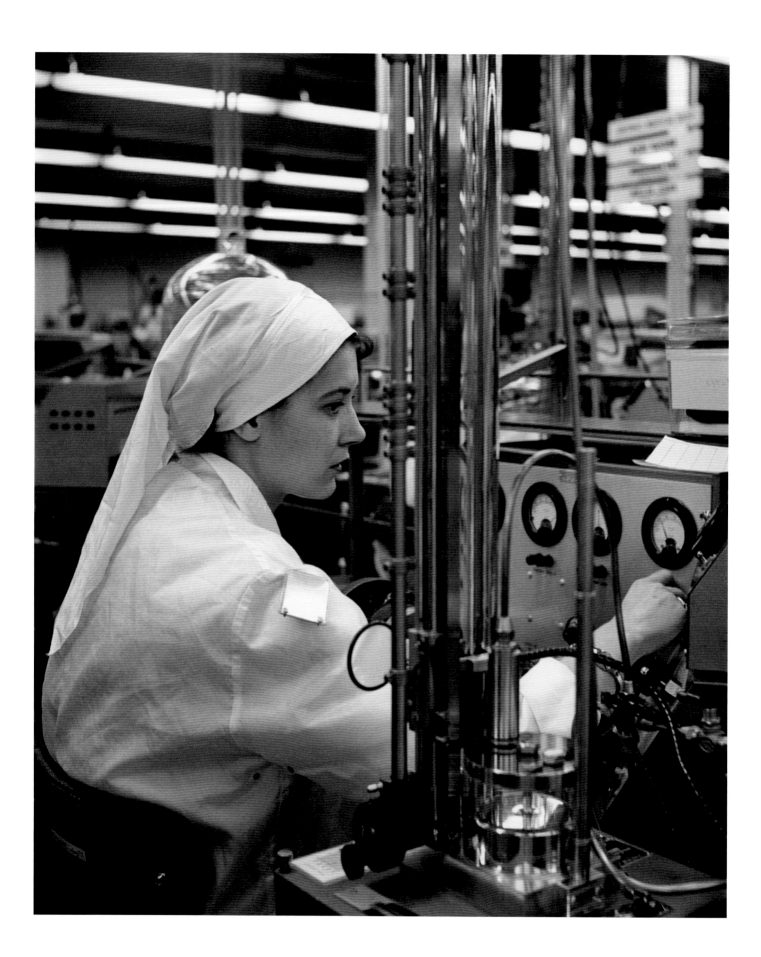

YESTERDAY'S NEW AGE of steel and concrete and mechanical muscle is now middle-aged. Perhaps the greatest bridges of today are the tiny transistors which span not might rivers but minute electrical currents. The cathode ray tube has made the giant, roaring rotary press seem prematurely old-fashioned, and a thousand electronic slaves depreciate the world of mechanical force.

This state is rapidly becoming a center of the mushrooming electronics industry. Minnesota plants produce calculating machines, sound-recording devices, hearing aids, and instruments for the measuring and recording of phenomena of the atmosphere, the stratosphere, and space.

In a pressurized, dust-free room workers dressed like doctors or nurses or nuns assemble and test one of the most accurate measuring devices known to man. The instrument's hundreds of parts are contained in a shell the size of a can of peas; its function is to sense movement. It is called a *hermetic integrating gyroscope,* hermetic because it is self-contained: no exterior reference — not radio waves, nor the positions of the stars — guides its operation. It can sense a movement three thousand times slower than that of a watch's hour hand. This delicate sensibility can guide a projectile with great accuracy through space.

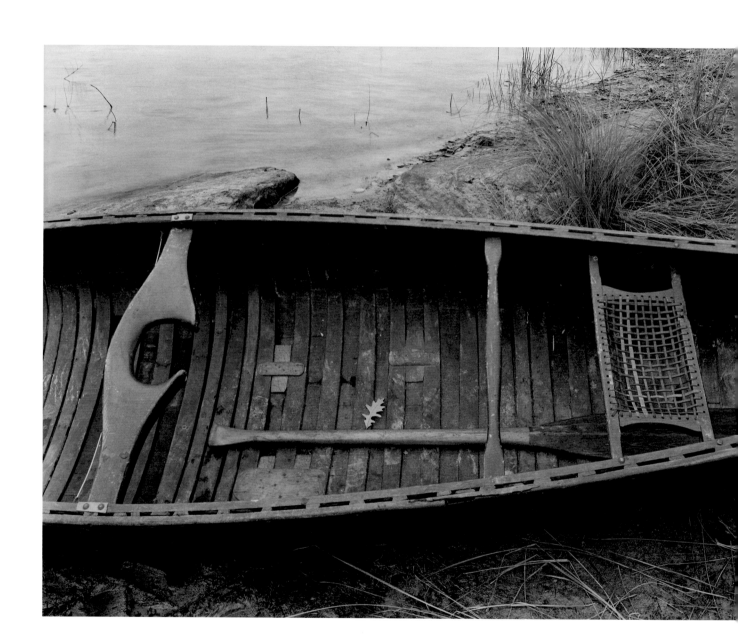

The measure of a civilization is not the possession of acres of diamonds, mines of gold, limitless water power, or towering forests. The Kaffirs of Africa had the diamonds; the Eskimos of the Yukon, the gold; the natives of Brazil, the waterpower; and the American Indian, the forest primeval. And they were all ill fed, ill housed, and ill clothed. Neither does ownership of natural resources offer security against the future. Passengers on airplanes today look down on the almost tenantless wastes stretching a thousand miles along the Tigris-Euphrates River; the land which was, according to tradition, the Garden of Eden — the smiling land of milk and honey.

So here comes our big and as yet unanswered question. How are we to apply the greatest natural resource — the mind of man — to all these other resources . . . so that we have no undeveloped Amazon Basin on the one hand — or any devastated desert area on the other?

JAMES W. CLARK
Commissioner, Department of Business Development

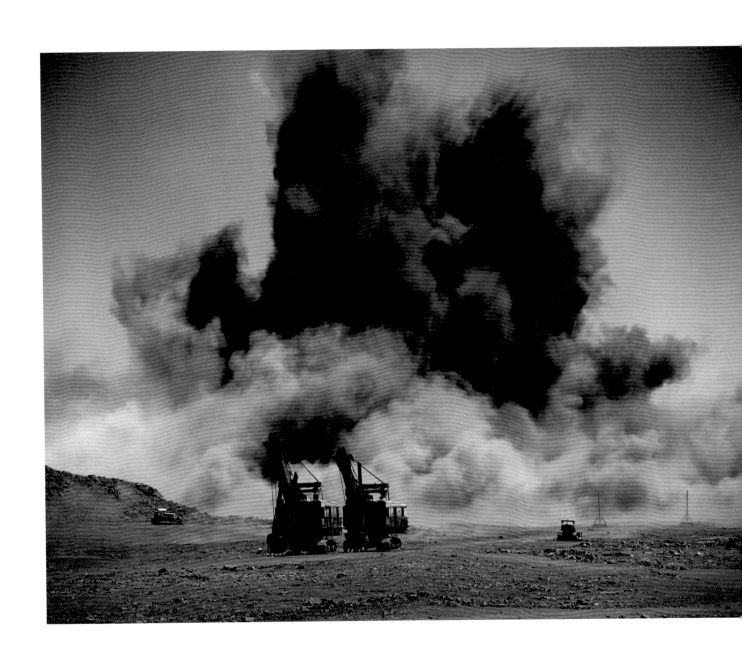

THE "VALUE ADDED" BY MINNESOTA MANUFACTURES first exceeded the cash receipts of Minnesota farms a half dozen or so years ago, and now it is said that Minnesota is an industrial rather than an agricultural state. The farmers reply with one voice that if farm prices were what they should be, farm receipts would still be ahead; and those who do not damn all statistics on principle point out that the ratio of farm income to manufactured value is still twice as great for Minnesota as it is for the nation as a whole.

Nevertheless it seems obvious that in an expanding economy Minnesota's manufacturing industries will continue to pull ahead of agriculture. The reason is obvious: a man can eat only so much, but there is no foreseeable limit to the number of objects that he can store in his garage—especially now that his car will no longer fit there.

It is equally obvious that Minnesota will continue to be a leading producer of butter, flax, feed grains, soybeans, green vegetables, meats, corn, and many other basic commodities. And certainly Minnesota's industrial growth is inextricably tied to the prosperity of its agriculture, for the modern farmer is a prodigious consumer of machinery, power, processed materials, and services.

We cannot afford to neglect any segment of our economy or any group in our society for such neglect will in short order reflect itself on all other groups. Truly, we are all in the same boat together.

We cannot afford to have our efforts to reach higher standards and attain more of the better things of life thwarted by the constant fighting among groups for a bigger piece of pie, at the expense of a smaller piece for the other fellow. It is far more constructive, far more exciting, and far more rewarding to make a bigger pie—and then we can all have a larger piece.

ORVILLE L. FREEMAN

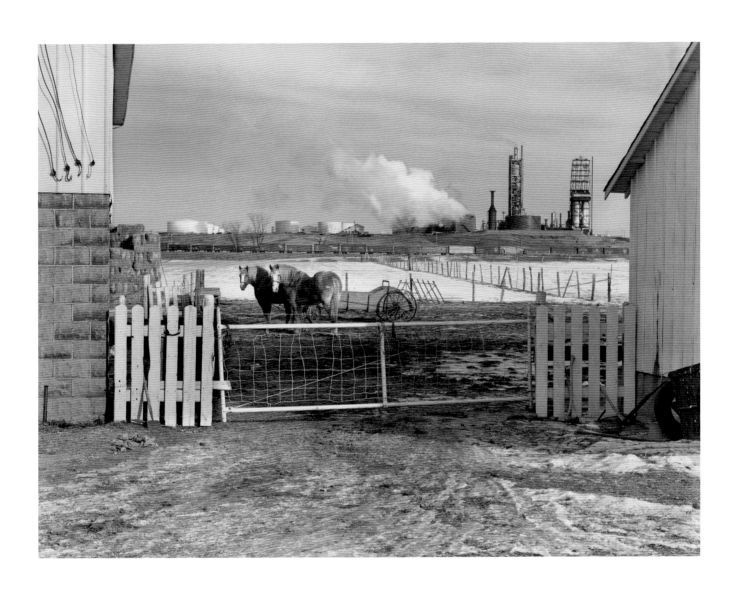

Adolf F. Meyer, hydraulic engineer:

This country is just beginning to realize that next to the air we breathe, water is nature's most important contribution to human life on this planet. . . . Minnesota is blessed with a good supply of water, but let no one think for a moment that we can afford to long permit any waste of this valuable resource. . . . Our heritage in stored surface and underground water will not last long if we are content merely to "mine" water.

Dr. George Selke, Commissioner, Department of Conservation:

First let us look at the nation. The growth of many cities is being limited by the limited supplies of water. Mining operations in certain areas are placed in mothballs because of the uncertain supply of water. California, with its growing population, is working feverishly to obtain greater supplies of water. Oil-rich Texans are thinking of importing water from the Mississippi.

What about Minnesota? . . . We have been guilty of faulty water conservation practices, such as the wanton slaughter of our forests, the ill-fated ditching program of northern Minnesota, the poorly considered draining of meadows and potholes that maintained the water table, indiscriminate water waste and pollution, a belated program of soil conservation. . . . Minnesota definitely lags far behind many other states in its understanding of water conservation.

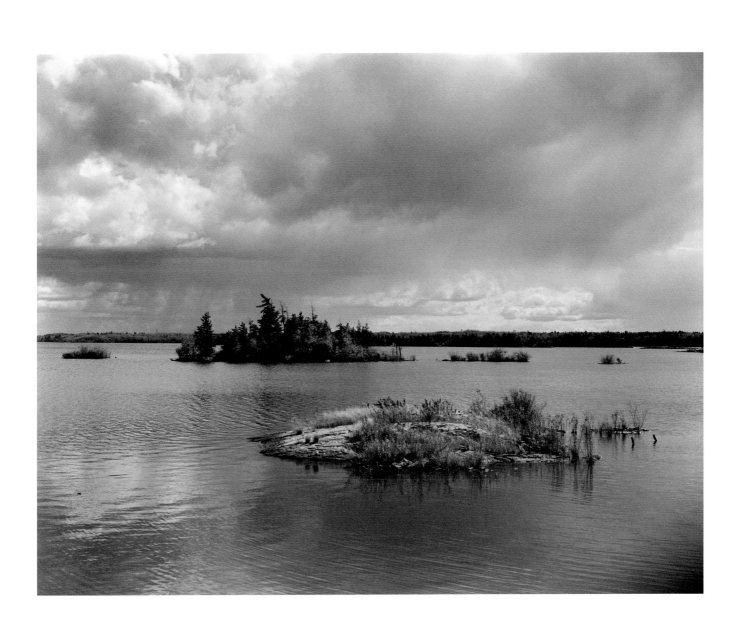

A Minnesota forester:

I've lived in the woods all my life; I learned how to cut and peel popple as a kid, helping support the family. I knew the names of all the trees and many of the other plants, and where they grew. After high school I went to a very good forestry school, and when I graduated I still knew next to nothing about the forest. I knew nothing about what makes the forest tick; and I know damned little more now, but I'm learning some of the questions we'll have to answer if we're going to grow the timber we need. I know that we can't just keep cutting and shoving seedlings back in the ground, and expect to come back in thirty years and cut again. This forest is one of the most complicated things in the world. Every part of it affects every other part. We've got to find out what things affect the soil, and what the function of the different plants is, and the function of the birds and animals, and the ground water and surface water and the sun and the snow, and what really happens after a burn . . .

I went to a field meeting out here to see a new control plot planting. It was all very neatly done, the trees were planted in nice straight rows, and it was all fine as far as it went; but I got a little tired of listening to everybody congratulate each other. Finally I said, "Well, now what has really been done here? What do we know about this plot of land? I don't even see any pits dug, to see what this plot is like below the surface. After all, the most valuable tool a forester can own isn't a typewriter; it's a blunt-nosed shovel."

One of the head men stepped up and said, "Who in hell are you?" And I said, "I'm nobody. My name is Mr. Nobody. But I love the forest."

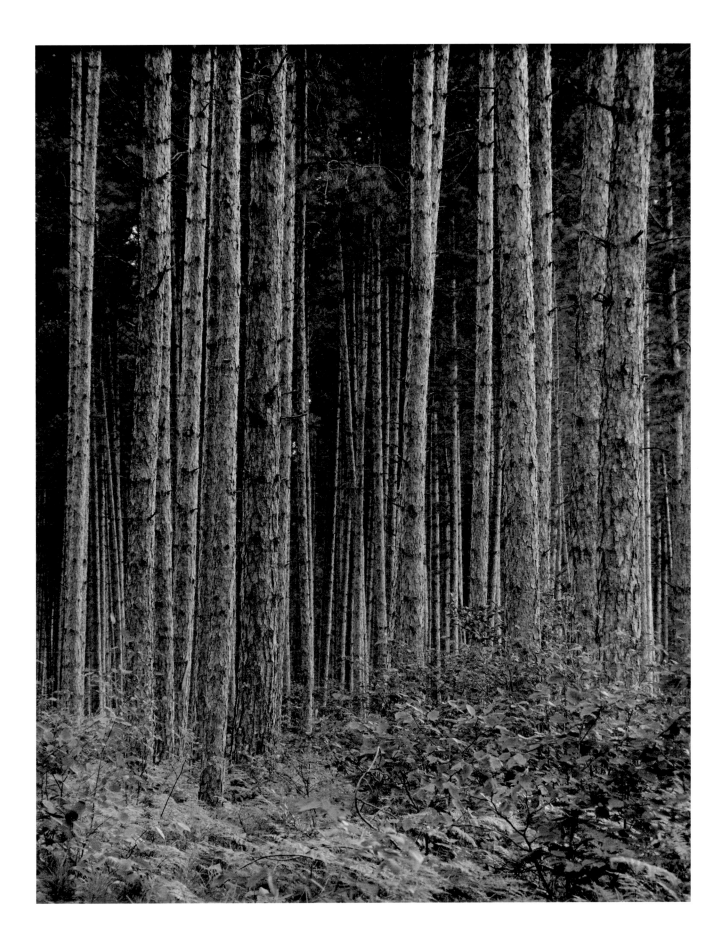

Sigurd Olson, conservationist:

Today millions are cut off from any direct contact with the earth, are discovering they can live without having to gather wood, carry water, or hunt food, that matters of security and community welfare are taken care of by others who are never seen. It is an exciting world in which to live and to many it seems as though the millennium is at hand. No longer is there anything to fear except man's own ingenuity and he can devote himself in large part to the pursuit of pleasure and to the arts.

But evidence is appearing that all is not well. There is wide unrest, frustration and even boredom with the new life. . . . G. M. Trevelyan once said, "We are literally children of the earth and removed from her our spirit withers and runs to various forms of insanity. Unless we can refresh ourselves at least by intermittent contact with nature we grow awry."

. . . But as yet there is no clear conception or acceptance of what the wilderness really means, no concrete understanding of why its preservation is a cultural necessity. If there was, there would be no pressures to exploit the natural resources or to convert the last great sanctuaries into amusement resorts. Only among those who have actually experienced the wild on expeditions into the interiors is there any real conviction of their worth. These people know for they have been shown and there is no doubting in their minds. But until all the people somehow catch their vision and understand its meaning, no natural area, no matter what its designation, will long survive on the North American continent.

Justice William O. Douglas:

We establish sanctuaries for ducks and deer. Isn't it time we set aside a few sanctuaries for men?

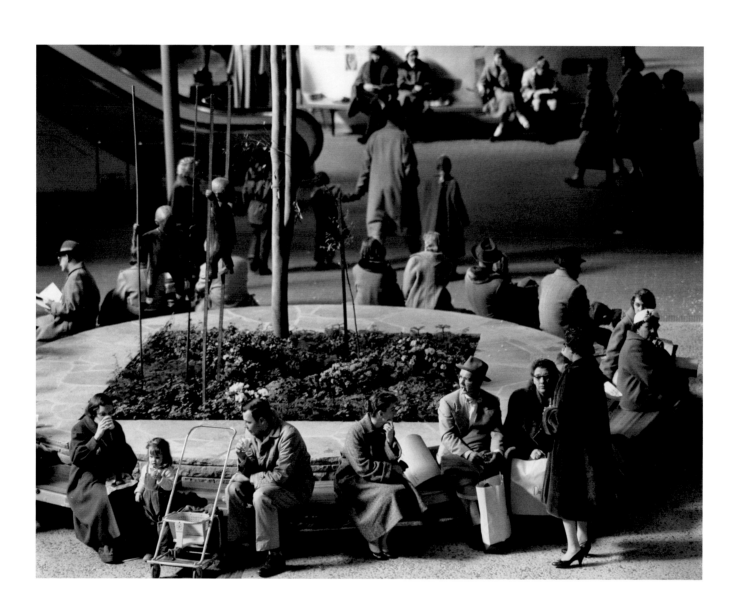

AFTER TRAPPING ANIMALS and cutting trees and mining iron, after learning to farm the land, to make it produce abundantly, after inventing processes that create wealth, and fabricating a thousand products with these processes — after doing these things, what will the people do now? Only more of the same? After evolving a government, after forming a Department of Public Health and a Bureau of Business Development and a University, when churches and temples and synagogues have been built to hold all the people, then is it only necessary to perfect and expand, and to keep the plant in good repair?

What is the function of one state among the United States? Is a state only a historical relic — plus a convenient subdivision for the administration of road-building programs, or a mechanism for the promotion of local interests, or an excuse for the perpetuation of moribund regional rivalries? Can a state have an independent intellectual flavor, a true, operating tradition, and can a tradition end on a line of longitude or in the middle of a river? Can a modern state be an experiment station for ideas, or is it a geographical place only, a place whose people share a similar history?

Is a state like a house, built to shelter its people? or is it like a plant which should in time drop its seeds and die? or is it like a machine, which, once built, should *do* something?

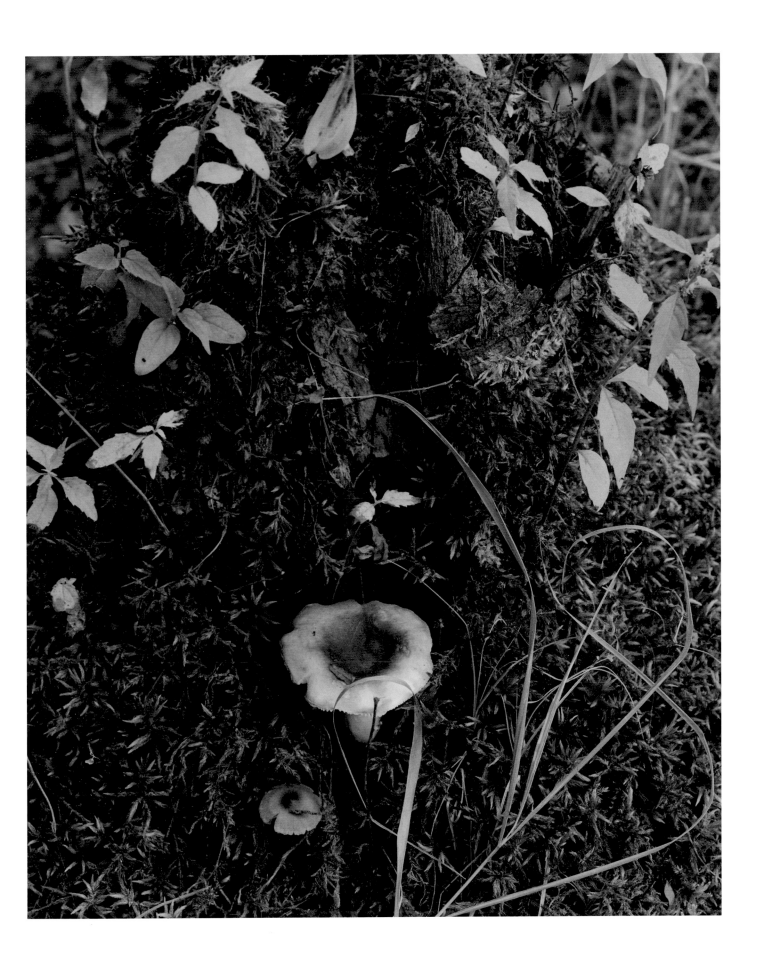

A Technical Note

OVER HALF of the photographs in this book were done with tripod-mounted cameras, on 4 x 5 film. These cameras were the Graphic View, with lenses of $8\frac{1}{2}$", $5\frac{1}{2}$", and $3\frac{1}{2}$" focal length, and the Graphlex D, used almost exclusively with a 17" lens. Of the remaining pictures, the great majority were done with the Simmon Omega 120, a few with the Automatic Rolleiflex.

The films used were, for 4 x 5: Super XX, Royal X Pan, and Ektachrome; for 120: Tri-X, Verichrome Pan, Ektachrome, and Super Anscochrome. Both Tri-X and Royal X Pan were given much gentler development, and consequently exposed at much lower speed ratings, than is normal in professional use of these films. Tri-X was developed for $9\frac{1}{2}$ minutes in Microdol, Royal X Pan for 13 minutes in D-76. Tri-X was exposed with a Weston meter at 200 for average existing artificial light or in overcast daylight, at 320 in direct sunlight. Royal X Pan was exposed at the very low (for it) rating of 650. These negatives are flat in contrast and moderately thin in density. They possess good scale throughout the curve and seem to me extraordinarily plastic: that is, susceptible to great freedom of printing control, especially with a variable contrast paper such as Varigam.

Full exposure and gentle development are paid for in loss of film speed. In exchange, the photographer gets a very complete image, with full rendering of form and texture: the space depicted is logical and convincing. If the photographer feels obliged to be able to photograph anything he can see, without adding light, he will standardize on a procedure favoring higher emulsion ratings.

I feel that my own picture-making failures can very seldom be blamed on inadequate film speed. I want to make pictures possessing the qualities of poise, clarity of purpose, and natural beauty, as these qualities were achieved in the work of the good wet-plate photographers. The compelling *clarity* of this early work is generally assumed to be a technical attribute, but I do not think that this is so. Mere sharpness will never produce clarity. Neither will a rich, complete tonality, although this is

more important. Neither will academic "design principles," regardless of how long ago, or how recently, the academy was formed — for such principles (concepts) can be no stronger or truer than the percepts from which they grow. The work of men like Brady and Jackson and O'Sullivan possessed clarity because the photographers knew what they wanted — they had to know; the technique was far too unwieldy to allow shooting by whim. In contrast, today's photographic technique allows such facility that the photographer must consciously discipline his shooting if his eyes and mind are to retain (or regain) mastery over his equipment. To learn to photograph purposefully — to be less like a sponge and more like a snare — will be very difficult today, when the photographer has almost no technical limitations to help him. But I think that this is his real problem. When he combines the flexibility of today's technique with the purposeful *intent* that the earlier photographers knew, then photography will become a mature and responsible language.

In photography the meaning of the word technique has been twisted by the gadgeteers until it now seems to refer only to esoteric mechanical problems. (Not only in photography: I once knew an orchestra conductor who could beat cut time with one hand and triplets with the other, simultaneously. He considered this performance part of his technique, even though it did nothing but waste his energy and confuse the musicians.) True technique is nothing but the means of achieving intent, with the greatest possible strength, clarity, and ease. Because crude technique will dilute the strength of any picture, the print should be as good as the photographer can make it: each tone and texture should be exactly right, considered as parts of the whole image. Precise technique, especially in printing, is frequently deprecated by photographers themselves on the grounds that subtle differences will in any case be lost in the reproductive process. This is too often true, but standards of reproduction will improve only when photographers consistently produce work which demands and deserves it. The rarity of fine photomechanical reproduction today is perhaps due more to the decline of technical standards in photography than to any lack of ability among engravers and printers. Years ago, a shoddy musical performance was often improved by a muffled, low-fidelity recording. Much contemporary photography is similarly blessed.

Identification of photographs

Afterword

Richard Benson

This is a book about Minnesota now. But as the mature man carries on his face and in his bearing the history of his past, so does the look of a place today show its past — what it has been and what it has believed in.

JOHN SZARKOWSKI began his preface for the 1958 edition of *The Face of Minnesota* with this statement. It reflects his belief that photography tells us something about the past, and that his photographs, even though contemporary with the book's publication, open a window onto the history of the state. We tend to think of photographs as records of their time, but these pictures are deeply subjective in their form. While a photograph might appear to record the world, it really is an artificial thing — a picture — made out of the stuff of the world but most emphatically not the world. The simple proof of this is that no two people could ever make the same picture of the same subject. Every photograph is different, and every one is a fictional account of the moment when it was made. The same can be said for writing, even in its most literal or documentary form. No matter how hard the author tries to be dispassionate and factual, any written description or exposition is, ultimately, a work largely formed by the imagination. In this book the photographer and writer are the same person, and he was deeply aware of the balance between fact and fabrication as he practiced both arts. He also understood that his love and fascination for Minnesota would best be served by a series of pictures and essays that would, together, create an image of the state and its people that neither medium alone could achieve.

The pictures he made for this book describe Minnesota in the mid-1950s, through the artist's canny eye focusing on the wear and tear of the state's rich past. One of the things that makes this book so special is that the majority of the accompanying essays dwell directly on the years prior to the time when Szarkowski was photographing and writing. Page after page is about history, and so, along with a vision of

Minnesota at that time, we get a rich verbal tale of the centuries leading up to it. Now, fifty years later, with this new edition, the whole picture becomes far more complex. Szarkowski's photographs belong to the histories of Minnesota and Photography, and his writing, so much of which tells a historical tale, prepares us to see the book in a fresh light. We have in our hands this great man's written essays and his visual tapestry of the state, but we must, inevitably, measure them against the new Minnesota of today, irreversibly different from a half century ago. Anyone trying to understand the sweeping changes in our society has no better tool than the multileveled story that is brought to us through the new printing of this seminal book.

Of course, there is yet another side to this book that makes it special. The author, then a young photographer/writer, went on to become a tremendously influential figure in photography in the twentieth century. He did this not through his marvelous photographs, but rather by putting the camera aside and spending twenty-nine years, from 1962 to 1991, as the director of the Department of Photography at New York's Museum of Modern Art. During his tenure there Szarkowski curated a series of innovative shows, but these were transitory, up for a few weeks and then off the walls, gone forever. As he did them he produced a series of companion books about photography that educated an entire generation and remain the most insightful examinations ever made of the medium. Virtually every contemporary photographer or scholar of photography has been deeply affected by the museum exhibitions and written publications of Szarkowski's work during these years. He wrote extensively about photography, from the stance of a practitioner, and he solved the century-old problem of how to put words and photographs together. I believe that he figured out how to do this in *The Face of Minnesota*.

Photographs appeared in books almost immediately after the medium was invented, yet they never sat well with words. In most cases some sort of caption accompanied the prints, and these usually steered the viewer's mind to an interpretation of the picture that often had little to do with how it looked. The height of this fundamentally bad practice was achieved by the picture magazines in the mid–twentieth century in which, so often, the photographer went out into the world seeking a picture that would fit an editor's preconception of the caption. The two greatest photographic books prior to *The Face of Minnesota* were probably Walker Evans's *American Photographs* (New York: Museum of Modern Art, 1938) and Henri Cartier-Bresson's *The Decisive Moment* (Paris and New York: Verve and Simon and Schuster, 1952). In both of these, the photographers, deeply suspicious of the caption, never put them on the same spread with the pictures. Evans gives the simplest of captions and lists them at the end of each section of the book. Cartier-Bresson, although wordier in his descriptions, also places them at each section's end. (This book came with a second set of the captions in a small stapled folder, to satisfy those with an irresistible need to read words as they view pictures.) Nowhere in either book is a caption printed adjacent to a photograph.

Some ambitious books combined words and pictures in a different manner, and Szarkowski's favorite seems to have been Wright Morris's *The Inhabitants* (New York: Charles Scribner's Sons, 1946). That book has a strongly emotional set of essays that each face a photograph, but the words never refer to the specific image. Instead they speak of the land and life upon it, echoing what the photographs describe. Another great example of words and pictures is *Time in New England* (New York: Oxford University Press, 1950), which Szarkowski also greatly admired. In that book Nancy Newhall sequenced a series of historical essays to accompany Paul Strand's photographs. Ranging from quotations to prose and poetry, the words, once again, do not refer directly to the pictures. Szarkowski's first book, *The Idea of Louis Sullivan* (Minneapolis: University of Minnesota Press, 1956), begins his liberation of the photograph from the caption. There are some concise identifying captions in that book, and for a number of them the photograph describes the object being written about, but many pages follow the innovative idea of Morris and Newhall to use writing that is not, in any specific way, connected to the picture with which it is paired. In *The Face of Minnesota* this break is complete: not a single essay refers to a specific photograph. Nowhere in the book does the writer tell the reader to look at this or that in a picture; instead there is a refreshing assumption by the author that the reader can engage the richness of two separate mediums that work hand in hand to describe complex ideas. In most cases we can see the connection: a text about rivers precedes photographs of barges and watery landscapes, or one on trapping precedes pictures of animals and fishing shacks. These connections do nothing to reduce the complexity of the words and the pictures as they stand alone. As we move through the book we gradually receive an understanding of Minnesota and its deep heritage, which neither words nor images could possibly give by themselves. The mind and eye of the photographer — simultaneously practicing a mechanical and a visual art — combine with his deep sense of history and brilliant use of words to produce a pageant of a time and place unmatched in the sparse history of great photographic books.

John Szarkowski (1925-2007) was already an accomplished photographer when he put aside his own work in 1962 to direct the photography department at The Museum of Modern Art in New York. During the next three decades, as curator, historian, and critic he transformed our understanding of the art of photography through dozens of influential exhibitions and books, including *The Photographer's Eye* (1966) and *Looking at Photographs* (1973). He returned to making photographs in 1991, and in 2005 his work was surveyed in a major traveling exhibition, accompanied by the book *John Szarkowski: Photographs.*

Verlyn Klinkenborg joined the editorial board of the *New York Times* in 1997. He is the author of *Making Hay, The Last Fine Time, The Rural Life,* and *Timothy; or, Notes of an Abject Reptile,* and his writing has been published in *The New Yorker, Harper's, Esquire, National Geographic, The New Republic, Smithsonian, Gourmet, Sports Afield,* and *The New York Times Magazine.* He has taught literature and creative writing at Fordham University, St. Olaf College, Harvard University, and Pomona College. He lives in rural New York.

Richard Benson has worked as a photographer and printer since 1966. His photographic work, as well as his research into the printing of photographs in ink in both photogravure and photo offset lithography, has been supported by the John Simon Guggenheim Memorial Foundation, the National Endowment for the Arts, and the Eakins Press Foundation. In 1986 he was awarded a MacArthur Fellowship. He has taught at Yale University since 1979 and served as dean of the Art School from 1996 to 2006. He is the coauthor, with John Szarkowski, of *A Maritime Album: 100 Photographs and Their Stories.*